Lists

Lists

To-dos

ILLUSTRATED

INVENTORIES

Collected Thoughts

AND **Other Artists'**

ENUMERATIONS

FROM THE SMITHSONIAN'S ARCHIVES
OF AMERICAN ART

Liza Kirwin WITH A FOREWORD BY JOHN W. SMITH

PRINCETON ARCHITECTURAL PRESS, NEW YORK Smithsonian
Archives of American Art

Published by
Princeton Architectural Press
37 East Seventh Street
New York, New York 10003

For a free catalog of books, call
1.800.722.6657.

Visit our website at
www.papress.com.

13 12 11 10 4 3 2 First edition

Front and back covers
Adolf Konrad, packing list in
his sketchbook, 1962–63. Adolf
Ferdinand Konrad papers, 1962–
2002.

Front flap
Oscar Bluemner, "Coloris maxima
fors," list from his painting
diary, 1924. Oscar Bluemner
papers, 1886–1939, 1960.

Back flap
Charles Green Shaw, "The Bohemian
Dinner" poem, undated. Charles
Green Shaw papers, 1874–1979.

Editor: Linda Lee
Designer: Deb Wood

Special thanks to: Nettie Aljian,
Bree Anne Apperley, Sara Bader,
Nicola Bednarek, Janet Behning,
Becca Casbon, Carina Cha,
Penny (Yuen Pik) Chu, Carolyn
Deuschle, Russell Fernandez,
Pete Fitzpatrick, Wendy Fuller,
Jan Haux, Clare Jacobson, Erin
Kim, Aileen Kwun, Nancy Eklund
Later, Laurie Manfra, John Myers,
Katharine Myers, Dan Simon, Andrew
Stepanian, Jennifer Thompson,
Paul Wagner, and Joseph Weston
of Princeton Architectural Press
—Kevin C. Lippert, publisher

Library of Congress Cataloging-in-
Publication Data

Kirwin, Liza.

 Lists : to-dos, illustrated
inventories, collected thoughts,
and other artists' enumerations
from the Smithsonian's Archives of
American Art / Liza Kirwin.

 p. cm.

 Includes index.

 ISBN 978-1-56898-888-7 (alk.
paper)

1. Artists—United States—History—
Sources. 2. Lists,—Miscellanea.
3. Archives of American Art. I.
Title.

 N6505.K47 2010

 709.73—dc22

 2009025316

Contents

Foreword by John W. Smith PAGE 6

Introduction PAGE 9

1. The List as Art PAGE 21

2. Expenses PAGE 33

3. Instructions PAGE 49

4. Recording Names PAGE 71

5. Inventory PAGE 87

6. To-do Personal and Private PAGE 109

7. Biographical Details PAGE 123

8. Exhibition PAGE 133

9. Inspiration PAGE 151

Selected Transcriptions

 and Translations PAGE 177

Notes to the Epigraphs PAGE 201

Credits for Supplementary Images PAGE 203

Index PAGE 207

Foreword

From the weekly shopping list to the Ten Commandments, our lives are dominated and governed by lists. Whether created to impose a sense of order in an otherwise chaotic world or as a simple memoir, they are an inescapable fact of life. When Liza Kirwin, curator of manuscripts at the Smithsonian's Archives of American Art, first suggested creating a book around the many lists buried in the Archives' collections, I was skeptical. But I was soon convinced that the ubiquity and variety of the material would provide a unique point of entry into the lives of artists and the world of American art.

One of my favorites comes from painter Clay Spohn, who on May 5, 1969, made a to-do list that included the following: "Make out your will for all your things in your studio, including your writings, notes, files, letters from & to friends, and other personal records, etc., to 'Archives of American Art'.... Do this for the future generations, so they might know about this age." In these few words, Spohn both encapsulates the Archives' mission and offers a compelling argument for its critical role in preserving the artistic legacy of the United States. Thanks to Spohn and other like-minded individuals, the Archives has grown to over sixteen million items, including correspondence, sketchbooks, photographs, audio and video recordings, business records, and a host of other material that sheds light on every facet of the visual arts in the United States.

Assembling this volume has been a team effort, and I am grateful to those who contributed their expertise, including Helena E. Wright, curator of graphic arts at the National Museum of American History; Ellen G. Miles, curator of painting and sculpture at the National Portrait Gallery; William T. Oedel, associate professor of

art history at the University of Massachusetts, Amherst; Ray Johnson specialist Julie J. Thomson; Danielle Schwartz, former Smithsonian research fellow; and Anna Reinhardt, daughter of artist Ad Reinhardt.

Among the Archives staff, I wish to thank Marisa Bourgoin, the Richard Manoogian chief of reference services, for her genealogical research; archivists Elizabeth Botten, Kathleen A. Brown, Kim Loren Dixon, and Judy Ng, and archives specialist Jean E. Fitzgerald for their invaluable suggestions; archivist Julie Schweitzer for her translation of French texts; Jessica Davis, Lindsey Kempton, and Richenda Annach, the industrious interns whose research enlivens many of the book's captions; intern Karla Steinberg, volunteer Cintia Nash, and collections specialist Jason Stieber for their help preparing transcriptions; and editor Jennifer Blakemore Dismukes, rights and reproductions coordinator Wendy M. Hurlock Baker, and Marv Hoffmeier for their technical support.

Archives specialist Mary Savig entered the project midstream and quickly became an indispensible list keeper and researcher.

I also thank Nancy Eklund Later, senior acquisition editor at Princeton Architectural Press, with whom this project began, and Linda Lee, our editor at Princeton Architectural Press, for her guidance and enthusiasm.

Finally, to curator of manuscripts Liza Kirwin for her inspired selection of material and the thoughtful texts included in the book. Her fresh and original ideas for presenting our collection through publications and exhibitions continue to widen our audience and deepen their appreciation and understanding of American art.

—JOHN W. SMITH

INTRODUCTION

ORDERS

8

Lists: To-dos, Illustrated Inventories, Collected Thoughts, and Other Artists' Enumerations from the Smithsonian's Archives of American Art celebrates a form of documentation that is familiar to everyone—the list. The Archives of American Art counts hundreds of thousands of lists in its collections, including to-do lists, membership lists, lists of paintings sold, lists of books to read, lists of appointments made and met, lists of supplies to get and places to see, and lists of people who are "in." Every exhibition generates a list. Many are historically important, throwing a flood of light on a moment, movement, or event; others are private, providing an intimate view of an artist's personal life. Architect Eero Saarinen made a list of thirteen reasons why he loved art critic Aline Bernstein, whom he married in 1954. Acerbic journalist H. L. Mencken made a list of his personality traits and numbered them between 1 and 29. Number 10 reads: "If I ever marry, it will be on a sudden impulse, as a man shoots himself." Sculptor Alexander Calder made an illustrated list of nine works of art for a visitor to see.

Almost every collection in the Archives contains a list of some sort, whether written down, typed up, or scribbled on the backs of envelopes or on the inside cover of a notebook. Lists are comforting. They set an agenda. They clarify and catalog. People formulate lists to impose order, to bolster an argument, to express an opinion, or to take inventory. In the late 1940s, art dealer Germain Seligmann—then living in Paris—made numerous lists of family treasures and gallery stock that had been seized and sold by order of the pro-Nazi Vichy government during World War II. His lists, including tapestries, silver, porcelains, and drawings, were part of his legal claim to retrieve stolen property.

List makers are task oriented. Jeweler Margaret De Patta kept a list of orders for her Modernist creations—rings, earrings,

FIGURE 1
MARGARET DE
PATTA, LIST OF
ORDERS FOR
JEWELRY,
CA. 1946

pins, pendants, bracelets—with the name of the piece and the purchaser. (FIGURE 1) She obviously derived great satisfaction from finishing projects: when she completed an order, she crossed off the name of the buyer and the item, transforming her to-do list into a *done* list. De Patta was a closer; she saved the done list as a written record of orders fulfilled.

John D. Graham's lists prove him to be a true multitasker. A painter, writer, collector, and art buyer, Graham was rarely without a to-do list. A typical day, as recorded in his 1937 diary, might include a list of letters to write, writing projects to complete, and objects to purchase for friends and acquaintances.

Lists tell us what we have done or what we hope to do. Artist Janice Lowry's elaborate illustrated journals are peppered with to-do lists. The recurrent tasks (pay bills, make doctor's appointment) are interspersed with her dream recollections and random thoughts, each page thick with collaged images, stamps, and stickers—a vivid backdrop for her daily chores. The lists propel her forward. On August 29, 2003, she writes, "I lay in bed turning, thinking—I need to water. Get Taylor to the vet. Frame my journals frame frame frame. So I don't sleep make some tea—and

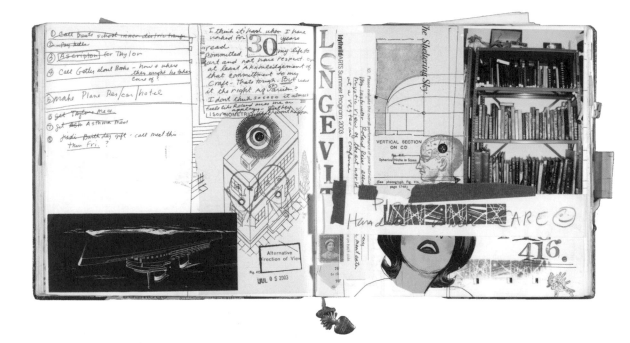

that is the message *pace and grace*. So maybe make a list of how to get it done." (FIGURE 2)

Lists can be equal parts drudgery and desire, such as Paula Cooper's list of tasks to be done before opening her gallery at 96 Prince Street in 1968. The gallery was one of the first ones to open in SoHo, which was then an industrial slum so foreign to the art trade that it was known as Hell's Hundred Acres. The Archives holds an early membership list of The Club, a postwar group of New York artists legendary for its polemic discussions. The list reminds us that someone had to keep track of who was who, and where they were, for scheduling future meetings. In the late 1920s, William Mills Ivins, the first curator of the newly established Print Department at the Metropolitan Museum of Art, made a list under the heading "What twelve prints that you have do you most prefer?" He tried to choose his favorites from a collection that included Albrecht Dürer's *St. Michael Fighting the Dragon* (ca. 1496), Hans Bladung's *The Conversion of St. Paul* (ca. 1515–16), Eugène Delacroix's *Juive d'Alger* (1833), and gave up in frustration. He declared, "It simply can't be done!"

Perhaps the Archives' most famous list is Pablo Picasso's recommendations for the 1913 Armory Show, the first international exhibition of Modern art in the United States. Painter Walt Kuhn, who played a major role in assembling the show, had limited knowledge of the European avant-garde. He relied on American artists then living abroad, as well as Europeans in the know, such as Picasso, for introductions to contemporary European artists and dealers. Picasso names Marcel Duchamp, whose *Nude Descending a Staircase* (1912) would cause an uproar in the American press, Fernand Léger, and the Spaniard Juan Gris, among others.

Some lists testify to an outcome; others present a process. In 1893 Charles M. Kurtz was responsible for hanging more than a thousand works of art representing the United States at the World's Columbian Exposition in Chicago. His pages and pages of hand-written lists indicating what to put where give present-day readers a sense of how he worried over the details of the installation, trying to get everything on the walls on a tight deadline.

FIGURE 2
JANICE LOWRY,
TO-DO LIST,
JULY 5, 2003

A simple address list can outline an audience. When sculptor Alexander Calder lived in Paris, from 1926 to 1933, he created his miniature *Circus*—small wire sculptures of performers ingeniously articulated to walk tightropes, dance, lift weights, and tumble—and invited members of the Parisian avant-garde to his studio and other intimate settings to see it in operation. Calder kept an address list of his French connections, such as Hans Arp, Constantin Brancusi, Fernand Léger, Joan Miró, Piet Mondrian, Man Ray, and Amédée Ozenfant, as well as notable Americans traveling abroad, including Alfred Barr, then director of the Museum of Modern Art, art collector Mrs. Chester Dale, and others. Calder likely used this list to send invitations to his Parisian performances of the *Circus*.

A list can be a streamlined source of biographical details. Every resume is an autobiography in list form. Painter Ad Reinhardt exploited the artistic resume with his detailed list of life events, set down in his elegant and distinctive calligraphy. (FIGURE 3) In 1954 painter Elaine de Kooning itemized her and her husband's studio costs for their joint tax return, listing their modest income and expenses, including studio rent, models, heat, telephone, etc. One learns the charities the de Koonings supported, the names of their models, the locations of their studios, how much money Elaine earned from her writing for *ARTnews*, as well as the fact that they claimed a loss of $1,987.74 for the year.

Before the age of computers and easily updated electronic lists, artists like Benson Bond Moore and Philip Evergood kept current by manually adding information to their lists. Moore must have taken great pleasure in updating his list of prints sold from 1937 to 1939. (FIGURE 4) He wrote the names of 273 collectors and their purchases on a single page until there was no more room to record another sale. The density of this register was proof of his commercial success. Painter Philip Evergood made a list of photographers and framers by gluing their business cards and other contact information together in one long strip. Each new attachment expanded his network.

FIGURE 3
AD REINHARDT,
"ARTIST'S CHRO-
NOLOGY BY
AD REINHARDT,"
CA. 1966

Artist's Chronology
(By Ad Reinhardt)

1913 Born, New York, Christmas Eve, nine months after Armory Show. (Father leaves "old country" for America in 1907 after serving in Tsar Nicholas' army. Mother leaves Germany in 1909.)

1913 Malevich paints first geometric-abstract painting.

1914 Matisse paints "Porte-Fenetre, Collioure."

1914 Mondrian begins "plus-minus" paintings.

1915 Gets crayons for birthday, copies "funnies" Moon Mullins, Krazy Kat and Barney Google.

1916 Juan Gris paints "Dish of Fruit."

1917 Cuts up newspapers. Tears pictures out of books.

1916 Dada in Zürich.

1917 October Revolution in Russia. Lenin replaces Kerensky.

1918 Peace, World War I ends.

1919 Enters Public Grade School No. 88, Fresh Pond Road, Ridgewood, Queens.

1919 Leger paints "The City."

1919 Monet paints "Water Lilies." Lilies

1920 Wins water-color flower painting contest.

1921 Abstract painters have trouble in Russia.

1922 Mexican painters issue anti-"art for art's sake" manifesto.

1922 Joyce completes "Ulysses." 1923 Marcel Duchamp gives up painting.

1918 Malevich paints "White on White."

1924 Copies Old English and German Black-Letter printing.

1925 Arp makes "Mountain, Table, Anchors, Navel."

1926 Picasso paints "The Studio."

1927 Wins medal for pencil-portraits of Jack Dempsey, Abraham Lincoln, Babe Ruth and Charles Lindbergh.

1927 Enters Newtown High School, Elmhurst, Queens.

1928 Wins prizes and medals for art and citizenship.

1929 Museum of Modern Art opens.

1929 Stock Market crashes.

1929 Georgia O'Keefe paints "Black Cross, New Mexico."

1930 Makes drawings of knights, heraldry, shields, stars, battle-flags.

1931 Enters Columbia College.

1932 Paints studies of Michelangelo's Sistine-Ceiling figures for literature class of Raymond Weaver who suggests courses with Meyer Schapiro who suggests joining campus radical groups.

1933 Falls asleep in all of Irwin Edman's lectures on aesthetics.

1933 Thrown off wrestling team for not keeping in training.

1934 Accused by Dean Hawkes of stuffing dormitory tenth-floor shower-drains with art materials and flooding ninth floor (not guilty).

1935 Elected to student Board on campaign promise to abolish fraternities.

FIGURE 5
FRANZ KLINE,
GROCERY LIST, CA.
1962

FIGURE 6
FRANZ KLINE,
RECEIPT,
DECEMBER 31, 1960

Even the most mundane lists can be intriguing specimens of cultural anthropology. A case in point is the grocery list found in Franz Kline's coat pocket around the time of his death in 1962. (FIGURE 5) Kline, a seminal force in the Abstract Expressionist movement and known for his big paintings with dramatic, masculine brushstrokes, was not above picking up a few things at the grocery store. The items he listed, his handwriting, and the paper he used all reveal something about him. He wrote hurriedly in pencil, misspelling *banana*, on the back of an invitation to a symposium, "The Art of Seeing," at the School of Visual Arts in New York City.

Though Kline was well-off when he died of heart failure at the age fifty-one, the list suggests that he led a pretty ordinary life—but then grocery shopping was simpler in 1962. He needed cornflakes, milk, oranges, "bannana," cream, cokes, bread, eggs, bacon, toilet paper, and V-8 juice—standard items even a half a century later.

FIGURE 4
BENSON BOND
MOORE, LIST OF
PRINTS SOLD,
1937-39

Another ordinary, but telling, list is Kline's receipt from John Heller's Liquor Store in Greenwich Village, dated December 31, 1960. (FIGURE 6) Presumably purchasing booze for a blowout New Year's Eve Party, Kline spent $274.51—an extravagant sum in 1960. He had the liquor—red wines, scotch, whisky, cognac, vermouth, and champagne—delivered to his loft at 242 West Fourteenth Street in New York City. Kline and his friends—Willem de Kooning, Philip Guston, Mark Rothko, Larry Rivers, Michael Goldberg—were heavy drinkers and hard partiers. Alcohol was part of the culture of Abstract Expressionism. As Elaine de Kooning recalls, "We thought it was social drinking because everyone else did it. Everyone was hung over every single day."[1]

It comes as no surprise that artists would illustrate their lists. In 1932 painter and color theorist Oscar Bluemner made an illustrated list of his recently completed landscape paintings, including thumbnail sketches with information about the dimensions, date, media, and in some cases the subject of each work of art. His list was a graphic catalog, a snapshot of his current production. In his preliminary sketches, Bluemner would also list every color he hoped to replicate in the studio. (FIGURE 7)

There are word lists, a vocabulary piled up through free association that helps an author think through a subject. Painter and feminist Joan Snyder made a list of words defining "female sensibility." Her list, written in hot pink felt-tip pen, provides a layering of meaning and richness to a larger concept. In 1951 Reinhardt made a list of words "undesirable" and others "more adequate" to replace the word *art*. In 1967 sculptor Robert Morris offered an alternative language for the new term *earthworks*. Morris's and Reinhardt's lists underscore the limits of language to define something as elusive as art.

It is often the casual record that reveals the rhythms of an age. Lists, whether dashed off as a quick reminder or carefully constructed as a comprehensive inventory, give insight into the list maker's personal habits and enrich the understanding of individual biographies. They reveal the process by which decisions are made or show the distillation of an argument to its essential points. In the hands of artists, lists can be works of art in and of themselves.

FIGURE 7
OSCAR BLUEMNER,
NOTES FOR A
PAINTING OF LITTLE
FALLS, NEW JERSEY,
1917

352

so the Water Color
with Tempera. June –17
in Oil finish Oct 6. as per
add't. notes and in ()
Foliage is hatched over
Palette

Little Falls

1) Spectrum Red (Vermil. or Cadm. R.) & Tar Red middle #2.

2) Tar Red 3 . dark Red. fullest Red Cadm R dk
dk Vermil.

3) Blue Red Tar Rose madder Carmine

4) light Ultramarine blue

5) deep Ultramarine

6) Vert Emeraude

7) Light Cadmium Yellow or Lemon Barium
or Tar Citron

8) Cobalt Violet dk , Tar Violet

9) Black

10) F. lake White (+ Tar Col) as medium
only a few

11) Zinc White (+ Ultra) drops linseed Oil

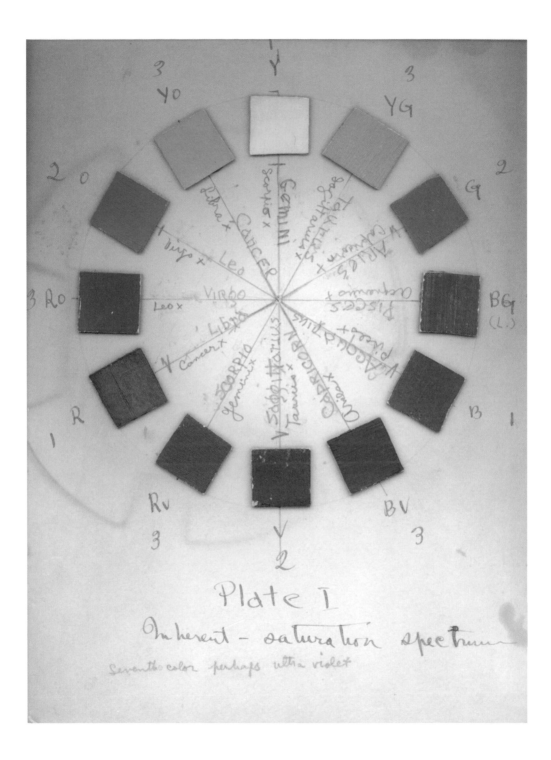

Plate I
Inherent — saturation spectrum
Seventh color perhaps ultra violet

There are illustrated lists and conceptual art projects represented as lists. Every color chart is a visual list. (FIGURE 8)

How many lists do you make or consult in a day? What does that tell us about everyday events? This book urges readers to consider common lists as firsthand accounts of our cultural history.

Notes
1. Elaine de Kooning quoted in Musa Mayer, *Night Studio: A Memoir of Philip Guston by His Daughter* (New York: Alfred A. Knopf, 1988), 68.

FIGURE 8
STANTON
MACDONALD-WRIGHT,
"PLATE I, INHERENT—
SATURATION
SPECTRUM," UNDATED

Art has always been what the artist decided to make it.

—SAMUEL J. WAGSTAFF

The List as Art

1 VITO ACCONCI TO DOROTHY AND HERBERT VOGEL
INSTRUCTIONS
1971 1 P., MIMEOGRAPHED TYPESCRIPT

*Performance and conceptual
artist Vito Acconci (b. 1940) has
a fear of flying. In this numbered
list from 1971, he leaves open-
ended instructions about what
to do with his apartment and its
contents should he die in transit.
Intended as a conceptual work of
art (and perhaps as a potential
postmortem performance),
Acconci mailed this list to art
collectors Dorothy and Herbert
Vogel and others in the art
world. It remains as the material
evidence of the art event.*

1. On February 8, 1971, I will fly, Air Canada, to Halifax, Nova Scotia; I am scheduled to return, by plane, on February 21.

2. Flying scares me; I am afraid that I will die on the trip to or from Halifax.

3. Before my trip, I will leave an envelope at the Registrar's Office, School of Visual Arts (215 East 23 Street, New York City); the envelope will contain a key to my apartment.

4. In the event of my death, the envelope can be picked up by the first person who calls for it; he will be free to use my apartment, and its contents, any way he wishes.

Vito Acconci

2 KARL KNATHS
COLOR STUDIES
CA. 1923 2 PP., EXCERPTED, COLORED PENCIL AND INK

*Painter Karl Knaths (1891–
1971) lived most of his life in
Provincetown, Massachusetts,
close to his source of inspiration—
the sea, dunes, and sky. A
Modernist inspired by Paul
Cézanne (1839–1906), Knaths
used color to structure his
compositions. In his sketchbooks
he tested harmonies and
arrangements, often making
columns of color—visual lists of
tints and shades—to keep track of
the colors he was using.*

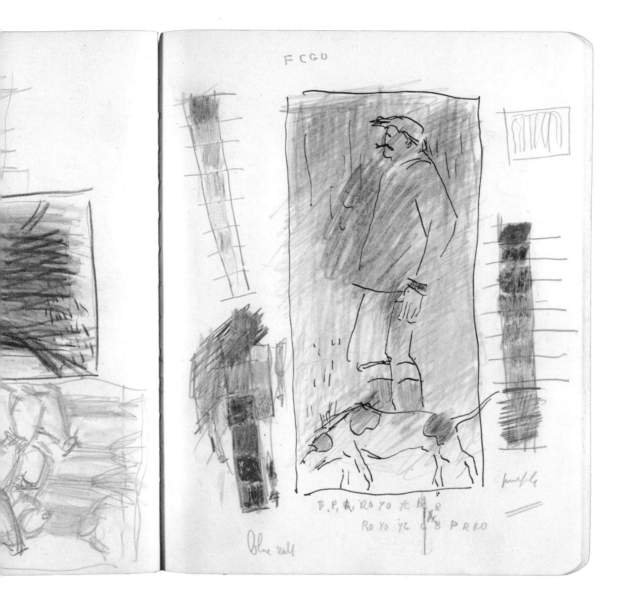

3 ADOLF KONRAD PACKING LIST DECEMBER 16, 1963

2 PP. (1 FOLIO), EXCERPTED, WATERCOLOR AND INK

During his frequent trips abroad, realist painter Adolf Konrad (1915–2003) filled stacks of sketchbooks with vibrant scenes of street life and picturesque landscapes. In this sketchbook from his travels through Rome and Egypt in 1962 and '63, he makes a graphic list of the things he needs to pack, as well as a drawing of himself wearing nothing but his underwear.

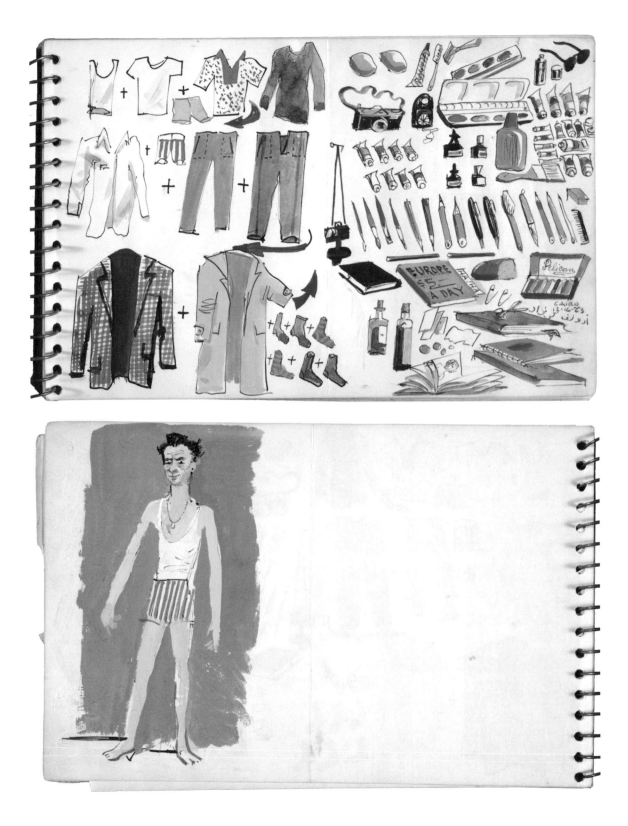

4 BENSON BOND MOORE
STUDIES OF DUCKS
UNDATED 1 P., PENCIL ON PAPER

Painter and printmaker Benson Bond Moore (1882–1974) specialized in landscapes and animals. A native and resident of Washington, D.C., he often sketched at the National Zoo. Ducks were a favorite subject. Here he makes a graphic list of ducks in various poses, numbered one to twenty-six, perhaps serving as a handy how-to-draw-a-duck reference for his paintings and prints.

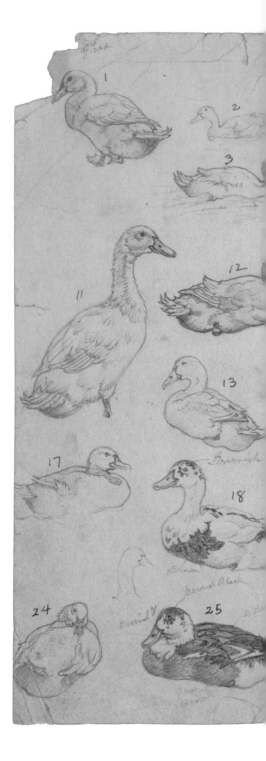

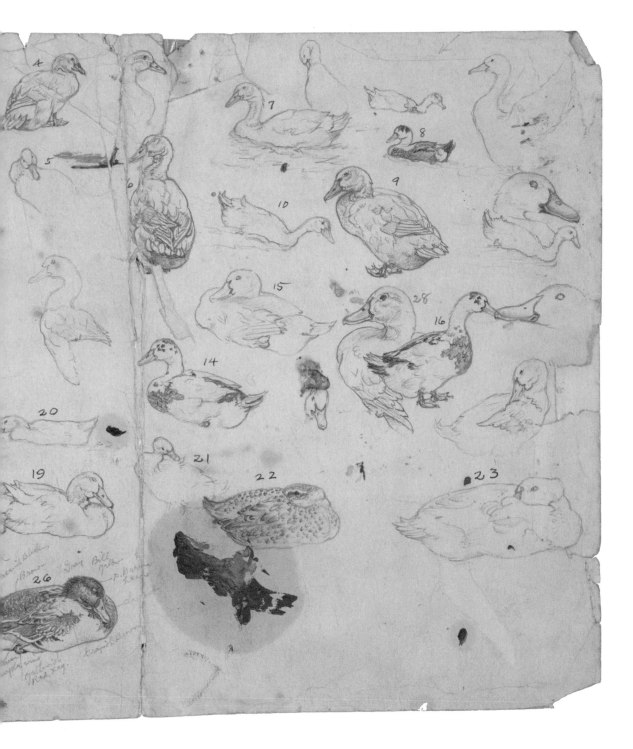

5 JOAN SNYDER
RESPONSE TO "WHAT IS FEMINIST ART?"
1976 2 PP., HANDWRITTEN

In 1976 Ruth Iskin, director of the Woman's Building Galleries in Los Angeles, along with art historians Lucy R. Lippard and Arlene Raven, asked artists who consider themselves feminists via mailed invitations to respond to the question, What is feminist art? As her response, painter Joan Snyder (b. 1940) sent this list of words defining "female sensibility," written on a single 8½-by-11-inch page as requested. Known for a more-is-more approach to painting—that is, large, intensely personal canvases, messy with emotion—Snyder's list is a chaotic layering of words, a personal vocabulary that creates unique rhythms and relationships that resonate with readers.

FOR TRANSCRIPTION OF COMPLETE LIST, TURN TO PAGE 178

BY JOAN SNYDER

①

FEMALE SENSIBILITY IS LAYERS, WORDS,
MEMBRANES COTTON, CLOTH, ROPE, RE-
PETITION, BODIES, WET, OPENING, CLOSING
REPETITION, LISTS, LIFESTORIES, GRIDS,
DESTROYING GRIDS, HOUSES, INTIMACY,
DOORWAYS, BREASTS, VAGINAS, FLOW,
STRONG, BUILDING, PUTTING TOGETHER
MANY DISPARAGING ELEMENTS, RE-
PETITION, RED, PINK, BLACK, EARTH
FEEL COLORS, THE SUN, THE MOON,
ROOTS SKINS, WALLS, YELLOW,
FLOWERS, STREAMS, PUZZLES, QUES-
TIONS, STUFFING, SEWING, FLUFFING,
SATIN, HEARTS TEARING, TEARING,
TYING, DECORATING, BAKING, FEED-
ING, HOLDING, LISTENING, SEEING
THRU THE LAYERS, OIL, VARNISH
SHELLAC, JELL, PASTE, GLUE, SEEDS,
THREAD, MORE, NOT LESS, REPETITION,
WOMEN CRITICS, WOMEN WRITERS,
WOMEN ARTISTS, EITHER NOURISHING

If you don't have
trouble paying
the rent, you have
trouble doing
something else;
one needs just a
certain amount
of trouble. Some
people need more
trouble to operate
and some people
need less.

—ROBERT RAUSCHENBERG

Expenses

6 PAULA COOPER TO-DO LIST
CA. 1968 2 PP., HANDWRITTEN

In 1968 art dealer Paula Cooper (b. 1938) opened the Paula Cooper Gallery at 96 Prince Street. It was one of the first art galleries in SoHo—then an industrial slum so foreign to the art trade that it was known as Hell's Hundred Acres. Her spacious five-thousand-square-foot loft allowed for large-scale works to be shown in a gallery. She also opened her space to special events that featured new music, poetry, and film. This list (not in Cooper's hand) includes tasks to do before opening the gallery, such as establish a proper sales journal and general ledger, analyze bank statements, and file tax returns—suggesting that even the most avant-garde ventures are founded on traditional business practices.

FOR TRANSCRIPTION,
TURN TO PAGE 178

Paula Cooper, Inc.
Work to be Done

					PREPARED	DATE	INDEX
					WJ		
					REVIEWED	DATE	

Claire

① Work on New Corp
 Books Required
 1) General Ledger + General Journal

 2) Sales Journal

 3) Cash Receipts

 4) Cash Disbursements

Buy loose ledger sheets for
 1. General Ledger Paper
 2. 10 Column for journals

Continue Cash Receipts + Cash Disbursements as
 you are now doing. Keep in mind that
 the corporation is a separate entity +
 not to be confused with Paula Cooper or
 transactions prior to the setting up of the
 gallery.

Since most sales are concurrent with the specific purchase
 keep the Sales Journal as follows:

Date	Invoice #	Buyer	Total Sales Price (Accounts Receivable)	Sales Tax	WH	Sale	Name of Artist	Due to Artist (Accounts Payable)	Purchases
10/9/68	1300	John Jones	1050 –		50 –	1000 –	C. Davis	400 –	400 –

This would get posted
to general ledger.

I'll leave the details to you. But the ultimate
goal is to record the sale and purchase from
artist at the same time and to account for
their collection or payments by using an
accounts receivable or payable account.

7 ELAINE DE KOONING
NOTES FOR JOINT TAX RETURN
1954 2 PP., ANNOTATED TYPESCRIPT

In 1954 painter Elaine de Kooning (1918–1989) compiled this list of income and expenses for herself and her husband, Willem de Kooning (1904–1997), in preparation for filing their 1953 joint tax return. While the claim indicated a loss of $1,987.74 that year, they were undeniably on their way to success in the art world.

Willem exhibited his Woman series (six fiercely abstract paintings of women) at the Sidney Janis Gallery in 1953. This was his third one-person show in New York and yielded a net profit of $6,202.76. He was also in demand as a lecturer and

juror. Both of the de Koonings had studios in New York City and summer studios in East Hampton, and made modest contributions to eight charities. They even had enough income to buy back a painting that Willem had sold to painter and writer John D. Graham in 1944 for $50—claiming a capital loss of $450 after its purchase. They supported fellow artists—Gandy Brodie, Milton Resnick, Giorgio Spaventa, and Alfred Leslie—by hiring them as models. And while Elaine was not considered her husband's equal as a painter, she was beginning to be singled out as a significant Abstract

Expressionist and continued to develop her reputation as a respected art critic.

FOR TRANSCRIPTION OF THE FULL LIST, TURN TO PAGE 179

Joint Return - Willem and Elaine de Kooning -- 1953 *Siegel*

Income

 A. from sale of pictures (Janis Gallery) ========== 9632.00
 minus commission to gallery ---------- 3429.98
 actual income from gallery ---------- 6202.76 *

 B. from service on painting jury (Chic.) ---------- 100.00 W
 articles for Art News ---------- 270.00 E
 " " New Mex. Quarterly ---------- 25.00 E
 sale of drawings from studio ---------- 66.50 E
 461.50 *

$6202 plus 461 equals Total Income 6664.26 *

Expenses

 Exemptions ========== 1200.00 *
 Rent for studios ---------- 1700.00 *.v
 $50 per mo. 88E.10 St. W
 50 per mo. 132 E. 28th St. E
 500 for summer studios (Easthampton) W&E
 Charity:
 $65 American Cancer Society
 50 American Red Cross
 50 March of Dimes
 25 Cerebral Palsy
 25 Tuberculosis Society
 10 Salvation Army
 50 Heart Fund
 100 Catholic Church charities
 total: ------- 375.00 *

Telephone (studio and outside business calls ----- 150.00
Heat (88 E. 10th St.) W 320.00
electric (88e. 10th St. and 132 E. 28th.St.) W+E 120.00
cleaning of studios W&E 260.00
maintenance, repair of studios 88.00
 total : ----- 938.00 *

Travel to and from N.Y.C., Chic., Montauk,
 Easthampton, Phila. in connection with
 lectures, serving on painting juries,
 interviews for articles ----- 350.00 W
Taxis to formal events, openings, lectures, etc. 250.00
Telegrams 50.00
 total : ---- 650.00 *

Photographs of paintings for publicity
 (releases to Museum of Modern Art,
 Time Mag. Harpers Bazaar, Janis
 Gallery, etc.) newspapers, mags. ------ 150.00 *
Art books, magazines, prints, art club
 fees, etc. ------ 208.00 *
Entertainment ------ 450.00 *

8 GEORGE PETER ALEXANDER HEALY PRICE LIST
MAY 1860 1 P., HANDWRITTEN

An internationally successful artist, G. P. A. Healy (1813–1894) painted hundreds of portraits, including those of kings, queens, and U.S. presidents— from John Quincy Adams to Ulysses S. Grant. Like many of his contemporaries, Healy based his prices on the gender of the sitter (women and children were more expensive than men) and size (standard sizes at 22 by 27 inches, to the "grand size" at 47 by 62 inches). This list, written in New Orleans in May 1860, enumerates his terms for commissioned portraits. As the list is not in Healy's hand, it is likely that he dictated his terms to an agent or potential patron who composed the list.

FOR TRANSCRIPTION,
TURN TO PAGE 180

Mr Healy's Terms

Heads of

Gentlemen	22.27	$2 00
of Ladies	22.27	2 50
Gentlemen	25 30	2 50
Ladies	25 30	3 00
Gentlemen Kit-Cat	29 36	3 50
Ladies Kit Cat	29 36	4 00
Small half length	36.42	5 00
Ladies Do		6 00
Half length	40 50	7 50
Ladies Do		8 00
Grand size	47 62	10 00

Children the same
as ladies

New Orleans May 1869

9 REGINALD MARSH
"EXPENSES IN THE PURSUIT OF ART"
1934 1 P., EXCERPTED, HANDWRITTEN

*At the end of 1934, painter
Reginald Marsh (1898–1954)
made this list of his "expenses
in the pursuit of art," including
the cost of frames, photographs,
models, studio rent, and
continuing education. In other
accounts he tallied his total art
earnings for 1934, which was
$1,432.01, leaving a net profit of
$381.69. Though Marsh also had
a sizable income from the sale
of stocks, he found a more stable
source of income when he began
teaching at the Art Students
League of New York in 1935, a
job that he kept until his death
in 1954.*

1934 —

Expenses in the pursuit of art.

1/14	Konzal frames	17.
1/23	anatomy lecture	12
1/24	Bogart photos	13.20
2/2	corner carpenter shop	17.00
2/12	PLOHN frame	7.50
3/2	USUI frame	31.75
3/12	SUNAMI photos	12.00
3/14	Mager panel.	5.75
3/30	Mager "	8.00
4/26	SUNAMI	10.50
5/14	to move etching press	13.50
6/11	Mural Painters 2 yrs. dues	20.00
6/11	Budworth	5.50
6/14	to move paintings from Flushing	10.
7/14	Schneiders —	11.86
9/29	USUI frames	200.65
10/16	model	2.50
10/2	SUNAMI	45.00
11/6	DUBOIS CLASS.	15.00
12/3	DUBOIS " FELICIA (Aug?)	18.00
12/7	USUI	101.75
	Budworth (cartens)	10
11 mos studio rent at 30.00		3.30.00

	918.56
model expenses one @ 2.00 for 36 weeks	72.00
Felicia's paint box.	9.00
TOTAL	999.56
etching expenses (see 1933 diary)	50.76
TOTAL	1050.32

10 HENRY MOSLER
EXPENSES
JANUARY 23 TO JUNE 9, 1877

2 PP., EXCERPTED, HANDWRITTEN

Born in New York City, Henry Mosler (1841–1920) first gained recognition in 1862 as a Civil War illustrator for Harper's Weekly. *The following year he studied at the Düsseldorf Academy and traveled between Paris, the United States, Düsseldorf and Munich before finally settling in Paris.*

Mosler's 1877 ledger provides a list of everyday expenditures of a successful artist in Paris. The accounts range from the mundane ("moving wood from studio to house") to the extravagant (tickets for operas such as Orpheus in der Unterwelt, The Flying Dutchman, *and* Les Huguenots*) and with recurring expenses for models, supplies, and studio rent. While in Paris, Mosler maintained his German connections, paying his Munich* Kunstverein, *or art association dues, most likely to remain active in this organization. Mosler's painting* Return *(1879) was exhibited in the Paris Salon of 1879 and purchased by the French government for their national collection—an extraordinary honor for an American artist at the time.*

1877

[Handwritten expense ledger — individual entries largely illegible]

11 GORDON NEWTON TO SAMUEL J. WAGSTAFF
VOUCHER
UNDATED 1 P., HANDWRITTEN

Samuel J. Wagstaff (1921–1987) was an innovative curator of contemporary art, first at the Wadsworth Athenaeum in Hartford, Connecticut, from 1961 to 1968, and then at the Detroit Institute of Arts (DIA) from 1968 to 1971, where he organized groundbreaking exhibitions about Minimalism and new directions in American art. He famously quit the DIA in 1971 when the museum trustees removed a Michael Heizer earthwork, Dragged Mass Geometric *(1971), because it had destroyed the museum's manicured lawn.*

While in Detroit, Wagstaff supported local artists, particularly the work of Gordon Newton (b. 1948). Some time, likely during Wagstaff's tenure at the DIA, Newton presented this voucher to him. Included in his list of expenses is $50.00 for rent, $30.00 for materials, $15.00 for food, and $5.00 for "Bad Habits."

Ron

I need 100. dollars

Rent — 50⁰⁰

MATERIAL — 70

Food — 15

Bad Habits — 5

100

Gordon

12 BELON TO JOHN VANDERLYN INVOICE FOR ART-RELATED SUPPLIES AND SERVICES JANUARY 27 TO OCTOBER 18, 1808

2 PP. (1 FOLIO), HANDWRITTEN IN FRENCH

One of the first professional painters in the United States, John Vanderlyn (1775–1852) studied painting in Paris from 1796 to 1801, a trip financed by Aaron Burr, his patron. When Vanderlyn returned to the United States, he lived in the home of Burr, who had by then been elected the vice president. Vanderlyn returned to Europe in 1803, living primarily in Paris. From 1805 to 1807 he lived in Rome, where he painted one of his most celebrated historical paintings, Marius amid the Ruins of Carthage *(1807), which received a gold medal at the Paris Salon the following year, an unprecedented honor for an American painter.*

This list of art-related purchases from 1808 includes the fee for transporting Marius amid the Ruins of Carthage *to the Salon and the fee for varnishing it, as well as his expenses for canvas, colors, brushes, pencils, and other materials. When Vanderlyn finally returned to United States in 1815, he painted portraits of prominent politicians, but never regained the level of success he enjoyed in Paris in 1808.*

FOR THE TRANSLATION, TURN TO PAGE 180

Mémoire de toille en couleur fourni a Monsieur
Vanderline par Belon rue de l'arbre sec no 3. a commandé
du 27 Janvier 1808 —

	une Boîte a couleur	7	10
	un pinceli eu		15
	un assortiment de couleur	1	17
du 28	huil de licte huil grasse essance en verni	2	15
	crayon Blanc		5
du 30	un chevalet		5
	une a quinin		6
	deux toiles de 25		6
du 8 fevrier	Couleur		15
du 16	1/2 once de vermilion de lachine en la Boîte	1	12
	une Boîte a couleur		10
	un pinceli eu		15
	une palotte	4	10
	Cinabre		10
	vermilion		18
	deux crayon		6
	huil d'licte en bouteille		6
	huil Grasse		12
	huil Blanch		
	un assortiment de couleur	2	15
	deux toiller de 25		6
	un couteau de Corne		15
du 17	une toile de 30	9	12
du 25	Couleur		8
du 10 mars	Couleur en essance		16
du 16	verni		18
du 17	trois tableaux tandu sur chassi a clef un de 6 pieds 3 pouces		
	sur 5 pieds 4 pouces		15
	un de 3 pieds 3 pouces sur 2 pieds 1 pouce	3	10
	un de 2 pieds 6 pouces sur 2 pieds	3	
du 22	un tandu sur chassi commun de 2 pieds 3 pouces sur 2 pieds	1	10
	pour avoir degraissé un grand tablau	3	
du 23	Crayon		4
du 30	Couleur		6
	Couleur	1	4
	huil Brosser	2	8
du 1 avrille	une demie Bouteil d'huil	1	4
du 18	un a quinin		6
	une Boîte a couleur	7	10
	un pinceli eu		15
	un chevalet de 6 pieds	6	
	huil d'licte		8
		105	18

Some things you can explain, and some things you can only say—go, try, and see for yourself.

—WILLIAM MILLS IVINS

Instructions

13 ART WORKERS' COALITION
13 DEMANDS
JANUARY 28, 1969 1 P., MIMEOGRAPHED TYPESCRIPT

In 1969 when Greek artist Vassilakis Takis (b. 1925) and friends removed one of his sculptures from an exhibition at the Museum of Modern Art (MoMA), he made the bold claim that although the museum owned legal title to the piece, he, as the artist, had the right to control its exhibition. This statement prompted the formation of the Art Workers' Coalition. Its first act, on January 28, 1969, was to present this list of thirteen demands to Bates Lowry (1925–2004), then director of MoMA. While these demands were not met, the coalition became a force for change in the art world, its meetings an important forum for debate. They organized artists' protests against the Vietnam War and, among other things, successfully lobbied MoMA and other museums to institute a free-admission day.

Art Workers' Coalition is here to save artists the embarrassment of being identified with:

1) The political ambitions of Nelson A. Rockefeller.
2) The Trustees of the Museum of Modern Art, who assume – to the detriment of the intellect, energies, and intentions of artists – that they establish cultural values.

Art Workers' Coalition therefore demands artists' representation on the board of trustees.

Art Workers' Coalition is here to reassert that the artist be given power to control his work. Art Workers' Coalition demands that the artist be given moral control and a share of the capital gains realized from the resale of his work. Art Workers' Coalition demands that the Museum pay rental to artists whose work it displays but does not own. Art Workers' Coalition demands that the artist be paid a residual on all reproductions of his work. Art Workers' Coalition demands that a share of all profits gained by the public or private resale of the work of dead artists be redistributed to contribute to the growth of living art.

DEMONSTRATION (9:30 pm)
May 26 ◉ AT The Museum of Modern Art

11 West 53 Street, New York, N.Y. 10019 Tel. 245-3200 Cable: Modernart

Rockefeller and the "Elite" invited to this evening's opening are more than capable of assuming the full financial support of the Museum of Modern Art. Art Workers' Coalition demands that admission fees be discontinued. We object to the fact that free access is given this evening to the very group most guilty of the subversion and rape of the content and meaning of the work of art. Art Workers' Coalition demands free access for all at all times.

Again, Art Workers' Coalition is here to rescue Art from identification with a social community that is guilty of promoting racism. Art Workers' Coalition demands that the museum set up a Martin Luther King Center devoted primarily to the work of black and Puerto Rican artists.

JOIN OUR DEMONSTRATION.

Art Workers' Coalition, P.O. Box 553, Old Chelsea Station, New York, N.Y. 10011

13 DEMANDS

submitted to Mr. Bates Lowry, Director of the Museum of Modern Art,
by a group of artists and critics
on January 28, 1969.

1. The Museum should hold a public hearing during February on the
 topic "The Museum's Relationship to Artists and to Society",
 which should conform to the recognized rules of procedure for
 public hearings.
2. A section of the Museum, under the direction of black artists,
 should be devoted to showing the accomplishments of black artists.
3. The Museum's activities should be extended into the Black, Spanish
 and other communities. It should also encourage exhibits with
 which these groups can identify.
4. A committee of artists with curatorial responsibilities should be
 set up annually to arrange exhibits.
5. The Museum should be open on two evenings until midnight and
 admission should be free at all times.
6. Artists should be paid a rental fee for the exhibition of their
 works.
7. The Museum should recognize an artist's right to refuse showing
 a work owned by the Museum in any exhibition other than one of
 the Museum's permanent collection.
8. The Museum should declare its position on copyright legislation
 and the proposed arts proceeds act. It should also take active
 steps to inform artists of their legal rights.
9. A registry of artists should be instituted at the Museum. Artists
 who wish to be registered should supply the Museum with documen-
 tation of their work, in the form of photographs, news clippings,
 etc., and this material should be added to the existing artists'
 files.
10. The Museum should exhibit experimental works requiring unique
 environmental conditions at locations outside the Museum.
11. A section of the Museum should be permanently devoted to showing
 the works of artists without galleries.
12. The Museum should include among its staff persons qualified to
 handle the installation and maintenance of technological works.
13. The Museum should appoint a responsible person to handle any
 grievances arising from its dealings with artists.

13

14 GEORGE BIDDLE TO EDWARD BRUCE LETTER

DECEMBER 15, 1938 1 P., TYPESCRIPT

*During the New Deal era,
painter George Biddle (1885–
1973) was a strong advocate
of government-sponsored art
projects. As the president of
the Mural Artists Guild of the
United Scenic Artists, Local
829, and twice vice chairman of
the American Artists' Congress,
Biddle often served as a liaison
between artists' groups and
government administrators.
In this December 1938 letter,
Biddle defends himself against
accusations from Edward Bruce
(1879–1943), the chief of the
Treasury Department's Section of
Fine Arts, that he was involved
in a standoff between the Mural
Artists Guild and the Section.
Biddle clarifies his points in
a list. The controversy is the
Mural Artists Guild's allegation,
made in late 1938, that the
mural commissions for the New
York World's Fair of 1939 were
awarded unethically.*

HELENE SARREAUX

CROTON ON HUDSON, NEW YORK

December 15,1938.

Dear Ned Bruce,

I believe that at one time our relation was a warm and friendly one. In deference to this relation I think that I should make clear to you:

(1)That I did not write the form letter from the Mural Artists Guild, which you allude to as a threatening letter. I saw a copy of it for the first time yesterday. I have done what I could to correct its unfortunate wording.

(2) I was not present at the meeting of the Guild, which decided to publish their correspondence with you over the recent World's Fair competition.

During recent years I have been President of the Mural Painters' Society, twice Chairman of the Mural Artists' Guild, twice Vice- Chairman of the American Artists' Congress. My role has been in great measure to act as a buffer between your Section and the frequently hostile or critical attitude of the artists.I do not think that during this period your Section has had a warmer or more loyal advocate. My task would have been a little easier (and pleasanter) and I could have also saved you from a few mistakes and a good many headaches if,during this time, you had ever had the courtesy to ask for my advice or cooperation.

Ever sincerely,

George Biddle.

15 ARTHUR WESLEY DOW
TEACHING DIAGRAM
CA. 1910 1 P., HANDWRITTEN

Painter, printmaker, and photographer Arthur Wesley Dow (1857–1922) was also an influential teacher at the Pratt Institute, the Columbia University Teachers College, the Art Students League of New York, and the Ipswich Summer School of Art, which he founded. In 1899 he revolutionized art instruction when he published his manual Composition: A Series of Exercises in Art Structure for the Use of Students and Teachers. *His method, partly inspired by Japanese prints, advocated good design through the harmonious arrangement of color and space. By applying his principles of design to a wide array of media—from painting and sculpture to metalwork and weaving—Dow broadened the definition of fine art and laid the foundation for the American Arts and Crafts movement.*

In this list Dow outlines the various practical applications of what he called the Principle of Fine Art. For Dow, these principles, funneled through a mind trained to appreciate historical examples, fans out to embrace a broad spectrum of finished work from "facade doors" to "advanced painting."

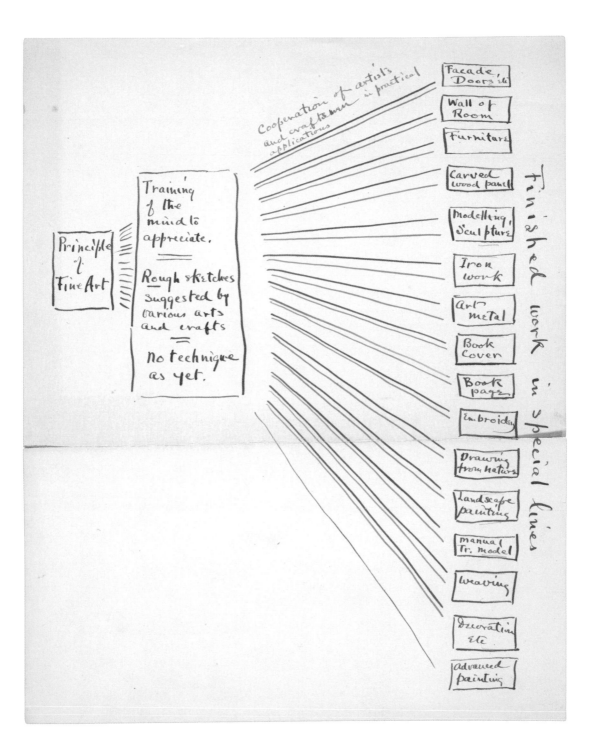

Principle of Fine Art

Training of the mind to appreciate.

Rough sketches suggested by various arts and crafts
=
No technique as yet.

Cooperation of artist's and craftsmen in practical applications

Facade, Doors &c
Wall of Room
Furniture
Carved wood panel
Modelling, Sculpture
Iron work
Art metal
Book Cover
Book page
Embroidery
Drawing from nature
Landscape painting
manual Tr. model
weaving
Decorative Etc.
advanced painting

finished work in special lines

16 FRANCIS ALEXANDER DURIVAGE
LIST OF HUMAN PROPORTIONS
AND COLORS ON A PALETTE
CA. 1845 2 PP., EXCERPTED, HANDWRITTEN, ILL.

On November 10, 1845, in Boston, writer Francis Alexander Durivage (1814–1881) presented this notebook of art instructions to his friend, portrait sculptor Edward Augustus Brackett (1818–1908). The notebook is primarily Durivage's English translation of a French text (the original source is unknown). The list on the left page is a guide to human proportions for sculptors; on the right, there is a list of colors arranged on a palette (the latter possibly in Brackett's hand).

FOR TRANSCRIPTION,
TURN TO PAGE 181

Woman 2nd part		Child front 2nd part	
8	"	5	"
"	"	1	"
1	"	"	"
"	"	2	"
2	"	1	"
2	"	1	··
"	3½	"	2
3	2	2	" 1¼
"	2¾	1 7/8	1 7/8
	3		3½
	1½	"	1 7/8
2	2	1	7/8
"	"	3	7/8
	3	1	"
	3¼	"	2⅛
	2¾		
	2 1/16		1 3/4
"	2	"	1½
"	2¼	"	1¾
"	" 7/8	"	" 3/4
"	2⅛	"	1/3
"	1 2/3	"	"
	2	✗	1½
"	7/8	"	" 3/4
✗	1⅓	"	15/16
"	1⅓	"	15/16
"	1⅓	"	7/8
"	1⅓	"	1 "
" "	"		
	1 11/16		2/3
	1 11/16		2/3
	1 11/16		2/3

Primary Pallette

① White

② Naples yellow

Raw Siena
③

Chinese Vermilion
④

Light Red or Venetian
⑤

⑥ Indian Red

Raw Umber
⑦

Burnt Umber
⑧

Vandike Brown
⑨
Black
⑩ Antwerp Blue
⑪ ⑫ Ultramarine Ashes

vie Read

Ultramarine Ashes

Oxford Ochre for draperies and back ground

17 HUGO GELLERT
LIST OF SLOGANS
CA. 1945 1 P., HANDWRITTEN, ILL.

For Hungarian-born mural painter and graphic artist Hugo Gellert (1892–1985), art and political action were one in the same. In the 1930s and '40s, he passionately supported the radical left as a muralist and as an organizer of the Artist's Committee of Action, the Artists' Union, and other collectives. During World War II, Gellert also supported the U.S. war effort. In this list he provides possible slogans for a parade float for the Industrial Union of Marine and Shipbuilding Workers of America (IUMSWA), such as "We build the ships to sail the seas to blast to Hell the Nipponese."

FOR TRANSCRIPTION,
TURN TO PAGE 182

Name of Ship - S/S Victory.

{ We thousands of Shipyard Workers are toiling
to day for Democracy to have its way - Our
Local Officers are representing us Today.

oo here operating 15,000's at work ✓

{ We build the Ships to Smash the Axis Blitz }

NOTE- Explain to boat Builder to make sure names of
Locals and companys they represent must be made big
enough for People watching Parade to see very Plainly.

{ We build the Ships to Sail The Seas ⊗
To Blast to Hell the NIPPONESE

we Buy
Buy Bonds to day to speed Ships on their way.

Special
Fraternal Greetings to the Workers of The United Nations
from the Shipyard Workers - C 10.
— Nat'l of Port Concil — Port IUMSWA

0 26-8 wide - Cab 8½ → Body is 21 Gt° → Since →⑧→

3 dots and a dash - making hash out of Japs

House Case L.O.C. 8 oo
34 Stop Plant
37 om sail

{ The Ships we build are building the Seas }
Bearing the flags of Democracy

19 E

Axis ships yow partner

59

18 FREDERICK HAMMERSLEY
NOTES ON "AN IDEA"
UNDATED 3 PP., HANDWRITTEN, ILL.

One of the defining artists of the so-called hard-edge painting style that originated in California in the 1950s, Frederick Hammersley (1919–2009) also taught between 1948 to 1971 at the Jepson Art Institute in Los Angeles, Pomona College in Claremont, California, the University of New Mexico in Albuquerque, and elsewhere. His teaching notes include a list of the complexities of a graphic idea as it develops and moves from head to hand.

FOR TRANSCRIPTION,
TURN TO PAGE 182

1. AN IDEA

2. AN IDEA IS MORE THAN GRAPHICS
it can be
3 its line, + shape + value & color.

4 its man & beast

5 & flesh & fantasy

8
GRAPHICS

~~graphics is not b~~
an idea is not graphics
an idea is more than graphics

line VALUE SHAPE

LINE

idea first

tools 2nd

idea | graphics
conception tools

19 HANS HOFMANN "ABOUT THE RELATION OF STUDENTS AND TEACHERS" UNDATED 1 P., HANDWRITTEN

When Modernist painter Hans Hofmann (1880–1966) settled in New York City in 1932, he opened the Hans Hofmann School of Art; in 1935 he founded a summer school in Provincetown, Massachusetts. Hofmann was a forceful teacher who influenced generations of artists, and his students included such luminaries as Jackson Pollock, Lee Krasner, Larry Rivers, Franz Kline, and Mark Rothko. (Hofmann's theories about the push and pull of colors played a pivotal role in the development of Abstract Expressionism.) However, this list titled "About the relation of students and teachers" may reveal the bitterness he felt toward some of his students. He writes, for example: "There is always an apostle who will deny his master."

FOR TRANSCRIPTION,
TURN TO PAGE 182

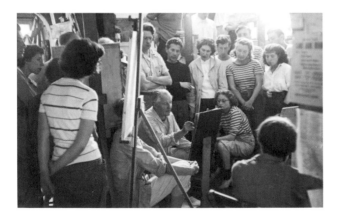

About (the relation of) students and teachers:

1.) What a teacher should know from the beginning:

" there is always an apostel who will deny his
 master.

2.) I Like what (Leonardo da Vinci) has to say:

" I feel sorry for the pupil who does not
surpass his master. "

3.) Some sickening ambitious man canot stand
the fact that they have been nursed by a
 superior mind.

4.) The man (painter) who calls him self-thought
does not know, that in reality he cultivates
 a small inferior ego. —

5.) It is amusing to observe that the smalest
dog prefer to soil the biggest poles.

6.) In the animal world there are certain
species which bite the hand that feeds them.

7.) Ignorance is the mother of arrogance.

20 LEE KRASNER TO SUSAN ROWE LETTER

MARCH 22, 1981 1 P., HANDWRITTEN

Throughout her career Lee Krasner (1908–1984) resisted the socially prescribed roles assigned to woman, wife, and widow. While she never achieved the fame of her husband, Jackson Pollock (1912–1956), she was a celebrated artist in her own right. In the 1960s and '70s, feminist art historians raised her visibility in the art world and considered her an Abstract Expressionist to be reckoned with.

In 1981 Susan Rowe, an art student at the University of Wisconsin-River Falls, sent a list of seven questions to Krasner concerning the artist's emotional attachment to completed works of art. Rowe's questions, focusing on feelings and preciousness and equating art making to childbirth, had a decidedly feminist twist. Krasner is polite but direct in her answers, twice admitting that she does not understand Rowe's meaning. She writes, "If what you mean is, do I consider my work 'precious,' the answer is no. It has to withstand the wear and tear of the world." The same could be said of Krasner, who stayed true to herself through the evolution of the feminist movement.

FOR TRANSCRIPTION,
TURN TO PAGE 183

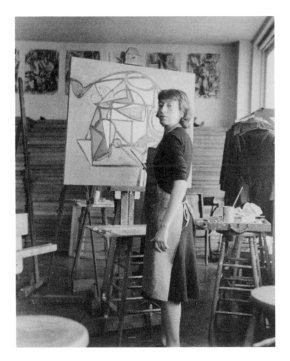

March 22, 1981

Dear Ms. Rowe,

In response to your questions:

1. The emotion I feel upon completing a work of arT varies. Among the responses, I may be pleased, uncertain, or have other reactions.

2. I'm not sure I understand what distinction you are making between q. #1, how I feel when I finish a work of arT, and q. #2, how I feel toward that finished piece. Perhaps you can clarify what you mean. The emotional response is part of the response to the work of arT.

3. My feeling toward a piece can change in time.

4. Never having borne a child, I cannot make the comparison between completing a work of arT and birth.

5. Again, I'm not sure I understand your question. If what you mean is, do I consider my work "precious", The answer is no. It has to withstand the wear and tear of the world.

6. At this stage in my life, I can sell or part with my work more easily.

7. My feelings about a lot of people seeing my work is that its' made to be seen.

I hope these thoughts have been helpful to you and good luck with your research.

Sincerely,
VH

21 HENRY VARNUM POOR TO WILLIAM KIENBUSCH LETTER

DECEMBER 9, 1937 4 PP. (2 FOLIOS), HANDWRITTEN, ILL.

In the summer of 1937, William Kienbusch (1914–1980) studied with artist Henry Varnum Poor (1888–1970) at the Colorado Springs Fine Arts Center. Taking Poor's advice, Kienbusch continued his studies in Paris later that same year. In a letter to Kienbusch in Paris, Poor recommends that he focus on the fundamentals of art—the relationships between color, line, and planes in still lifes. With two illustrations he lists the elements of a simple still life and how to arrange the objects, noting that "taken in an experimental way still life can be lots of fun." He further urges his eager student to "enjoy the actual means and forget a little about the sky-aiming ends."

FOR TRANSCRIPTION,
TURN TO PAGE 183

move slowly around them studying the
relationships of planes & lines that happens
from each point of view. If there is a
simple fundamental order in the ground
plan you'll find there is order in the
elevation from any point of view. Several
times, after doing one
canvas of a still life,
I've then done another
changing my point of
view but not touching
the objects, & have
gotten a much better
thing in the second.

1 pitcher 2 grapes
3 apples 4 red bananas
5 plums etc.
seems silly, but I
don't explain it well

Taken in an experim-
ental way still life
can be lots of fun.
Think of order & contrast
in color & tone too. Draw
some Cézanne & Chardin
still lifes. I don't know
why it's so hard for present
day students to do intelligent

1 vase 2 petits-pains
3 grapes 4 lines of drape
5 plums etc.

copying. Guess they have a lot of false pride
& ambition to swallow. Anyhow Bill, excuse
my giving all this advise, but learn as much
as possible to enjoy the actual means & forget
a little about the shy-aiming ends. They
will stay with you anut anyhow, but

22 ARTURO RODRÍGUEZ
LIST OF PAINTBRUSHES
CA. 1978 1 P., HANDWRITTEN, ILL.

*Painter Arturo Rodríguez
(b. 1956) was born in the small
town of Ranchuelo, in the Las
Villas province of Cuba. In
1971 his family went into exile
in Spain and settled two years
later in Miami, Florida. A self-
taught artist, Rodríguez kept
notes on methods and materials
with particular attention to the
techniques of the old masters.
He made this aide-mémoire
to distinguish the properties of
various paintbrushes.*

BRUSHES

← ANGULAR

← DAGGER

LONG HAIRED LINER

SWORD LINER

LINERS AND STRIPERS

← FAN BRUSH - BLENDER

USED DRY FOR DELICATE BLENDING

ROUND

← BRISTLE BRUSHES

FLAT

BRIGHT

FILBERT

← BLENDERS

← ROUND BRISTLE

← VARNISH BRUSHES

Well, I have a list somewhere. I have a telephone list that we made up. And they became the charter members.

—LUDWIG SANDER

Recording Names

23 PAUL BRANSOM
ALPHABETICAL LIST OF ANIMALS
UNDATED 1 P., HANDWRITTEN, ILL.

Paul Bransom (1885–1979), known as the "dean of animal artists" because of his success as an animal illustrator, developed his talent through on-the-job training. At fourteen he apprenticed with a draftsman at the United States Patent Office in Washington, D.C., and then worked briefly as a draftsman for both the Southern Railroad and the General Electric Company before moving to New York at seventeen to seek his fortune as an artist. The New York Evening Journal *hired him to carry on Gus Dirk's comic strip,* Latest News from Bugsville, *after Dirk committed suicide in 1902. Bransom wrote and illustrated the strip from 1904 to 1907. During his long career, he illustrated a number of books including Jack London's* The Call of the Wild *(first illustrated edition, 1912), Kenneth Grahame's* The Wind in the Willows *(second edition, 1913), and Marlin Perkin's* Zooparade *(1954). This list was most likely an early draft for an animal alphabet book.*

A	is	for	ALLIGATOR	(APE
B	,,	,,	BEAR	(BISON
C	,,	,,	CROW	(CAMEL, CRANE, COBRA)
D	,,	,,	DEER	(DUCK
E	,,	,,	ELEPHANT	(EAGLE
F	,,	,,	FOX	(FLAMINGO, FROG, FALCON
G	,,	,,	GIRAFFE	(GULL, GOOSE,
H	,,	,,	HIPPOPOTAMUS	(HERON, HYENA, HAWK)
I	,,	,,	IGUANA	(IBEX, IBIS.
J	,,	,,	JAGUAR	(JACKAL, JAY
K	,,	,,	KANGAROO	
L	,,	,,	LION	(LEOPARD
M	,,	,,	MACAW	(MONKEY, MUSK OX, MANDRILL
N	,,	,,	NARWHAL	(NEWT)
O	,,	,,	OWL	(ORANG, OTTER, OUNCE, OSTRICH, OCELOT)
P	,,	,,	PORKUPINE	(PELICAN, PHEASANT, PUMA
Q	,,	,,	QUAIL	
R	,,	,,	RACOON	(RABBIT, RHINOCEROS, REINDEER)
S	,,	,,	SNAKE	(SWAN, SQUIRREL, SEAL, SKUNK, SEA-LION)
T	,,	,,	TIGER	(TURTLE, TURKEY, TAPIR
U				
V	,,	,,	VULTURE	(VISCACHA, VOLE, VAMPIRE, VICUGNA, VIPER
W	,,	,,	WALRUS	(WOLF, WEASEL, WAPITI, WOLVERINE
X			XENURINE (ARMADILLO)	
Y			YAK YAPOK	
Z	,,	,,	ZEBRA	

24 ALEXANDER CALDER ADDRESS BOOK CA. 1930 1 P., EXCERPTED, HANDWRITTEN

In 1926, when Alexander Calder (1898–1976) moved to Paris, he had little direction in his life. Seven years later, he returned to the United States an accomplished sculptor with his own expressive vocabulary—wire drawings, articulated toys, and mobiles—that became his singular contribution to American art. While in Paris he recorded his connections with other artists and members of the avant-garde in his handmade address book. This first page includes contact information for Romanian sculptor Constantin Brancusi, German photographer Ilse Bing, and American composer George Antheil, among others.

FOR TRANSCRIPTION,
TURN TO PAGE 184

A

M. & Mme. Hans Arp
21 rue des Chataigniers
Meudon (S & O)

Artigas 32 rue de l'Orne (15

Brancusi 11 Impasse Ronsin (15

Mlle. Ilse Bing 146 ave. du Maine.

M. & Mme. Maurice Bos 3 r. de Rouvay
Neuilly

Mlle Marcelle) 94. ave. Mozart (16
Bechman

George Antheil Hotel Glycine
rue Jules Chaplain

Mme. Muriel Ames 29 rue Boulard (14

Mr. & Mrs. Clark Minor
Hotel Matignon
6 ave. "

Bilbao, 53 rue de la Glacière

25 PHILIP EVERGOOD
LIST OF CONTACTS
CA. 1947 9 PIECES TAPED, PRINTED, HANDWRITTEN

*The art business involves a
network of professional services.
In the late 1940s, painter Philip
Evergood (1901–1973) glued and
taped together scraps of paper
and business cards to create
this list of services available
near his New York City studio,
including picture framers, art
dealers, galleries, an art critic,
and a camera store. Presumably,
Evergood pasted on new contacts
as needed. It is easy to imagine,
from the pinhole at the top of
this well-worn list, that Evergood
tacked it up in his studio and
referred to it often.*

FOR TRANSCRIPTION,
TURN TO PAGE 185

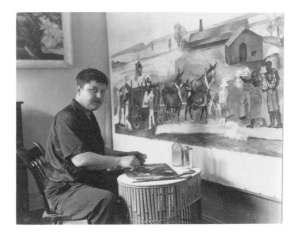

MURRAY HILL 6-1320

M. Toberoff Co., Inc.

MANUFACTURERS OF
PICTURE FRAMES

M. TOBEROFF CO. Inc
130 Lexington Ave (near 29"
MU 6.1320

Beneri J.
Benevig.
116 E 18 4 A3 E 52

Bampei Usui 33 E 12
 AL 45062

Henri Heydenryk
 68 W 56 CO 5.5094

Sam Lieberman 40 E 8
 AL 4.1095

Zinn
AL 4-7961

Jules Rabinstein
Siegen Frame Co
 Gr 3-3749
 45 Fourth

David
K. Ovesi ×

 Orch. 4 2 7
 101 East 16

Peerless
Photos

Monday
Wed
Friday

alexander lazuk
MIDTOWN FRAME SHOP
individual framing

61 west 74th street, n. y. 23 endicott 2-1284

Custom Prints.
 Ernest Hopf
 CH 3-4078
 302 - W. 13 th. St.
 NYC.

26 RAY JOHNSON TO ELLEN H. JOHNSON
THANK-YOU NOTE
CA. 1979
AND LIST OF SILHOUETTE PORTRAITS
OCTOBER 13, 1978 1 P., HANDWRITTEN ON PHOTOCOPIED LIST

Ray Johnson (1927–1995) is best known for his enigmatic collages and as the founder of the New York Correspondance [intentional misspelling] School, an international network of poets and artists who exchanged artwork through the postal system. Between 1976 and 1982, he made silhouette portraits. In a 1982 interview with Henry Martin (later published in the journal Lotta Poetica *2, no. 6, February 1984), Johnson explained the process:*

> *In 1978 and 1979, I was doing life-sized heads, but since then I've reduced them to about four and a half inches high. I do that photographically and just do zap zap zap on a copy machine that reduces my original drawings, which are drawings that I made from life if the people themselves are alive and from photos or previous silhouettes if they're not.*

This list of those who participated in his "silhouette portraits" project is a who's who of the famous and not-so-famous—an art-world jumble with Johnson as the only common denominator. It is unclear if he actually made silhouettes of everyone on this list, or if the list was a call to action to enlist support for the project, or if the photocopied list, sent through the mail, was an event in and of itself. He sent this particular list to art historian Ellen H. Johnson (1910–1992) as a thank you for participating in his project. In a subsequent list of silhouette portraits dated 1979, Ellen Johnson's name appears at number 207.

Ellen, thank you. Ray

OCTOBER 13, 1978

I THANK THE PEOPLE LISTED BELOW, WHO
HAVE KINDLY POSED FOR SILHOUETTE PORTRAITS:

Wish you could see all of these portraits.

1. WILLIAM BURROUGHS
2. ROBERT DASH
1. PHYLLIS FLOYD
3. GEORGE WILLIG
4. MARION WILLARD
5. DAN JOHNSON
6. CHRISTOPHE de MENIL
7. HAROLD ROSENBERG
8. IVAN KARP
9. BETTY KATZ
10. ARMAN
11. DOROTHY LICHTENSTEIN
12. DAN RATTINER
13. DOUGLAS BAXTER
14. KLAUS KERTESS
15. JOHN RUSSELL
16. GINGER GETTLING
17. JOHN MACWHINNIE
18. SAUL STEINBERG
19. HARRY REEMS
20. PALOMA PICASSO
21. JOE BRAINARD
22. TED CAREY
23. RICHARD BERNSTEIN
24. ROY LICHTENSTEIN
25. TITO SPIGA
26. ALFONSO OSSORIO
27. PETER BEARD
28. DAVID HOCKNEY
29. DAVID BOWIE
30. DAVID BOURDON
31. VICTOR HUGO
32. BILL KING
33. KATHARINE KUH
34. ROSAMUND BERNIER
35. CRAIG CLAIBORNE
36. ARAKAWA
37. BILL KING
38. CHARLES FAHLEN
39. HOLLY SOLOMON
40. WILLIAM WOLGIN
41. CHARLES HENRI FORD
42. YVES FERNANDEZ
43. ERO LIPPOLD
44. BRIAN O'DOHERTY
45. JOHN LORING
46. ROBIN LEE CRUTCHFIELD
47. JOEL GREY
48. ATIRNOMIS
49. NAM JUNE PAIK
50. MARC STEVENS
51. HENRY GELDZAHLER
52. BILL KATZ
53. JEANNE DIAO
54. DOROTHY MILLER
55. PETER HUJAR
56. ANNE d'HARNONCOURT
57. WILLY EISENHART
58. ELAINE BENSON

59. DAVID BOYCE
60. MICHAEL BENNETT
61. ROBERT HUGHES
62. SUZI GABLIK
63. MIKE BELT
64. HUGH ROBERTS
65. BUSTER CLEVELAND
66. GERARD MURRELL
67. JOHN EVANS
68. JOHN WILLENBECHER
69. DAVID HARTMAN
70. MARILYN GELFMAN-PEREIRA
71. SUSAN HALL
72. CAROLE SPEARIN McCAULEY
73. WILL FARRINGTON
74. JANE KAPLOWITZ
75. TOBY SPISELMAN
76. AMEI WALLACH
77. HORACE SOLOMON
78. CYNTHIA PATTISON
79. ROBERT ROSENBLUM
80. ARTURO SCHWARZ
81. CHRISTOPHER SCOTT
82. TIMOTHY BARRY
83. SUSAN SUTTLE
84. LARRY RIVERS
85. SYLVIA SLEIGH
86. ROY SLADE
87. JIM MELCHERT
88. ANNA CANEPA
89. CHARLOTTE BROWN
90. WILLIAM WILSON
91. MARION LOCKS
92. MICHAEL QUIGLEY
93. JOHN NEFF
94. RAY COLBY
95. JOY HOKANSON
96. LEONARD KASLE
97. JIM CRAWFORD
98. GERTRUDE KASLE
99. MARY ANN MELCHERT
100. DIANE VANDERLIP
101. CRAIG GHOLSON
102. FLORA IRVING
103. JACK YOUNGERMAN
104. JOHANNA VANDERBEEK
105. JANN WENNER
106. LAWRENCE ALLOWAY
107. ED HIGGINS
108. TOM ARMSTRONG
109. CAROLINE KAPLOWITZ
110. ZANDRA RHODES
111. MADELINE GINS
112. JEFF TURTLETAUB
113. JOHN LOMBARDI
114. NOELLE FAHLEN
115. MARIO AMAYA
116. ANDY WARHOL
117. NANCY GROSSMAN
118. BILL COPLEY
119. TERRY KISTLER
120. FRANCES BEATTY

121. DAVID JACOBS
122. SCOTT BURTON
123. LOUISE NEVELSON
124. WALTER GURBO
125. JEROLD ORDOVER
126. BARBARALEE DIAMONSTEIN
127. GARY LAJESKI
128. NORMAN FISHER
129. MAY WILSON
130. CHUCK CLOSE
131. HEDDA STERNE
132. JOHN BELUSHI
133. JANE WENNER
134. PAULA COOPER
135. BILL de KOONING
136. JIM ROSENQUIST
137. EDWARD ALBEE
138. POLLY KRAFT
139. LESLIE CLOSE
140. HOWARD KANOVITZ
141. DAN FLAVIN
142. LYNDA BENGLIS
143. HALINA ROSENTHAL
144. JIMMY ERNST
145. TONY ROSENTHAL
146. SALLY QUINN
147. BETTY BENTON
148. RICHARD FEIGEN
149. MARTHA HOGARTH
150. WILLIAM HOGARTH
151. NANCY WILSON ROSS
152. CLAUDIA DE MONTE
153. ED McGOWAN
154. LEON POLK SMITH
155. LUIS CAMNITZER
156. COCO GORDON
157. FRANCES LEWIS
158. SYDNEY LEWIS
159. ANNETTE HANSEN
160. SVEND HANSEN
161. TIMOTHY BAUM
162. ELLEN HIRSCHLAND
163. JUDITH BERNSTEIN
164. ALVIN FRIEDMAN-KIEN
165. BERTY SKUBER
166. HENRY MARTIN
167. CHARLES MARTIN
168. PETER WHITSON WARREN
169. DIANN MISTRETTA
170. DON MISTRETTA
171. RICHARD LIPPOLD
172. CHARLES ADDAMS
173. ALEXANDRA ANDERSON
174. THOMAS LAWSON
175. PETER FRANK
176. MARTHA WILSON
177. KAREN SHAW

178. DEE SHAPIRO
179. LINDA ROSENKRANTZ
180. CHRISTOPHER FINCH
181. LEO CASTELLI
182. JULIE MARTIN
183. BILLY KLUVER
184. RAGLAND TOLK-WATKINS
185. MARK STEVENS

27 WALT KUHN
LIST OF MODELS
1946–48 2 PP., EXCERPTED, HANDWRITTEN

*Walt Kuhn (1877–1949), who
was known for his paintings of
circus and vaudeville entertainers,
often worked from models. In this
notebook from the late 1940s, he
lists contact information for his
models with annotations, such as
"blonde," "not reliable," "110 lbs
brunette," "nice chap," etc.*

FOR TRANSCRIPTION,
TURN TO PAGE 185

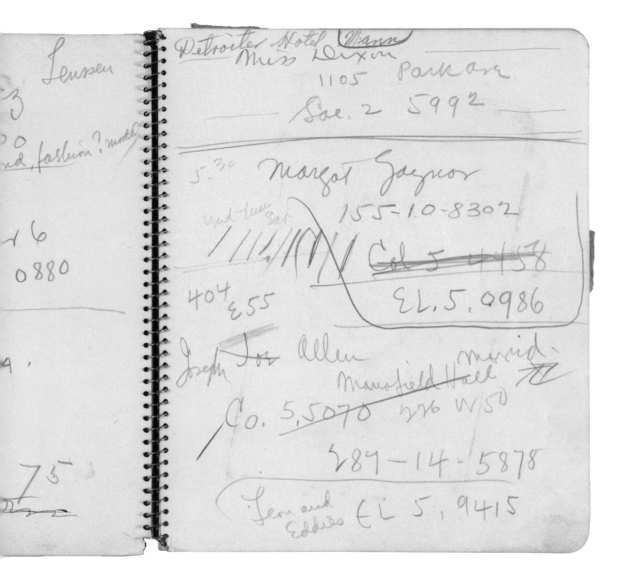

Detroiter Hotel (Mann)
Miss Dixon
1105 Park ave.
Sae. 2 5992

5-30 Margot Gaynor
 155-1.0-8302
wed-tues Col. 5-4458
/ / / / / / / /
Sat
404 E55 EL.5.0986

Joseph Jos Allen murid.
 Mansfield Hall
Co. 5.5070 226 W50
 589-14-5878
(Leon and Eddies EL 5,9415)

28 PABLO PICASSO
RECOMMENDATIONS FOR THE ARMORY SHOW FOR WALT KUHN
1912 1 P., HANDWRITTEN

Painter Walt Kuhn played a major role in assembling the 1913 Armory Show, the first international exhibition of Modern art in the United States. Because he had limited knowledge of the European avant-garde, he relied on American artists living abroad— Walter Pach, Jo Davidson, and Alfred Maurer—as well as informed individuals, such as Pablo Picasso (1881–1973), for introductions to contemporary European artists and dealers. This list is Picasso's recommendations for the exhibition: Marcel Duchamp—name spelled out phonetically—whose Nude Descending a Staircase *(1912) caused an uproar at the exhibition, Fernand Léger, and Juan Gris, among others. Curiously, Picasso did not include Georges Braque, whose name was later added in Kuhn's hand. The Europeans stole the show, overshadowing their American counterparts. The list conveys the collaborative efforts of the show's organizers.*

FOR TRANSCRIPTION, TURN TO PAGE 186

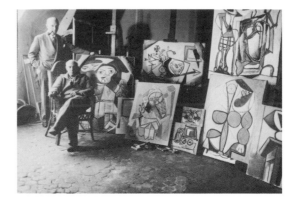

Handwriting by Picasso) ✗

Juan Gris
13 rue Ravignan

Metzinger
Glesses

Leger

Duchan

Delannoy

LeFauconnier

Marie Laurencin

dela Fresnay

Braque .

list prepared by Picasso) ✗
1912) ✗

29 LUDWIG SANDER
LIST OF MEMBERS OF THE CLUB
CA. 1949 1 P., HANDWRITTEN

The Club (also known as The Eighth Street Club) was founded in 1949 by Willem de Kooning, Franz Kline, Ad Reinhardt, Philip Pavia, and others. Their weekly discussions and panels helped define the avant-garde art community in New York City in the 1950s.

In a 1969 interview with the Archives of American Art's oral historian Paul Cummings, painter Ludwig Sander, a charter member of The Club, discussed the origins of the group: "Well, I have a list somewhere. I have a telephone list that we made up. And they became the charter members. With the exception of a few names that . . . never came to meetings, or only came once." It is possible that the list of charter members he refers to is the document at right found among Sander's personal papers.

FOR TRANSCRIPTION,
TURN TO PAGE 186

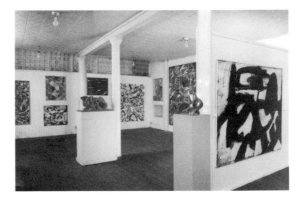

Lewitin ~~113 W 13th~~ Waverly Helena Newman OR3-0680
Gruppe 62 7-5416
CH 3-3819
1. Rosati — 252 W. 11 St. WA9-0267
3 Pavia — 53 W. 8 GR5-5864
4. De Kooning — 85 Fourth Ave. c/o. ~~Siegle Frames~~ Siegle GR3-3749
5. Resnick 47 East 8 St.
6. Conrad — 52 East 9 St. AL-4-8470
7. Lassaw — 487 – 6 Ave. WA9-6293
8. Kline — 52 East 9 SP 7-1945
9. Alcopley — 29 Charles Ch2-6267 ~~4~~
10. Falk — 186 Spring St. WA5-5072
11. Reinhardt — 7 Washington Pl. OR4-9176
~~Cavallon — 20 Leroy St. Ch 3-7678~~
13. ~~Lee~~ — 324 E. 31 St. LF2-7482
14. ~~MU9-4272~~ ~~Ave B GR5-1027~~
Navarretta 247 W. 10th St CH 3-0935
15 Adelanto 63 East 11 — OR4-2176
16 Sander 67 W 3rd OR 4-2898
17 ~~Charles Egan 3 S7 DU K2 4~~
OFF.
MU3-3684 E 77 BV 8-8343
18 LEO CASTELLI
19 Jack Tworkov 234 E 23 MU 6-9198
20 Aaron Siskind 47 E 9 St Gr.3-5497
Rudy Burckhardt 116 W 21 WA 4-6928
Jeanne Reynal 220 E. 17 St OR.3-1790
Joop Sanders 479 6th Av GR.2-2096.

So I did a mental inventory of the things, the rude actions in my previous history. I did find instances where things that I have done or said might be considered rude.

—RAY JOHNSON

<u>Inventory</u>

30 OSCAR BLUEMNER
LIST OF WORKS OF ART
MAY 18, 1932 1 P., HANDWRITTEN, ILL.

Painter and color theorist Oscar Bluemner (1867–1938) was a fervent list maker. His copious notes, punctuated with lists of works of art and lists of color combinations, are evidence of his all-consuming commitment to aesthetic exploration. "One rule," wrote Bluemner, "draw and paint, equally, constantly, separately, thinking, feeling." In this illustrated list of recently completed landscape paintings, Bluemner made thumbnail sketches with the dimension, date, media, and sometimes included the subject of the work. The crowded page, as well as Bluemner's habit of appending one list to another with shorthand marks and abbreviations, tended to obfuscate rather than clarify his inventory.

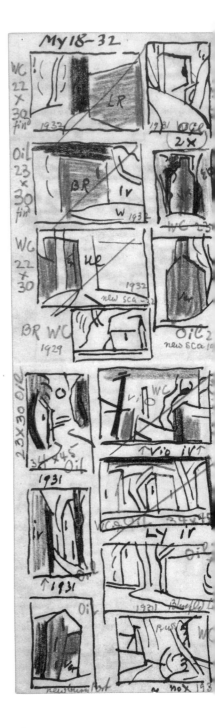

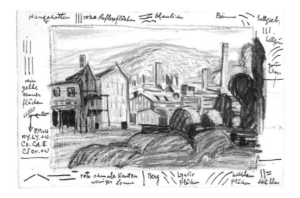

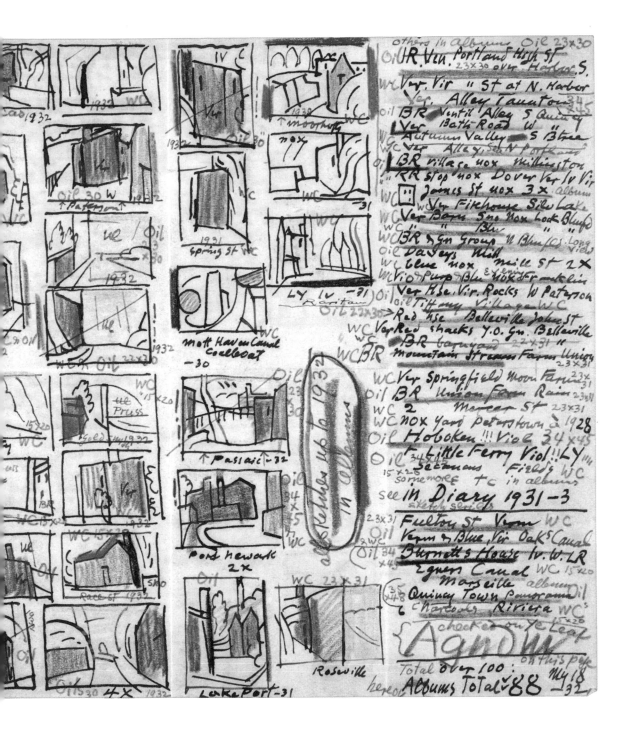

31
ALEXANDER CALDER TO AGNES RINDGE LETTER
CA. 1942 2 PP., HANDWRITTEN, ILL.

In this letter Alexander Calder (1898–1976) writes to Agnes Rindge (1900–1977), educator, collector, and director of the Vassar College Art Gallery, with an illustrated list of nine of his sculptures for her to see in New York City: eight at his apartment at 244 East Eighty-sixth Street and one large mobile in Martha Graham's studio. Rindge may have been looking to select pieces for the exhibition Sculptures by Calder and Paintings by Joan Miró held at the Vassar College Art Gallery in March 1942.

FOR TRANSCRIPTION, TURN TO PAGE 186

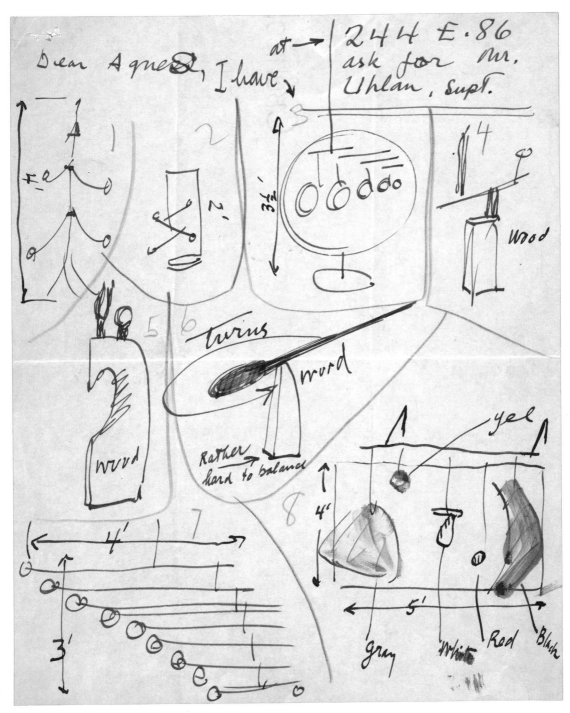

32 JOSEPH CORNELL
LIST OF ITEMS PURCHASED AT THE THIRTEENTH NATIONAL ANTIQUES SHOW NEW YORK CITY, MARCH 1957

1 P., ANNOTATED TYPESCRIPT

Known mainly for his shadow-box constructions and collages, Joseph Cornell (1903–1972) frequented New York's antique and secondhand shops in search of evocative objects—bottles, marbles, toys, maps, clay pipes, engravings—to use in his art. In 1957 he attended the thirteenth National Antiques Show at Madison Square Garden and made a list of items, including a clear marble with a miniature dog at its center, a butter mold in the shape of a swan, a toy wagon, and wax figures "said to be valentines." Presumably Cornell purchased these items from the fair and later annotated the list, indicating those he sold, gave away, or retained.

March 1957 Mad. Sq. Garden Antiques Fair

2 butter moulds - swan design, hand carved *Sold*
- have

Red Riding Hoodish painted red, green, blue)
 its charm the paint much worn (touch yellow)

pr vaseline wine glasses *No*

sulphide marble - standing dog or sheep *Sold*

match container - china - ca. 1890 , corsted ✓ *given away*
torso (bought as joke)

fancy pin box - cardbd very Victorian *no*

ruby col. min. oil lamp with wick working *gave to miss Fallon*

pr. min perfume containers - frog & dog shapes *No*

misc. marbles *Sold*

pr. of hand made scales, box & all hand printed/ing *?*
(painted cover

Pennsylvania glass bell effete shepherd boy with white *Sold*
dog - wax figures - said to be valentines - this espec-
ially complete with base legs

min. toy wagon, horse & driver, German ca. 1900 *have*

set of cards (picked from broken lot) of characters
in various amusing scenes - heads An/embossed holes *have*
with numbers - the counterparts missing to fill in -
colored - never seen anything like them

MARGARET DE PATTA
LIST OF PRODUCTION JEWELRY
CA. 1946

In the July 1947 issue of Arts and Architecture, *Modernist jeweler Margaret De Patta (1903–1964) asked the question, "What happens to an artist when the demand for his work exceeds his ability to supply it?" Her answer was to develop a line of affordable reproductions of her own work. In 1946 she and her husband Eugene Bielawski established Design Contemporary, a company that offered copies of De Patta's most admired rings, cufflinks, brooches, and earrings. Although De Patta was "proud of the fact that the popularly priced piece is indistinguishable from the 'one of a kind' piece," she nevertheless fretted over her status as an artist and eventually refocused her energies on design and experimentation. This list shows some of the pieces and prices for her line of production jewelry.*

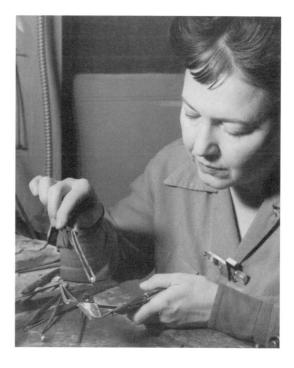

Piece No		Wax	Cast	
▦	1	35	1.25	1.60
▢	2	35	1.00	1.35
▥	3	75	1.25	2.00
◔	4	50	1.50	2.25
◣	5	50	2.00	3.25
◭	6	35	2.50	3.00
▢	7	35	1.00	1.35
◪	8	35	1.00	1.35
◁	9	50	2.00	2.50
◎	10	75	HEAD .75	3.25
▮	12	85	1.00	1.35
◭	13	35	1.00	1.35
▽	14	35	1.00	1.35
▽	15	50	2.25	3.00
▤	16	25		
▤	17	25		.75
▥	18	25		1.00
▥	19	25		
▥	20	25	1.10	2.00
◭	21	35	1.25	1.60
◯	22	50	2.25	3.00
▦	23	25	.75	1.00
◭	24	25	.75	1.00
◪	25	25	.60	1.00
◭	26	25	.75	1.00

34 WILLIAM MILLS IVINS
LIST OF PRINTS FROM HIS NOTEBOOK
1927–28 1 P., EXCERPTED, HANDWRITTEN

When the Metropolitan Museum of Art was founded in New York City in 1916, William Mills Ivins (1881–1961) was appointed the first curator of the newly established Print Department. For the next two decades, he amassed an extraordinary collection of prints through gifts and purchases. He later served as assistant director of the museum and then as director from 1940 until he retired in 1946.

In his notebook from the late 1920s, he made a list of significant prints under the heading "What twelve prints that you have do you most prefer?" A second list of names on the lower right, mostly those of prominent print collectors, suggests that Ivins posed the question to these men. Whether or not he conducted this survey is unknown, but the x's next to specific titles might indicate Ivins's tally of responses. The consummate curator, Ivins himself was unable to select just twelve. On the lower left he writes: "It simply can't be done!"

FOR TRANSCRIPTION,
TURN TO PAGE 187

What twelve prints that you have do you most prefer?

× × Mantegna's Oblong Entombment
× × Dürer's St Michael
× × Dürer's Flagellant
× × Rembrandt's Raising of Lazarus
 Florentine Mount of Olives
× × Florentine Monks in the Mountains
× × Ugo da Carpi's Miraculous Draught of Fishes
× × Delacroix's Juive d'Alger
 × Ingres's Odalisque
× × Daumier's Mère d'une actrice
 Degas's Le Bain
× × Gauguin's Woman on Beach
 Girtin's Porte St Martin
 Venetian woodcut Pietà
 × Baldung's Conversion of S. Paul
 Goya's all are bound
 × Canaletto's Porte al Dolo (round basin)
 Piranesi's Arch of Trajan
 Holbein's Erasmus with the Term
× × Hokusai's Army in the Mountains
× × Matisse's Portrait of a Young Girl
× × Rodin's Lithograph
 Dürer's Woman of Babylon
 Dürer's Sudarium & one Angel
 Hogarth's Lord Lovat

Ivins.	G.
Foster.	G.
Mansfield.	G.
Veeder.	G.
Ledoux.	G.
Dr. Norrie.	G.
Dr. Goodridge.	
Geo.	Central Union.
Geo. Pratt.	

It simply can't be done!

35

DAVID TRUMBULL LANMAN
TO HIS SISTER ABIGAIL TRUMBULL LANMAN
LETTER
DECEMBER 2, 1844

4 PP. (1 FOLIO), HANDWRITTEN LETTER ON ANNOTATED AUCTION CATALOG PRINTED BROADSIDE

This printed broadside auction catalog is a list of paintings, prints, and ephemera for sale from the estate of painter John Trumbull (1756–1843), one year after his death. Known for his portraits and history paintings of the American Revolution, Trumbull had firsthand experience of the Revolutionary War, serving as a colonel in the Continental Army and as an aide to General George Washington. Four of his historical paintings hang in the Rotunda of the United States Capitol.

Trumbull's great-nephew, David Trumbull Lanman (1802–1866), sent this catalog, annotated with appraisal prices, to his sister Abigail (1806–1890) in case she wanted items removed from the sale "because you don't wish them sold for less than what you suppose they are worth or what you would be willing to give for them. I want you to name the price. I shall bid for you or let them go to any one who will give more…" Later in the letter, Lanman ponders about how to best control the market for his great-uncle's prints.

FOR TRANSCRIPTION, TURN TO
PAGE 188

OIL PAINTINGS, PRINTS, &C.

My dear Sister,

NEW-YORK, DEC. 2 1844

SIR:—

Your attention is respectfully invited to the inspection of a few **PAINTINGS**, mostly by the pencil of Col. JOHN TRUMBULL, which will be sold at Auction on Tuesday, Dec. 10, at 11 o'clok, by W. H. FRANKLIN, No. 15 BROAD STREET, NEAR WALL, where they may now be examined. Sale without reserve, to close his estate.

CATALOGUE.

Appraisal Prices *Apprisal*

$100 1. HOLY FAMILY—Mother and Child—copy from Vandyke, by Col. T.

$75 2. LADY DRESSING—Copy from Murillo by Col. T., a fine painting.

$150 3. THE CHASTITY OF SUSANNAH—or Susannah and the Elders, by Col. T.

$100 4. HEAD OF GOVITUS—Copy from the original in the Royal Gallery in London, by Col Trumbull, a very valuable Painting.

$100 5. SPANISH LADY—Original, by Valasquez, procured by Col. Trumbull in London.

$50 6. LANDSCAPE—Near Bath, England, by Col. T.

$50 7. Do. do. do. do. to match.

$50 8. Do. do. do. do. do.

$10 9. Do. unknown, by Col. T.

$20 10. DRAWING in India Ink—Study of the Picture of Peter the Great at Neva—original in the Trumbull Gallery at New-Haven, by Col. T.

$20 11. Two Drawings in India Ink—Sketches of Pasaic Falls, N. J. by Col. T.

$10 12. ONE SKETCH in India Ink, of Niagara, by Col. T.

$15 13. PORTRAIT of a Revolutionary officer, unknown, by Col. T.

$20 14. PORTRAIT of Dr. Smalley, one of the commissions under Mr. Jay's Treaty With Col. T., by himself.

$20 15. PORTRAIT of Sir Grenville Temple, well known in Boston—by Col. T.

$20 16. PORTRAIT of Ralph Hickley, a servant to Sir Joshua Reynolds through life—a fine head, by Col. T., taken from Life in London.

$25 17. PORTRAIT of Mr. Ellis, an English Merchant, a fine Picture, by Col. T.

18. PORTRAIT of Mrs. Trumbull, Wife of Col. T., by himself. 15 x 12, a fine Painting. $75

19. PORTRAIT of Mrs. Mitchell, Wife of an English Clergyman, by Col. T. $15

20. PORTRAIT of Mr. Palmer an Artist of London, by Col. T. $20

21. PORTRAIT of Mr. Elis, now a member of Parliament, taken when young, in London. $20

22. PORTRAIT of Dr. Edward Marcelin. $20

23. PORTRAIT of a Matron Lady—Supposed mother of the late Doctor Hossack $10

24. PORTRAIT of Mrs. Trumbull, small size, by Col. T. $20

25. MINIATURE of Gen. Green, of the Revolutionary army of the U. S, $15

26 MINATURE of Col. Trumbull, do. of Mrs. T.

27. LARGE PORTFOLIO containing 8 Prints from Raphael's Frescoes in the Vatican, very fine engravings, and scarce. $40

28. PROOF Prints of the Declaration of Independence—these proofs are scarce and the plates destroyed. 6a $4

29. PRINTS of the Battle of Bunker Hill, and death of Gen. Warren. 6a $3

30. PRINTS of the attack on Quebec, and death of Gen. Montgomery. 6a $3

31. SORTIE of Gibralter, engraved by Sharp, whose works are rare, and much prized in England—fine prints. 6a $4

32. PRINTS, full length, of Gen. Washington. 6a $1

33. Two Portfolios, containing old Engravings of Battles, sketches &c., &c. $5

34. SEVERAL Volumes of Autobiography, Reminiscences and letters of Col. J. Trumbull, from 1756 to 1841, by himself $17

35. PRINTS of Judge Jonas Platt. 6a 25

36. PRINTS of Chief Justice Oliver Elsworth, from Paintings by Col T. 6a 25

Most of the above were appraised by Mr. Jocelyn at New Haven, those not appraised I have put their value as I estimate them, If you would like any of these

36 MORRIS LOUIS TO LEONARD BOCOUR LETTER
MAY 22, 1962 1 P., ANNOTATED TYPESCRIPT

Inspired by Helen Frankenthaler's method of staining raw canvas with thinned paint, Morris Louis (1912–1962) experimented with pouring paint on wide spans of unstretched canvas. To achieve his desired effect—thin veils of overlapping color—he worked closely with paint manufacturer Leonard Bocour (1910–1993) to refine Magna, a quick-drying, oil-based acrylic paint that could be thinned with mineral spirits or turpentine and then poured. In this letter to Bocour, Louis lists his order for Magna colors and then complains that his previous order was not fresh and pure—he calls for greater quality control. The Sam he refers to is likely Sam Golden, who along with Bocour developed Magna as the world's first artist's acrylic paint in 1947.

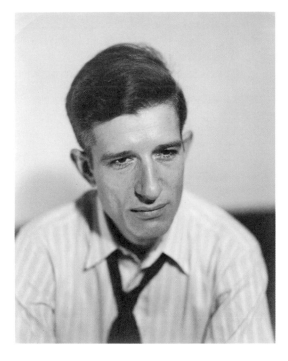

MORRIS LOUIS
3833 LEGATION STREET, N.W.
WASHINGTON 15, D.C.

May 22, 1962

Dear Len,

I need the following gallon cans of Magna colors so could
you stir things up and get it to me soon----

1 gal.	Bocour Green
1 "	Bocour Blue
1 "	Yellow Ochre
1 gal	Raw Sienna
1 "	Aliz. Crimson ———————— B.O.
1 "	Cad. Red Light
1 "	Cad. Yellow Medium
1 "	Cad. Yellow Pale
1 gal.	Cad. Orange

I hate to reopen the complaint department because I know
this whole deal is not likely to buy you any real estate,
but will you please see to it that the colors are made
fresh each time? I have a gallon of Green Earth and Raw
Sienna which are solid pigment you couldn't cut with a
knife because they were kept too long at your place till
I ordered them. Sam is doing me no good by making up
more than I ask for and keeping it on hand till I reorder--
by then the stuff is no good at all. Another important
matter which I've hollered about before is that the machine
is hardly cleaned between the different colors. In my last
order which included Aliz. Crimson and Cobalt Violet it is
apparent that the Crimson was made first and then the Violet
without cleaning up. The result is that the Violet looks
almost identical to the Crimson and is really a red instead
of a violet. So not only don't I get a violet to work with
but it comes expensive at 40 a throw. Please tell the boys
to behave and do the job right-- it hurts when they don't.

Hope the new quarters for Bocour are coming along. Best to
all,

 Morris

GERMAIN SELIGMANN
LIST OF OBJECTS TO TRANSFER TO THE USA
1947 1 P., TYPESCRIPT IN FRENCH

Established in Paris in 1880, with a branch opening in New York City in 1904, Jacques Seligmann & Co., Inc. was one of the most prominent dealers in antiquities and Renaissance art, and took a leading role in promoting contemporary European and American painting. Jacques Seligmann's son, Germain (1893–1978), grew up in the family business and by 1920 was a partner (along with his father) and president of their New York office. Germain divided his time between Paris and New York until 1939, when the company headquarters moved to New York, and he established his legal residence there.

In the summer of 1940, shortly after the outbreak of World War II, the Seligmann family house and its contents were seized and sold by order of the Vichy government, along with Germain's private art collection and the gallery's stock.

In 1945 the postoccupation French government issued special ordinances requiring owners to declare all seized property by December 31, 1947. This 1947 list is Germain's formal claim to the personal possessions that had been stolen by the Germans or forced to be hidden by friends or servants during the war. The list reflects retrieved objects to be transported to the United States.

FOR THE TRANSLATION,
TURN TO PAGE 188

M. Germain SELIGMANN

LISTE des OBJETS à TRANSFERER aux U.S.A.

	Estimation.- 1947.-
1°. Deux tapisseries anciennes........................	I.400.000 Frs.
2°.-Panneau en tapisserie ancienne représentant une jeune femme tenant un cierge........................	420.000 "
3°. Buste en marbre "L'Impératrice"...................	I.050.000 "
4°. Plat en faïence avec inscriptions hébraïques.......	315.000 "
5°. Petit bassin en faïence...........................	I75.000 "
6°. Portrait de jeune homme, copie d'après Dürer.......	2I0.000 "
7°. Paire de flambeaux en argent......................	98.000 "
8°. Légumier argent avec couvercle et plateau.........	I40.000 "
9°. Quatre gouaches chinoises.........................	I4.000 "
I0°. Bougeoir porcelaine bleue.........................	2I.000 "
II°. Colonne bronze noir en trois éléments.............	5.500 "
I2°. Dessin représentant un "Nu"......................	56.000 "
I3°. Ecrin avec argenterie............................	7.000 "
I4°. Grand plat long métal argenté....................	24.500 "
I5°. 2 filtres à café argentés........................	700. "
I6°. Cuillères manche nacre...........................	700 "
I7°. Trois dessins....................................	
I8°. Petit tableau en tapisserie en longueur..........	24.500 "
I9°. Deux jardinières en faïence......................	3.500 "
20°. Une pierre sur socle.............................	mémoire
2I°. Un écrin vide....................................	mémoire
22°. Un canapé et huit fauteuils Directoire, bois peint en blanc, couverts en tapisserie....................	240.000 "
	4.205.400 "

NOTE.-

Monsieur Germain SELIGMANN, citoyen Américain depuis I937 a quitté l'Europe pour l'Amérique à cette époque. Il habitait auparavant à Paris 23, rue de Constantine et avait également un pied à terre Avenue Foch.

N'ayant pas terminé son déménagement avant guerre, il désire transporter à New-York les objets ci-dessus qui font partie de son mobilier personnel. Un premier envoi a été autorisé et effectué en I946.

Les objets ci-dessus ont été pour la plupart retrouvés après avoir été emmenés par les Allemands ou cachés par des amis ou des domestiques.

Il est tenu à la disposition de l'Administration :

- Un certificat de résidence aux U.S.A. , devant Notaire, certifié par le Consulat de France;

- Certificat de Nationalité Américaine (Notaire, Consul de France)

- Déclaration de propriété (Notaire, Consul de France);
- Extrait de catalogues, copies et photos de pièces et lettres collationnées (Notaire et Consul de France) attestant la propriété desdits objets et prouvant notamment que les deux tapisseries n'avaient été amenées en··· France que pour une exposition avant guerre.

38 CAROL THOMPSON
LIST OF BOB THOMPSON'S PAINTINGS AND DRAWINGS DESTROYED BY FIRE
1977 1 P., ANNOTATED TYPESCRIPT

An African American artist at the center of the Beat scene, Bob Thompson (1937–1966) fused Abstract Expressionism and figuration into intensely emotional paintings, many of which are homages to European masterworks. Thompson lived fast and worked hard, creating more than a thousand works of art before his death in Rome at age twenty-eight from a drug overdose. In 1977, a fire in the apartment of his widow, Carol Thompson, in New York City destroyed forty-five of his paintings and drawings. This list indicates the works lost in that fire.

List of paintings and drawings that were destroyed by fire in 1977

1. Ship of Fools 1961 o/c 59 x 52
2. The Hat Shop 1961 o/c 45 x 56
3. Satry & Maiden 1965 o/c 24 x 48
4. Nude oil on wood 1960 12 x 14 approx.
5. Ecco & Narcissus 1965 aquatex on paper 12 x 16
6. The Picnic 1963 o/c 14 x 18
7. Le Passage 1960 oil on masonite 1960 40 x 48 approx. — res
8. Bird Rites 1965 o/c 20 x 24
9. Spain being secuccred etc. 1964 o/c 9 x 12
10. The Flagellation of Christ 1964 o/c 14 x 18
✱11. Untitled (Green bird & women in cave) 1962 o/c 40 x 48 *
⟵12. Portrait of Carol 1960 o/c ~~24 x 30~~ 26x24 24 x 30
13. The Recliners 1965 o/c 12 x 16
14. Pietra aquatex on paper 1965 10 3/4 x 10 1/4
15. Pompillio & Nymph " " "
16. The Expelltion " " "
17. Triumph of Truth " " "
18. Bird Feeding 1961 oil on wood 11 x 5 1/2
19. Untitled " " " " "
20. Miraculous Draught of Fishes 1966 crayon on paper 8 1/2 x
21. Blue women & Elephant " " " " 7 x 10
22. Adam & Eve " " " " 8 1/2 x
23. Portrait of Carol on Chez lounge 1962 gouache on paper 21 1'
24. The Search 1963 gouache on paper 30 x 40 21X14
25. The Chase 1963 pastel " " 19 x 25
26. Red Man (untetled) 1966 oil on paper 5 7/8 x 4 -
27. Trythich on wood 1961 10 1/2 x 3 3/4
28. " " " " "
29. 5 small paintins on wood 1961 - all same size.
34. 6 " " " cardboard box tops (match boxes)
40. The Ressurection 1966 ink on canvas 24 x 30
41. The Conversion of St. Paul 1966 ink on paper 18 x 24
42. Le Caprice or Dante's Inferno 1963 gouache on paper 24 x 36 appr
43. Portrait of Elaine & Carol 1960 o/c/ 36 x 44 no slide or pho
✱ painting returned by Bill Barrell done in Ibizza.

44. Portrait of Carol 1964 O/C 21 X 30 -
45. 3 panel Chair back 1961 O/wood 13X

39 WORTHINGTON WHITTREDGE "COMPLETED COMMISSIONS AND OTHER PICTURES" 1852–57 2 PP., EXCERPTED, HANDWRITTEN, ILL.

Landscape painter Worthington Whittredge (1820–1910) kept a list of paintings commissioned and other works completed between 1852 and 1857, with thumbnail sketches for important works such as From the Harz Mountains *(1853),* Landscape in the Harz Mountains *(1852), and a "duplicate" version of the latter (1853). A native of Cincinnati, Whittredge spent ten years abroad—from 1849 to 1859—studying at the Düsseldorf Academy, traveling in Europe, and painting. His ledger not only accounts for his sales but also documents his travels from Germany, south through Switzerland, to Rome.*

FOR TRANSCRIPTION,
TURN TO PAGE 189

Completed Commissions and other Pictures

(left page)

...ssions and other Pictures

...Harz Mountains 33/24½ inches. To Cincinnati
...cepted by Mr Chas. Stetton for his
...n May 6th 1849. $100.

...tion from studies made in the Harz Mountains
...ar Langenfeld. 63½/46½ inches. To John
...Cin. Commissioned May 5th 1849. $400.

...this above with alteration 35½/26 in. To
...laghorn Philadelphia. Commissioned by T.B.
...ept 20th 1853. Price $150.

...to A. G. Burt Cincinnati Price $100.

...to Mr L. B. Harrison Cincinnati Motive from
...ake. Commissioned Sept 25th 1853.
...175.

...icture to Cincinnati for sale $25

...tion from studies made in the Weser Gebirge near
...66/57 inches. To R. W. Burnet Cincinnati
...$500.

...from a motive in the Harz Mountains about
...29/36 in To M. W. Scarborough Cincinnati
...a present to Dr Richards Commissioned
...mer of 1850. Price —— $150.

...m the Weser Gebirge bei Minden about 23/30 in.
...Wm Harrmann Cincinnati Commissioned
...1853. Price $100.

(right page)

April 1833 — From a study made near Bourg Steinfurt Westphalia
About 30/48 in. To David B. Lawler Cin. Commissioned
June 1852. Price $200.

June 14th 1852 — Composition from Studies made in the Park at Cappenberg. To
Mr Griffin Taylor for Mrs Dixon Commissioned 1850.
Price $250. Size near 4/5 feet.

Oct. 1855 — niedertäfchen an Countries Emilie Schmidt and Swatches,
im Schmalzer Thal Wein

April 19th 1856 — Composition from studies on the Nahe. about 26 by 25 inches
To a Lady. ordered by Baldwin. price $100

April 19th 1856 — Subject from the Elbe, Dessau. about 30 by 42 inches
to Reuben Springer. price

June 1857 — Subject from German landscape. about 32 by 4 ft 4
To Mr Gared... Baldwin. Painted in Rome

June 1857 — Subject from Bremen about 4 by 5 feet
to Mr Mills Dunham. sent in March 1858 to the
Philadelphia Academy and sold to Mr Sam. B.
Tyler for $350. Rome

Real happiness consists in not what we actually accomplish, but what we think we accomplish.

—CHARLES GREEN SHAW

To-Do Personal and Private

40 WILLIAM E. L. BUNN
"GRIEF LIST" DECEMBER 24, 1938

2 PP. (1 FOLIO), HANDWRITTEN

Painter William E. L. Bunn (1910–2009) is detail-oriented. In his notes to his New Deal mural, 1848, Fort Kearney, Protectorate on the Overland Trail, 1871, *for the post office in Minden, Nebraska, he pinpointed the moment when he learned that the Treasury Department's Section of Painting and Sculpture had awarded him the commission: July 26, 1937, at 11:30 p.m., a Monday. The subject of his mural, Fort Kearney, was a military post in Nebraska and a safe haven for early settlers and gold seekers traveling the Oregon Trail. Bunn used historical research to faithfully represent the fort at the peak of westward migration in the mid-nineteenth century. On Christmas Eve 1938, he made a "grief list" of all the details that needed fixing—from "put in buffalo skull" to "paint cats and dogs"—before finishing the mural in early 1939.*

FOR TRANSCRIPTION,
TURN TO PAGE 189

GRIEF LIST Dec 24th

Faces on all people

Adobize buildings ✓

Weatherstrip buildings

Whites on commanders' stable

" " hospital ✓

Dexter block on building down left.

Telegraph Wires ✓

Outhouses & wells

Lettering & modeling on cannvas tops

Put in buffalo skull

" " " hunt

Tree foliage repainted

Glaze ends of wagon covers —

Glaze distance lights ✓

Glaze hills into being

41 LEO CASTELLI TO-DO LIST
CA. 1968 2 PP. (1 FOLIO), HANDWRITTEN

One of the most influential art dealers of the twentieth century, Leo Castelli (1907–1999) had a demanding schedule. He kept track of his daily tasks—from picking up tooth powder at the drugstore to phoning Jasper Johns—in multiple to-do lists. He opened his first gallery in Manhattan in 1957 at 4 East Seventy-seventh Street and later moved to 420 West Broadway in SoHo. For decades Castelli developed and promoted Pop Art, Minimalism, Conceptual art, Neo-Expressionism, and other movements. The artists he represented—Jasper Johns, Robert Rauschenberg, Roy Lichtenstein, Andy Warhol, Ellsworth Kelly, Donald Judd, and others—became art-world superstars.

A true multitasker, Castelli's list shows his everyday, personal approach to managing the affairs of the gallery. Among the other tasks he mentions are architect Philip Johnson's "window sketches" (possibly referring to Frank Stella's designs for stained-glass windows for Johnson in 1968); framing Robert Rauschenberg drawings and choosing one of his paintings for Japan; phoning artists Bruce Nauman, Robert Morris, and Andy Warhol, as well as Sidney Felsen, one of the founders of Gemini Graphic Editions Limited. By 1968 many of Castelli's artists, including Stella and Rauschenberg, were creating prints through Gemini.

DRUG STORE SCHICK, BLADES, TOOTH POWDER
 PLASTIC BAG ANACIN

LEO CASTELLI 4 east 77 new york 10021 bu 8-4820

- SCARPITTA {REPRINTS NEW PRICES } IVAN
 (PHOTOS FOR EUROPE, REPRINTS
 (DISTRIBUTION))

- STELLA FROM DAVIDSON (SHOW TO ASHER)

- PHIL JOHNSON (WINDOW SKETCHES)

✓ FRAMING RR DRAWINGS MEMOS
 INVOICES
- ✓ AIR PLANE TICKET ({ L.C. (TOM, ARTHUR)
 NICK

- PHONE IVAN

- CHECK 1200. — TAXES

- TRAVELLER'S CHECKS

- PHONE NAUMAN (PRICE FILMS)
 " MORRIS
 " J.J.
 " ANDY

- RR CHOICE PTING FOR JAPAN, ALSO REBUS !!
- NOX SYD FELSEN

113

42 MIGUEL COVARRUBIAS TO NICKOLAS MURAY

LETTER

CA. 1940 2 PP. (1 FOLIO), HANDWRITTEN

In 1940 Mexican caricaturist Miguel Covarrubias (1904–1957) was a busy man. In this hurried letter to his friend photographer Nickolas Muray, he lists the tasks that have delayed him from writing sooner: finishing the essay "Modern Art" for the exhibition catalog Twenty Centuries of Mexican Art *(at MoMA); making a drawing of the exhibition opening for* Vogue *magazine; organizing the first Inter-American Conference on Indian Life, held in Patzcuaro, Mexico, in April 1940; and helping novelist and screenwriter John Steinbeck (here called Joseph) and director Herbert Kline on the film* The Forgotten Village *(about modern life encroaching on a small Mexican village) that premiered in 1941. Covarrubias's list not only reveals the demands on his time, but the range of his talent.*

FOR TRANSCRIPTION OF
THE COMPLETE LETTER,
TURN TO PAGE 190

Dear Nick –

I am terribly sorry to have let go all this time without writing and you are right to be mad at me as I could see by your letter. Still, you know my greatest weakness has always been letter-writing, particularly when I get into one of those hectic impasses of work. I can really say I have never been so busy in all my life; here is a sample:

1 – The organization of the G.D.... Mexican Exhibition which took every minute of two months and the details of which I am still struggling with.

2 – The preparation of my section (modern art) for the catalogue.

3 – My own book which has suffered heavily

4 – A drawing for Vogue of the opening of the Exhibition with about 50 people in it – – – – – –

5 – The arrangement of a great reception of all the worker's, women, etc organizations with banquets etc for the frustrated flight of Ya Ching, plus emigration and Federal Communications permits, etc.

43 JOHN D. GRAHAM
TO-DO LISTS
SEPTEMBER 8-11, 1937

2 PP., EXCERPTED, HANDWRITTEN, ILL.

*John D. Graham (1887–1961),
a Russian immigrant, writer,
painter, collector, connoisseur,
and charismatic spokesman
for the avant-garde, was an
incessant list maker. His 1937
pocket diary reveals the force of
his imagination and his running
to-do lists, which include "prepare
all mail, paint, write," "cash
my check," as well as names of
places to visit on his upcoming
trip to Oaxaca, Iguala, Juchitan,
Guatemala, and San Salvador.
He also itemized work to do
on writing projects, including
revisions of his treatise* System
and Dialectics of Art, *published
that year, and editing his
autobiographical essays, "From
White to Red" and "Childhood,"
which were never published. With
most of his energy consumed by
these activities, he had little time
to paint. His diary was one place
where he indulged in graphic
expression. He covered his lists
of objects to buy and sell, letters
to write, and people to meet with
multicolored pencil drawings
and Picassoesque doodles. A
cryptic note in red pencil, "Milk
7B" (7 bottles), indicates the
number of milk bottles delivered
to Graham's door between
September 1st and 8th in 1937.*

FOR TRANSCRIPTION,
TURN TO PAGE 191

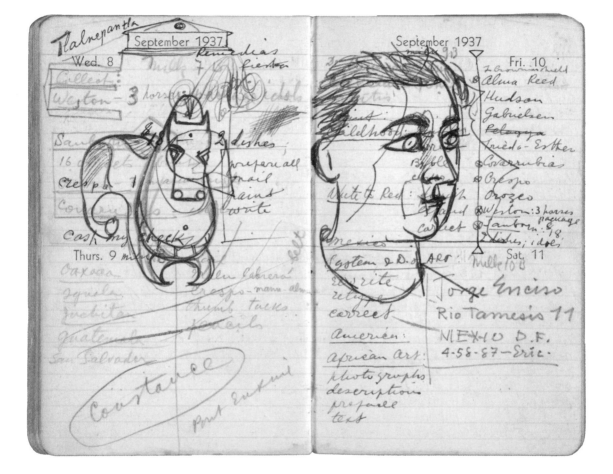

44

JANICE LOWRY
TO-DO LIST
AUGUST 9, 2003

2 PP., EXCERPTED, HANDWRITTEN, ILL., VARIOUS MEDIA

*Janice Lowry's (1946–2009)
sketchbook/journals are evidence
of her passion for assemblage. In
each she combines verbal and
visual expression with a variety
of techniques and materials—ink
pens, colored pencils, photographs,
stamps, and watercolors—to
create highly personal documents
that embody her life-long
commitment to the everyday. Her
books include many to-do lists,
with some tasks completed and
crossed off and others migrating
to subsequent to-dos.*

FOR TRANSCRIPTION,
TURN TO PAGE 191

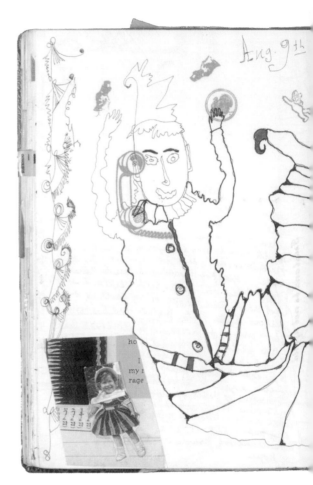

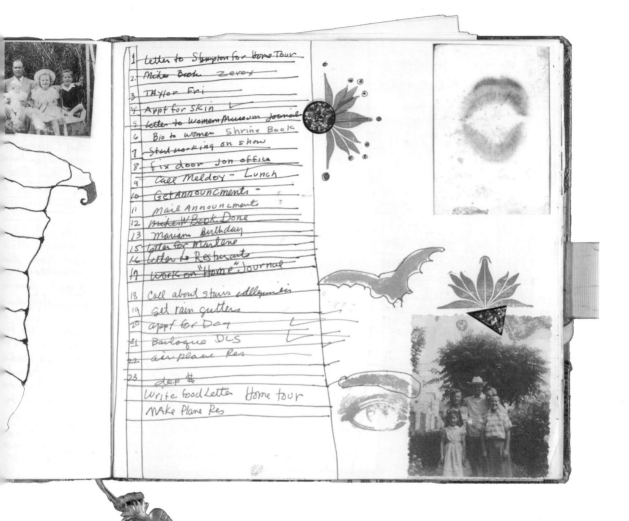

1 Letter to Shampton for Home Tour
2 Mike Book zerox
3 Taylor Fri
4 Appt for Skin
5 Letter to Women Museum Journal
6 Bio to Women Shrine Book
7 Start working on show
8 Fix door son office
9 Call Meldoy - Lunch
10 Get Announcments -
11 Mail Announcement
12 Make N Book Done
13 Mariam Birthday
15 Letter for Marlene
16 Letter to Resturats
17 Work on "Home" Journal
18 Call about stairs colleguen in
19 Get rain gutters
20 appt for Dog
21 Barloque DCS
22 airplane Res
23 dep $
Write food Letter Home Tour
Make Plane Res

45

JAMES PENNEY
TO-DO LISTS

JULY 1932 2 PP., EXCERPTED, HANDWRITTEN, ILL.

Painter James Penney (1910–1982) was born in Missouri and attended the University of Kansas before moving to New York City in 1931 and studying at the Art Students League of New York. In his July 1932 sketchbook, he made two lists: one of things to "concentrate on"—a mural, exhibitions, and portraits—and the other of survival tips, including "spend what you have on material" and "don't go back to Kansas." Captivated by building projects in the city, Penney sketched the steel joints, lifting hooks, and pulleys in the construction of Radio City Music Hall on the page opposite the lists. Penney remained in New York, won numerous mural commissions, was appointed a vice president of the Art Students League, and, in 1954, became a professor of art at Hamilton College in Clinton, New York, where he worked until his retirement in 1976.

FOR TRANSCRIPTION,
TURN TO PAGE 192

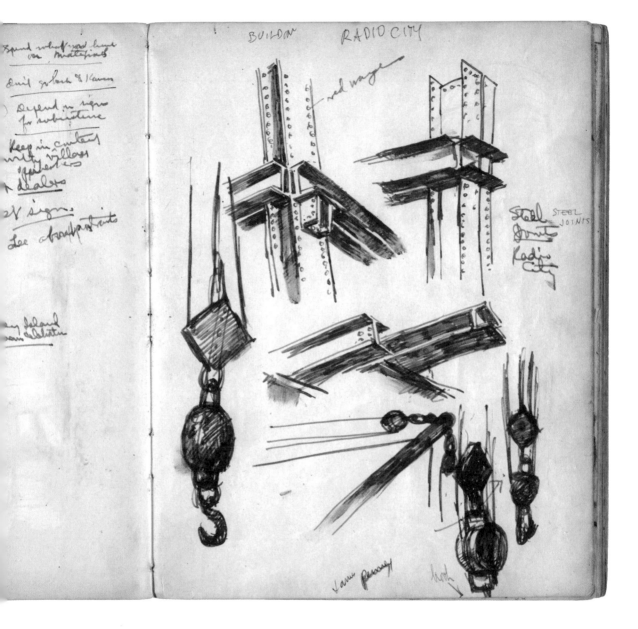

I was born in 1901 in the Chelsea section of Manhattan [that] was known as the Tenderloin district of conglomerate humanity and gaudy, glittery, noisy fame. I believe this was a fitting birthplace for a painter interested in people.

—PHILIP EVERGOOD

Biographical Details

46 HARRY BERTOIA
"MAY-SELF RATING CHART"
SCHOOL ASSIGNMENT
1932 1 P., EXCERPTED, HANDWRITTEN

Sculptor and designer Harry Bertoia (1915–1978) was just fifteen years old when he moved from Italy to the United States to live with his brother, Oreste. Two years later, struggling to assimilate as a student at the Elizabeth Cleveland Intermediate High School in Detroit, he made this list of personal attributes as part of an illustrated booklet titled My Career. *Though Bertoia is hard on himself—only scoring "excellent" in health, neatness, and accuracy—in* My Career *he states his aim to be an artist. His teacher, Gladys M. Little, was so impressed with his vocational analysis that she saved* My Career *and donated it four decades later to the Archives of American Art. After high school Bertoia attended the Cranbrook Academy of Art, where, along with neatness and accuracy, he developed a fluid sense of sculptural form that made him a leading designer of modern furniture.*

My-self Rating Chart

	VERY POOR	POOR	FAIR	GOOD	EXCELLENT
1. General appearance				X	
2. Health					X
3. Quickness of thought			X		
4. Skill in using hands			X		
5. Self control				X	
6. Industry				X	
7. Initiative			X		
8. Neatness					X
9. Accuracy					X
10. Courtesy				X	
11. Dependability			X		
12. Honesty				X	
13. Ability to work with others			X		
14. Adaptability				X	
15. Leadership			X		
16. Memory				X	
17. Common Sense				X	
18. Courage			X		
19. Loyalty				X	
20. Perseverance			X		
21. Self Confidence			X		

47 LOUIS MICHEL EILSHEMIUS
CALLING CARD
UNDATED 2 PP., 1 ITEM, PRINTED

In a calling card, Louis Michel Eilshemius (1864–1941) summarized an outlandish list of his achievements with unequivocal confidence: "All the supreme Genius Minds down the ages find Domain in Eilshemius." As early as 1910, in aggressive attempts to establish his importance, Eilshemius distributed self-promoting propaganda, such as this list, and threw vitriolic tantrums in New York galleries.

Beyond the wiles of his printed material and public outbursts, Eilshemius was a reclusive painter fraught with frustration and paranoia. His social standing slowly ascended when Marcel Duchamp (1887–1968) took an interest in his works that were included in the Society of Independent Artists exhibition of 1917, in New York City. Eilshemius was welcomed into the lofty Société Anonyme, founded in 1920 by Duchamp and artist and patron Katherine S. Dreier to promote avant-garde art in the United States. In 1921 the Société Anonyme celebrated the artist's eccentricities by organizing the first of seventeen one-person Eilshemius shows.

A few Inventions and Discoveries

1. How to paint wonderful frames around his paintings in gold, mahogany, any material (1911)

2. Discovered his Magic Ink. Brown and Indelible (1919)

3. A Game: "Sixers" (fine to play on trains like pinochle)

4. A Cure for Diseases (1917)

5. A new way to Mesmerise (1915)

6. A quick new way to paint portraits and interiors.

7. How to make moon and stars glow, also real water and waves to dash, etc. (Printed Nov. 1930)

8. Paints in 50 technics.

He Lives at 118 East 57th Street, N. Y. C.

AN UNUSUAL INVENTOR IS
LOUIS MICHEL EILSHEMIUS, M.A.

Educator, Ex-Actor, Amateur All Round Doctor, Mesmerist-Prophet and Mystic, Reader of Hands and Faces, Linguist of 5 Languages, Graphologist, Dramatist (7 Works), Short Story Writer and Novelettes (26 Works), Humorist Galore, Ex-Mimic, animal voices and humans, Ex All Round Athletic Sportsman (to 1889), Universal Supreme Critic. Ex Don Giovanni, Designer of Jewelry etc., Spiritist, Spirit-Painter Supreme, Best Marksman to 1881, Ex Chess and Billiard Player to 1909, Scientist supreme: all ologies, Ex Fancy amateur Dancer, The most rapid master creator in the 3 Arts, Most wonderful and diverse painter of nude groups in the world. Travelling salesman—in 30 cities on 30 nights, Philanthropist, Saved 20 lives—3 from suicide, Greatest Religionist, Globe Trotter, Half the Globe, Western.

His middle name is "Variety". All the supreme Genius Minds down the ages find Domain in

EILSHEMIUS

Born 1864 near Newark, N. J.

48 H. L. MENCKEN TO CHARLES GREEN SHAW
LETTER
DECEMBER 2, 1927 5 PP., TYPESCRIPT

*Charles Green Shaw (1892–
1974) hobnobbed with New York
celebrities throughout the Roaring
Twenties. He often contributed
light-hearted essays on the city's
social scene to magazines like
the* New Yorker. *Using his
connections, he wrote* The Low
Down *(1928), a book of celebrity
portraits. Journalist H. L.
Mencken (1880–1956) sent Shaw
this amusing list of twenty-nine
personal facts for the book. They
were published nearly verbatim.
An acerbic critic of American
life and long-time writer for the*
Baltimore Sun, *Mencken's lively
list lays bare his opinionated
prose style.*

FOR TRANSCRIPTION OF
THE COMPLETE LETTER,
TURN TO PAGE 192

H.L.MENCKEN
1524 HOLLINS ST.
BALTIMORE.

1927

December 2nd

Dear Charles:-

A few notes:

1. I bought some brown shoes six or eight years ago, and have worn them off and on ever since. I have also taken to brown oxfords.

2. I have now seen about twelve movies, four or five of them to the end. I liked them all pretty well, but am not tempted to go back.

3. My favorite drinks, in order, are: beer in any form, Moselle, Burgundy, Chianti, gin and ginger-beer, and rye whiskey. I use Swedish punch only as a cocktail flavor. I dislike Scotch, and seldom drink it. It makes me vaguely uneasy. I also dislike Rhine wine, save the very best. I never have a head-ache from drink. It fetches me by giving me pains in the legs. When I get stewed I go to sleep, even in the presence of women and clergymen.

4. Curiously enough, I greatly dislike the common American dirty stories, and avoid the men who tell them habitually. They seem dull to me. I love the obscene, but it must have wit in it.

5. As for politics, I always go to national conventions, and have missed very few in 28 years.

6. Of my inventions I am vainest of Bible Belt, booboisie, smuthound and Boobus americanus.

49 HENRY OSSAWA TANNER
NOTES ON HIS CHILDHOOD
UNDATED 4 PP. (1 FOLIO), HANDWRITTEN, ILL.

Deeply frustrated by racism in America, painter Henry Ossawa Tanner (1859–1937), who was of English, African, and American Indian descent, moved to Paris in 1891 and remained there for the rest of his life. As an expatriate he not only found a receptive social climate in France but also won critical acclaim for his poignant paintings of biblical themes.

Among Tanner's autobiographical notes on his childhood is a list of his earliest recollections. He begins with a story about his mother being removed from a streetcar because of the color of her skin. She was traveling between Washington, D.C., and Alexandria, Virginia, in the midst of a snowstorm, with the infant Tanner in her arms. His mother's account filled Tanner with rage. He wrote, "I never knew the story till I was a man grown . . . I left the house immediately and it took several hours walking among the trees and under the night skies to cool the heat and hatred . . . that stayed in my bosom." Tanner's list of autobiographical fragments, written over a page of his figure studies, literally entwines his story with his art.

FOR TRANSCRIPTION,
TURN TO PAGE 193

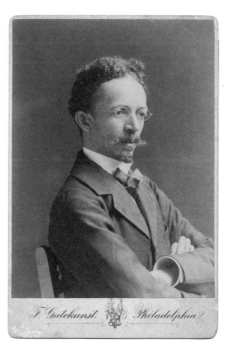

F. Gutekunst Philadelphia

To Alexandria
Mother put off—

(1) Changes & troubles came me or mine [illegible].

An infant in arms found my parents living in Alexandria. & by some unhappy chance, found my mother in Washington with me a baby in arms night came suddenly down & with it came storms. She would rush to take the street car so soon went her veil & up went the [illegible] the very thing that she had hoped might save her was her undoing.

I never knew this story till I was a man grown. He was living in Philadelphia [illegible] Cars Park (2) [illegible] & left the same immediately & it took several hours walking in among the trees tender the night skies to cool [illegible] within his capital. & rod at that [illegible] in my bosom. for years it seemed to me that that hell preached at that time so much [illegible] with live brimstone was the [illegible] by such hints [illegible] we moved away from Washington & I have no memory [illegible] coming back to tell me [illegible] [illegible] of mother being the wrong thing that some [illegible] [illegible] with my sister & about three [illegible]
[illegible] afterdays. One day we took a train going somewhere we crowded, my mother had [illegible] instead when a good [illegible] middle age man of [illegible] race that had formerly enjoyed [illegible] let some mother been soon [illegible] gave my mother a seat. My mother said it was not a very rare thing, but always thanked God she had seen it.

(3) Try at with all the [illegible] that I had bottled up within me
with [illegible]
I could never say the word eternally damnation.

(2) when I first heard this story from my mother [illegible]
in Frederick Md.

remembrance of the war — we were in [illegible]
[illegible] nailed up and [illegible] cautious
done at night Rebel soldiers [illegible] all day [illegible] terror through
one stopped & banged at the door & sent a [illegible] on
the house finally a officer came [illegible] in the North of France was nailed up
a [illegible] in of our little house in color [illegible] before the shutter
an american flag drawn in color [illegible] [illegible]
four valuables [illegible] in the garden [illegible] & soldiers could be seen
(5) so from our attic windows the rebel camp [illegible] at the [illegible] station
[illegible] my father [illegible] in some cause was at the [illegible] "Hello" Sent to
& by his clothes [illegible] recognized as a [illegible] "take this" [illegible] he had
what pace [illegible] being with, here daddle on [illegible] said he was [illegible] the
out of the [illegible] "Believe" my father [illegible]
we early heard the story of Harpers Protestant

Our list of European stuff stupefies everybody. I am simply in heaven with delight at the coming certain success. This show will be the greatest modern show ever given anywhere on earth, as far as regards high standard of merit.

—WALT KUHN

<u>Exhibition</u>

50 JOSEPH KOSUTH TO LEO CASTELLI LETTER

CA. 1971 1 P., ANNOTATED TYPESCRIPT WITH NAIL ATTACHED

For conceptual artist Joseph Kosuth (b. 1945), art is about the production of meaning. To prepare art dealer Leo Castelli (1907–1999) for his exhibition, Kosuth sent Castelli a list of "a few basic things" that he needed to know about his art. The show presented blown-up photostats of dictionary definitions for single words, such as radical *and* idea, *each with the same title,* Titled (Art as Idea as Idea). *What was of the first and foremost importance for Kosuth was not the photostat on the wall of the gallery but the signed and dated, smaller original document (not exhibited) from which the larger version was made. The original served as a kind of "deed" for the copy—the latter which could be "destroyed and re-made" at will. Kosuth taped to the letter the simple L-shaped nail he preferred for the installation. With his* Titled (Art as Idea as Idea) *series, Kosuth sought to demonstrate that the* idea *was the art, not the object. Without a doubt, Castelli understood the complexity of Kosuth's work, as this list marked the beginning of a long relationship between the two men.*

LEO:

SINCE I'M NOT COMPLETELY CLEAR AS TO HOW FAMILIAR YOU ARE WITH
THIS WORK, YOU SHOULD KNOW A FEW BASIC THINGS.

1. THEY ARE NOT PAINTINGS. IN FACT, WHEN I BEGAN THIS WORK AN
ASPECT OF IT WAS ANTI-PAINTING. THEY ARE BLOW-UP PHOTOSTATS,
AND CAN BE DESTROYED AND RE-MADE. (YET THEY ARE ORIGINAL WORKS).

2. THE 'ORIGINAL' DOCUMENT, WHICH IS SIGNED AND DATED AND IS
GENERALLY RATHER SMALL (APROX. 6" X 5") IS WHAT IS IMPORTANT.
IT IS FROM THIS "PASTE-UP DOCUMENTATION" THAT THE PHOTOGRAPHER
MAKES THE BLOW-UP. WITHOUT THIS THE COLLECTOR HAS NOTHING.
IT IS LIKE THE DEED TO THE WORK.

3. EACH WORK HAS THE SAME TITLE: "TITLED (ART AS IDEA AS IDEA)"
FOR YOUR PURPOSES (RECORDS, ETC.) IT WILL PROBABLY BE NECESSARY
TO DIFFERENTIATE THEM FURTHER.

4. SINCE I STOPPED THIS WORK IN 1968 WHEN I BEGAN OTHER WORK, THE
AMOUNT OF IT I HAVE IS LIMITED, OF COURSE. THE PRICES ARE A
REFLECTION OF THIS. PERHAPS IT WOULD BE GOOD IF WE DISCUSSED
THIS ASPECT OF IT SOMETIME. THIS WORK IS RATHER EASY FOR ME
TO SELL.

AT SOME POINT, LEO, I WOULD LIKE TO DISCUSS WITH YOU THE THINKING
BEHIND MY WORK (AND THE GENERAL AREA). AS I'M SURE YOU REALIZE
IT IS MUCH, MUCH, MORE COMPLEX THAN IT APPEARS.

REGARDS,

JOSEPH KOSUTH

(INSTALLATION: FOR THE
PHOTOSTAT TO BE HELD TO THE
WALL I RECOMMEND A NAIL
SUCH AS THIS ONE.)

51

CHARLES M. KURTZ
LIST OF WORKS OF ART FOR THE U.S. GALLERIES OF THE WORLD'S COLUMBIAN EXPOSITION
CHICAGO, 1893 1 P., EXCERPTED, HANDWRITTEN

The 1893 World's Columbian Exposition in Chicago brought together the largest selection of American art ever before assembled in the United States. Halsey C. Ives was the chief of the Fine Arts Department for the Exposition. His assistant, Charles M. Kurtz (1855–1909), was not only involved in appointing the juries and influencing their selection, but he also had the daunting task of installing the American galleries—more than one thousand works of art.

Kurtz pondered his options until the very day the pavilion opened to the press, on May 1, and even then did not finish the installation (it was not completed until the Exposition fully opened to the public in late May). During the planning stage, he made multiple lists of possible arrangements. This list is an early draft of galleries three through seven, featuring a broad sampling of American painters from Colonial portraitist John Singleton Copley to Impressionist painter John Henry Twachtman.

The exhibition was a great success; some critics claimed that the American galleries excelled over the French.

FOR TRANSCRIPTION,
TURN TO PAGE 194

United States

	Red	
Gallery 3	577	Sargent. Ellen Terry —
	532	Hitchcock - Tulips
	573	Melchers - Sermon

Gallery 5	353	Vonnoh - November
	300	Dannat - Spanish Girls -
	307	Mac Monnies - June Morning
	285	Robt. Reid - Port. of Little Miss S.
	276	Twachtman - Brook in Winter

Gallery 4	254.	Jouett - Portrait of John Grimes.
	212	Smybert - Bp. Berkley -
	214	Stuart - Washington.
	218	Bingham - Election.
	220	Bingham - Election Returns -
	209	Bingham - Stump Speech
	206	Bingham - Jolly Flatboatman.
	198	W. S. Mount. The Long Story.
	234	Alloton - Paul & Silas.
	243	Cole - Roman Aqueduct
	249	Copley - Port. of Madame Boylston

H. P. Gray - Judgment of Paris.
(Haverton) Bringing Home the Bride
Dielman - A N.Y. Arab

Gallery 7	502	M'Ewen - Sorceress
	476	Orrin Peck - The Letter

Gallery 6	410	E. L. Weeks - The Gauges.

	100	B. R. Suz - Reflections.
	983	Johnson - Nantucket School of Philosophy -
	911	Tryon - Day Break, New Bed's

British

Roll Call - Lady
Butler.

52 MARVIN LIPOFSKY
PRICE LIST FOR THE STATE UNIVERSITY OF NEW YORK AT BINGHAMTON
OCTOBER 15, 1971 1 P., HANDWRITTEN, ILL.

In 1964 Marvin Lipofsky (b. 1938) received an MFA degree in studio glass from the University of Wisconsin-Madison, the first such degree awarded in the United States. By the 1970s he was an established and influential artist and teacher at the University of California, Berkeley, and the California College of Arts and Crafts in Oakland. When asked to participate in the Master Craftsmen exhibition at the State University of New York at Binghamton, he sent the university museum a price list with illustrations of his signature, curvilinear glass pieces.

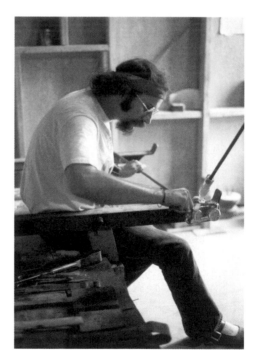

MARVIN B. LIPOFSKY
1012 PARDEE
BERKELEY CALIF 94710
(TEL 8437593)

10·15·71
STATE UNIV. OF NEW YORK AT BINGHAMTON

"MARVIN'S MINIATURES SERIES"...
(AND SOFT LOOPS)

1 $175⁰⁰

2 $150⁰⁰

3 $125⁰⁰

4 $150⁰⁰

5 $150⁰⁰

6 $175⁰⁰
 (SOFT LOOP)

7 $175⁰⁰
 (SOFT LOOP)

8
 $1,100⁰⁰
 INSURANCE

END ALL WAR

53 BETTY PARSONS GALLERY, NEW YORK CHECKLIST FOR THE EXHIBITION PAINTINGS BY BOB RAUSCHENBERG MAY 14, 1951 1 P., ANNOTATED TYPESCRIPT

Painter, sculptor, and graphic artist Robert Rauschenberg (1925–2008) helped define American art in the 1950s and '60s, first with his "combines"— found objects and paint in sculptural collages—and then with his silkscreen paintings that incorporated found objects and found images. This typewritten, annotated list of artworks is for Rauschenberg's first one-person show that took place from May 14 to June 2, 1951 at the Betty Parsons Gallery in New York City. He was twenty-five years old and virtually unknown; the exhibition was his first big break in the New York art world. The note "x = In gallery" presumably indicates the paintings that remained in the gallery after the show closed. The note "photo Siskind" specifies the paintings that photographer Aaron Siskind shot for the gallery.

Betty Parsons Gallery

May 14th, 1951

BOB RUASCHENBERG

Catalogue:

X "No 7 - 1951" 380

"22 The Lily White" —— 200 X

"No. 1 - 1951" —— 150 †

"Mother of God" —— 450 †

X "Crucifixion and Reflection" 500 †

"The Man with Two Souls" — 400 †

"Tides" —— 400 †

X "Pharaoh" —— 600 †

"No. 2 - 1951" —— 150 †

"Eden" —— 450 † photo Siskind

"No. 3 - 1951" —— 400 †

X "No. 4 - 1951" —— 250 †

"No. 5 - 1951" —— 450 †

"Trinity" —— 500 † photo Siskind

X No 6 - 1951 250

Stone, Stone, Stone, photo Siskind
should have come 1st " "

X = in gallery —

54 AD REINHARDT
LIST OF PAINTINGS
CA. 1966 1 P., HANDWRITTEN, ILL.

Painter and theorist Ad Reinhardt (1913–1967) was known for his radical, achromatic black paintings. From the mid-1950s until his death, he painted almost exclusively with black. From a distance these canvases appear to be solid black, but up close or in raking light, one can discern geometric shapes in subtle shades of black. Reinhardt made this graphic list of black paintings for a major retrospective of his work at The Jewish Museum in New York City in 1966. In his thumbnail sketches, Reinhardt reveals their underlying geometry and provides supplementary information, including date, title, and dimension.

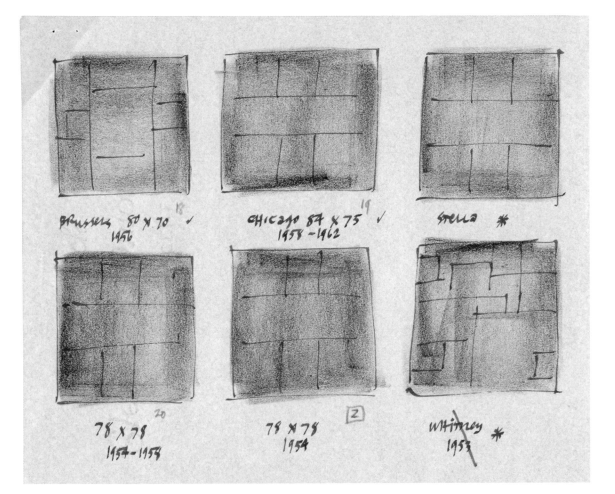

55 JUTA SAVAGE TO DOROTHY WEISS LETTER

OCTOBER 6, 1984 1 P., HANDWRITTEN, ILL.

The Dorothy Weiss Gallery,
founded by Dorothy Weiss
(b. 1921) in San Francisco and
active from 1984 to 2000,
specialized in contemporary
clay and glass. Although Weiss
favored nonfunctional pieces,
every year she held a Teapot
Invitational exhibition. In this
letter to Weiss, Juta Savage
(b. 1940) makes an illustrated list
of her teapots, showing variations
of her standard forms. Weiss
marks a few with an x in pencil,
for possible reproduction on the
announcement card for the first
Teapot Invitational that opened
on November 29, 1984.

IV Bert

Attached are my tea pot drawings. Since I couldn't make up my mind, decided to send you all of them. Please tell the person who does the announcements, that when she chooses one, to choose one of the ones marked by a small X (in pencil). It was too much a hassle to cut them apart.

Just

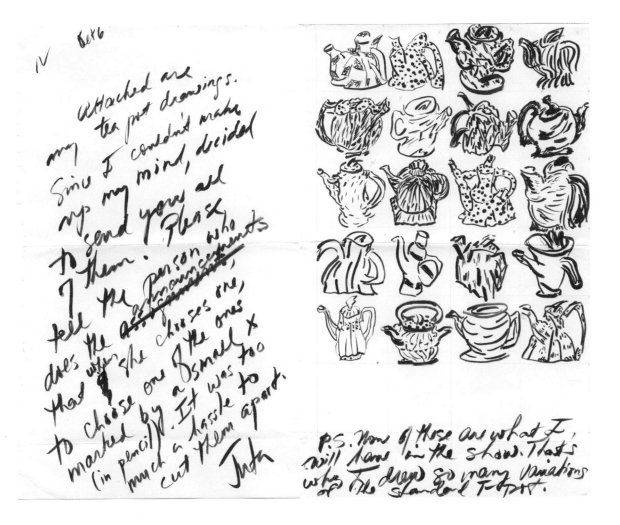

P.S. None of these are what I will have in the show. That's why I drew so many variations of the standard T-pot.

56 EVERETT SHINN LIST OF PAINTINGS FOR THE EIGHT EXHIBITION
1908 1 P., EXCERPTED, HANDWRITTEN

The Eight exhibition organized by painter Robert Henri in 1908 at Macbeth Gallery in New York City was a watershed event in the history of American art. Named for the eight artists who participated—Everett Shinn (1876–1953), John Sloan, William Glackens, Robert Henri, George Luks, Ernest Lawson, Maurice Prendergast, and Arthur B. Davies—the exhibition called attention to a new American realism focusing on urban street life.

In his account book, Everett Shinn made a list of eight paintings that he lent to The Eight. He sold one painting, Girl in Blue (1908), from the show to Gertrude Vanderbilt Whitney, sculptor and founder of the Whitney Museum of American Art.

FOR TRANSCRIPTION,
TURN TO PAGE 195

1908.

National Arts Club.

(send Dec. 30) (oil)

1. Spanish Dance. Music Hall. 300.
2. Out-door stage. France. 250.

Exhibition of the Eight.
Macbeth — Feb. 3 to 18.

1. Gaîté MontParnasse. 300
2. Rehearsal of the Ballet. 400.
3. White Ballet. 400.
4. Leeder of the Orchestre. 400.
5. The Gingerbread Man. 400
6. ~~Orchestre pit~~ (Japanese Artist) 400
7. Girl in Blue. 300. sold. Mrs. Harry Payne Whitney.
8. Hippodrome. London. 500.

Exhibition of the Eight.
Phila. Penn'a Academy.
 March 7 to 28.

1. Gaîté mont parnasde. 300.
2. Rehearsal of the Ballet. 400

57

N. C. WYETH
"LIST OF TITLES FOR ANDREW WYETH'S WATERCOLORS"
OCTOBER 6, 1937 3 PP., HANDWRITTEN

*Andrew Wyeth (1917–2009),
one of the most popular painters
in the United States, had his
first one-person show at the
Macbeth Gallery in New York
City in October 1937, when
he was only twenty years old.
Wyeth studied painting with a
demanding taskmaster: his father,
the illustrator and painter N. C.
Wyeth (1882–1945). The elder
Wyeth made this list of his son's
watercolors for art dealer Robert
Macbeth (1884–1940), proprietor
of the gallery. Twenty-two of
these works were selected for the
exhibition and all twenty-two
sold. The paintings that were not
selected for exhibition were held
as stock in reserve.*

FOR TRANSCRIPTION,
TURN TO PAGE 195

List of titles for
andrew wyeth's water colors.

(Ⓐ)

Large papers.

mrs Pegram - Coast farm

1	The Lobster Trap	Mrs C V Whitney
2	The Lobster-man	Sold Miss Emmett
3	The Gray House in Martinsville	Ret
4	The Bobsled	Balto. WC. Ex
5	Patching the Roof	Mrs Geo Barstow Jr.
6	Surf – An impression	Sold Homes y
7	Fisherman's Houses	Ret
8	The Bay	
9	The Gam	Stock
10	Early Morning	B Wilkin
11	Sunrise	Stock
12	In Port Clyde	Ret
13	Silver Sunrise	G. M. Weed
14	Maine Fisherman	Balto WC Ex

Small papers.

15	Church of the Fishermen	E R Brumley
16	Fisherman's Son	Ret
17	Impression	Ret
18	Caldwell's Island	Mrs Robt F Welch
19	The Lobster Car	Stock
20	After the Shower	Robt Brockman

Nature *with her own color combinations causes our soul to vibrate and furnishes themes.*

—OSCAR BLUEMNER

Inspiration

58 JONATHAN BOROFSKY TO LUCY R. LIPPARD LETTER

AUGUST 14, 1974 2 PP. (1 FOLIO), HANDWRITTEN

In the late 1960s, Jonathan Borofsky (b. 1942) began counting as part of his artistic practice. He wrote sequences of numbers on graph paper, along the margins of his notebooks, and in correspondence. By August 14, 1974, when he wrote this letter to Lucy R. Lippard (b. 1937), he was up to 2,166,003 and counting, but he also mentions a relatively new interest, "psychological paintings on canvass [sic] board." These works, as he notes, had "taken on a greater importance," so much so that he began to title them—I'm afraid of death, I dreamed I could fly, Sabby makes me angry when he barks, *etc. With this list, Borofsky takes a break from purely counting to enumerating titles.*

FOR TRANSCRIPTION OF THE COMPLETE LETTER, TURN TO PAGE 196

Aug. 14, 74

Dear Lucy,

Im still counting (2,166,003 as of this morning) and making those personal "feeling" or "psychological" paintings on canvass board. The paintings have taken on a greater importance for me recently. Some of the latest ones are titled —

1. I'm afraid of death
2. I dreamed I could fly
3. Sabby makes me angry when he barks
4. I'm afraid to sleep alone in the house
5. I'm afraid Benita didn't get home safely.
6. I dreamed my sailboat was spotlighted on a stage.
7. Paul inflicts his need to be perfect on others
8. I feel like crying.

As you can see, the subject matter has become more immediate and "everyday" rather than deal with the past ("Mom I lost the elections") I've also had one full dream that I've been able to paint.

So things have been going very well here in Southampton. You have a standing invitation to come out here for some ocean when you wish. Bring Charles and Ethan for

59 GEORGE CATLIN "AMUSEMENTS"

CA. 1830 1 P., EXCERPTED, HANDWRITTEN

In 1828 painter George Catlin (1796–1872) began recording American Indian culture through portraits and scenes from daily life, including buffalo hunts, foot races, and powwows. To bankroll his life's work, he traveled with his own exhibition, advertised as Catlin's Indian Gallery, to many American cities as well as to London and Paris. Never financially successful, Catlin was eventually rescued from debt by Joseph Harrison, Jr., a wealthy American industrialist, who purchased the paintings, papers, and related artifacts in 1852. The artwork and ephemera were left neglected in a warehouse, until Harrison's widow donated the entire collection from her husband's estate to the Smithsonian Institution.

While Catlin was not the first artist to paint American Indians, he was the first to portray them as culturally complex human beings rather than as savages. Although referred to as "amusements" by Catlin, the list included sacred rituals, such as the Sioux Scalp Dance, which was part of an elaborate ceremony commemorating dead warriors and the spoils of war. This list attests to Catlin's genuine interest in cataloging the customs of American Indians, then considered to be a vanishing race.

FOR TRANSCRIPTION,
TURN TO PAGE 196

amusements

Ball play dance
Ball play — Ball up
Ball play — Ball down
Ball play of the women
Game of "Tchung=Kee"
horse Race
Foot Race
Canoe race
Archery . mandans .
Dance of the Chiefs . Sioux —
Dog Dance, Sioux —
Scalp Dance , Sioux .
Begging Dance . Sacs & Foxes.
Buffalo Dance . mandans
Ball play Dance . Choctaw
Dance to the Berdash . Sac.
Beggars Dance — Sioux
Dance to the Med. Bag of the Brave . Sac.

60 ARTHUR DOVE
LIST OF WEATHER ABBREVIATIONS
1924 1 P., EXCERPTED, HANDWRITTEN

Between 1922 and 1929, Arthur Dove (1880–1946) and fellow artist Helen "Reds" Torr (1886–1967) lived on a forty-two-foot sailboat, the Mona. *Life on the water was not only economical, it also offered a close connection to nature, which became a wellspring of inspiration. On the* Mona, *Dove developed his own idiosyncratic style of formal abstraction based on his ideas about pure forms in nature and characterized by experimentation with color, composition, and materials. In a small notebook, he meticulously kept notes on the weather while he and Torr sailed the Long Island Sound. The interior cover of the journal includes a list of frequently used abbreviations, such as* c *for cloudy and* f *for fog. His abstract paintings during these years, with titles such as* Sunrise *and* After the Storm, *were inspired by the conditions they sailed through. In 1932, Dove married his shipmate.*

FOR TRANSCRIPTION,
TURN TO PAGE 196

a. Blue sky. clear or hazy
c. Cloudy. detached clouds
d. Drizzly rain
f. fog
g. gloomy - dark
h. hail
l. lightning
m. Misty coast, watery haze
o overcast unbroken clouds
p. passing showers
q. squally
r. rain - continued
s. snow
t. thunder

Log of Mona.
May 4 Sunday.
At Wharf. Caught 5 tanks
7.30 A.M. Wind. SE
Refs. B. 5 gal. Gas 3 gal Oil. —
 May 5.
Homeward. Pict. Rev. Bros.
Smooth. SE. 2. B. 7.30 A.M.
 f. Low.
 May 6
Pict. Rev. Tested R.P.M.
350. poor. Gasket? valve
arms.? SE 1 Smooth B.
11:30. f even.
 May 7.
6. A.M. SE 1 Rps. R.J.L.
 May 7 9 10 11 12
Rain SE. 4 - 9

61 REGINALD MARSH TO LAWRENCE A. FLEISCHMAN LETTER

JUNE 10, 1953 1 P., HANDWRITTEN

*One of the founders of the
Archives of American Art,
collector Lawrence A. Fleischman
(1925–1997), was keen to
document his art collection with
the respective artist's written
commentary. In 1953 he asked
painter Reginald Marsh (1898–
1954) to respond to a series of
questions about his painting* Eyes
Tested *(1944). The painting
presents a voluptuous woman
striding down Third Avenue
in New York City under an
optometrist's trade sign, while two
downtrodden men on the curb
fail to notice her; she, likewise,
is oblivious to them as she looks
in the opposite direction. Their
failure to see one another's social
circumstances suggests that they
may need their eyes examined.
This letter, in the form of a list, is
Marsh's reply.*

FOR TRANSCRIPTION,
TURN TO PAGE 197

REGINALD MARSH
ONE UNION SQUARE
NEW YORK CITY

June 10 - 53 -

Dear Mr. Fleischman:

In response to your letter requesting
The artists conception of "Eyes Tested" —

No 1. In 1944 — I was making a series of drawings
in monochrome, in Chinese Ink

No 2. The location painted is situated near my house —
I saw The "eyes tested" signs — almost daily.

No 3 = The doorways of 3rd Ave were often
used by drunks for resting places

No 4 — Although I am male and well married —
I like to think about young girls, and to
paint them —

No 5 — I am not senile . I am 55.

No 6 — The 3rd Ave El. station and tracks
eventually to be torn down — are good
to paint

No 7 . I like to play with light & shadow
effects —

No 8 . all these together would be good picture
materials

No 9 . after your version I tried again once
or twice — but didn't seem to do it well.

No 10 — The "eyes" blew away in the hurricane

Yours truly -

Reginald Marsh

62 ROBERT MORRIS TO SAMUEL J. WAGSTAFF
POSTCARD
FEBRUARY 13, 1967 1 ITEM, TYPESCRIPT

*Artist Robert Morris
(b. 1931) avoided making formal
statements about his work.
Instead, he raised provocative
questions about the essence of art.
In this postcard to curator and
collector Sam Wagstaff (1921–
1987), Morris lists alternate
terms for earthworks, a form of
art created in nature that uses
natural materials such as soil
and stones. With these invented
words and phrases, Morris
neither criticizes nor endorses
the movement, but plays with
the nebulous border separating
the untouched earth—"at her
fatuous flat chested best"—from
one that is manipulated by the
artist. Morris's list underscores
the role of language in artistic
representation.*

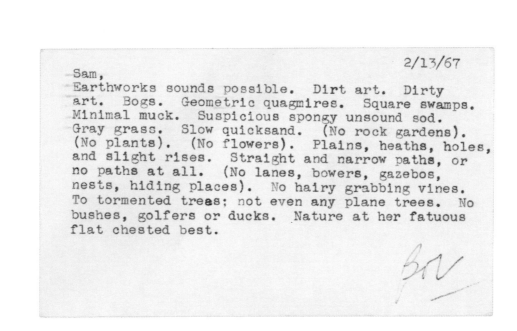

2/13/67

Sam,
Earthworks sounds possible. Dirt art. Dirty
art. Bogs. Geometric quagmires. Square swamps.
Minimal muck. Suspicious spongy unsound sod.
Gray grass. Slow quicksand. (No rock gardens).
(No plants). (No flowers). Plains, heaths, holes,
and slight rises. Straight and narrow paths, or
no paths at all. (No lanes, bowers, gazebos,
nests, hiding places). No hairy grabbing vines.
To tormented trees; not even any plane trees. No
bushes, golfers or ducks. Nature at her fatuous
flat chested best.

63 AD REINHARDT TO KATHERINE SCRIVENER
POSTCARDS
APRIL 16, 1951 3 ITEMS, HANDWRITTEN

Ad Reinhardt (1913–1967) thought long and hard about art and language. In this set of three postcards to an acquaintance, Katherine Scrivener, he provides a list of "more adequate words" and "undesirable words" for art, *as well as a list of "dualisms." Reinhardt, who was deeply interested in Eastern philosophy, favored words for* art *that were intellectually and emotionally expansive. Unlike the binary oppositions fundamental to Western thought, Reinhardt understood duality as a philosophy of balance, where two opposites coexist in harmony and are able to transmute into each other—the yin and yang of all things.*

DEAR MISS SCRIVENER: 3 CARDS — I WASN'T SURE WHAT YOU
ASKED ME FOR — (A LOT OF WORDS FOR WHAT THEY'RE WORTH)
1 - 'UNDESIRABLE' AND 'MORE ADEQUATE' WORDS FOR 'ART'
('FINE' & 'PURE' ART), 2 - VARIETY OF DUALISTIC WORDS (ENDLESS,
OF COURSE) — I HOPE YOU FIND THEM AS CURIOUS AS I HAVE —
GOOD LUCK, Ad Reinhardt

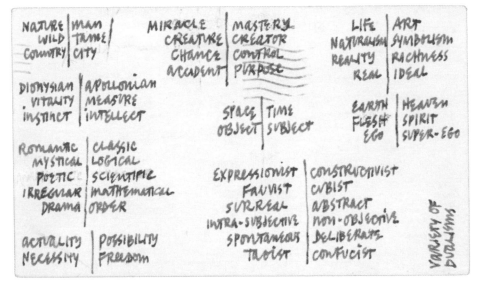

NATURE	MAN		MIRACLE	MASTERY		LIFE	ART
WILD	TAME		CREATURE	CREATOR		NATURALISM	SYMBOLISM
COUNTRY	CITY		CHANCE	CONTROL		REALITY	RICHNESS
			ACCIDENT	PURPOSE		REAL	IDEAL

DIONYSIAN	APOLLONIAN					EARTH	HEAVEN
VITALITY	MEASURE		SPACE	TIME		FLESH	SPIRIT
INSTINCT	INTELLECT		OBJECT	SUBJECT		EGO	SUPER-EGO

ROMANTIC	CLASSIC
MYSTICAL	LOGICAL
POETIC	SCIENTIFIC
IRREGULAR	MATHEMATICAL
DRAMA	ORDER

EXPRESSIONIST	CONSTRUCTIVIST
FAUVIST	CUBIST
SURREAL	ABSTRACT
INTRA-SUBJECTIVE	NON-OBJECTIVE
SPONTANEOUS	DELIBERATE
TAOIST	CONFUCIST

ACTUALITY	POSSIBILITY
NECESSITY	FREEDOM

VARIETY OF DUALISMS

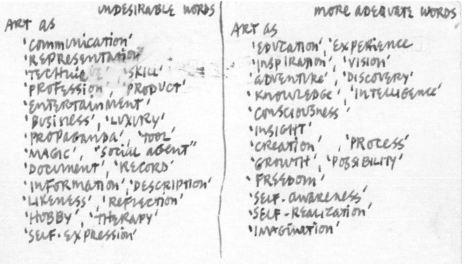

UNDESIRABLE WORDS	MORE ADEQUATE WORDS
ART as	ART as
'COMMUNICATION'	'EDUCATION', 'EXPERIENCE'
'REPRESENTATION'	'INSPIRATION', 'VISION'
'TECHNIQUE', 'SKILL'	'ADVENTURE', 'DISCOVERY'
'PROFESSION', 'PRODUCT'	'KNOWLEDGE', 'INTELLIGENCE'
'ENTERTAINMENT'	'CONSCIOUSNESS'
'BUSINESS', 'LUXURY'	'INSIGHT'
'PROPAGANDA', 'TOOL'	'CREATION', 'PROCESS'
'MAGIC', "SOCIAL AGENT"	'GROWTH', 'POSSIBILITY'
'DOCUMENT', 'RECORD'	'FREEDOM'
'INFORMATION', 'DESCRIPTION'	'SELF-AWARENESS'
'LIKENESS', 'REFLECTION'	'SELF-REALIZATION'
'HOBBY', 'THERAPY'	'IMAGINATION'
'SELF-EXPRESSION'	

64 EERO SAARINEN
LIST OF ALINE BERNSTEIN'S
GOOD QUALITIES
CA. 1954 1 P., HANDWRITTEN

Finnish-born architect Eero Saarinen (1910–1961), the designer of such structural icons as the TWA terminal at John F. Kennedy International Airport (1962) in New York and the Gateway Arch in St. Louis (1965), met his second wife, Aline (1914–1972), on January 28, 1953. Aline, then an art editor and critic at the New York Times, *was writing an article on Saarinen's new General Motors Technical Center (1955) in Warren, Michigan—a sleek corporate campus of steel, aluminum, and glass. They fell in love instantly. As Aline recalled, they stood before each other the day after their first meeting, "feeling strange and awed and breathless." In December 1953 Eero divorced sculptor Lily Swann Saarinen and married Aline on February 8, 1954. In this list, written around the time of their marriage, Saarinen enumerates Aline's positive traits.*

I – FIRST I RECOGNIZED THAT YOU WERE
VERY CLEVER

II – THAT YOU WERE VERY HANSOME

III – THAT YOU WERE PERCEPTIVE

IV – THAT YOU WERE ENTHUSIASIC.

V – THAT YOU WERE GENEROUS.

VI – THAT YOU WERE BEAUTIFUL

VII – THAT YOU WERE TERRIBLY WELL ORGANIZED

VIII – THAT YOU WERE FANTASTICALLY EFFICIENT

IX – THAT YOU ~~WILL~~ DRESS VERY VERY WELL

IIIA – THAT YOU HAVE A MARVELOUS SENSE
OF HUMOR

X THAT YOU HAVE A VERY VERY BEAUTIFUL
BODY.

XI THAT YOU ARE UNBELIEVABLY GENEROUS
TO ME.

XII THAT THE MORE ONE DIGS THE
FOUNDATIONS THE MORE AND MORE
ONE FINDS THE SOLIDEST OF
GRANIT FOR YOU AND I TO BUILD
A LIFE TOGETHER UPON ← I KNOW THIS IS NOT
A GOOD SENTENCE.

65 CHARLES GREEN SHAW
"THE BOHEMIAN DINNER" POEM
UNDATED 1 P., TYPESCRIPT

Charles Green Shaw (1892–1974) seemed to have lived a charmed life. Born into wealth, he reveled in the glamorous 1920s New York social scene. A satirical journalist, painter, defender of avant-garde art, children's book author, illustrator, playwright, and a master of the bon mot, *Shaw explored his passions through multiple means. His poems often consisted of short declarative phrases. A case in point is "The Bohemian Dinner," in which Shaw creates an abstraction of an experience in list form—from "The ride down town" to "The limping home" and then to "The bed."*

In the 1930s, Shaw threw himself into painting. The visual rhythms of New York City were the inspiration for his art.

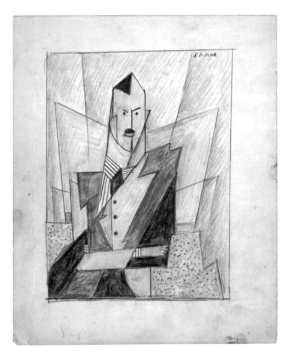

The Bohemian Dinner.
—————————

The ride down town.
The Washington Square district.
The "bohemian" restaurant.
The descending steps.
The narrow hall-way.
The semi darkness.
The checking the hat.
The head waiter.
The effusive greeting.
The corner table.
The candle light.
The brick walls.
The "artistic atmosphere".
The man who plays the piano.
The wailing sounds.
The boy fiddler.
The doleful discords.
The other diners.
The curious types.
The long hair.
The low collar.
The flowing tie.
The loose clothes.
The appearance of food.
The groan.
The messy waiter.
The thumb in the soup.
The grated cheese.
The twisted bread.
The veal paté.
The minced macaroni.
The cayena pepper.
The coughing fit.
The chemical wine.
The garlic salad.
The rum omelette.
The black coffee.
The benedictine.
The Russian cigarette.
The "boatman's song".
The mock applause.
The 'tempermental' selection.
The drowsy feeling.
The snooze.
The sudden awakening.
The appearance of the check.
The dropped jaw.
The emptied pockets
The last penny.
The bolt for the door.
The hat.
The street.
The lack of car fares
The long walk up town.
The limping home.
The Bed.

66 ROBERT SMITHSON
"A METAMORPHOSES OF THE SPIRAL"
CA. 1970 9 PP., EXCERPTED, HANDWRITTEN

In April 1970 Robert Smithson (1938–1973) completed his monumental earthwork Spiral Jetty *on the bed of the Great Salt Lake in Utah. In his sketchbook, he describes the dynamic, hallucinatory sensation of the site:*

Through the vaporous abstraction of Box Elder County, Utah, I beheld a wide expanse of lake, whose waters were so bloody a hue as to bring to my mind a geography of unspeakable carnage yet at the same time a voluptuous calm prevailed. A luminous languor coupled with a foreboding sense of menace produced a gyratory dimension. Innumerable spirals flashed from the lake assuming no distinct or definite existence, but instead whirled off into burning distances.

In the same sketchbook, under the heading "A Metamorphoses of the Spiral," Smithson made a list of twenty-one quotes about spirals, culled from such wide-ranging sources as Samuel Beckett's The Unnamable *(published in English in 1958, first published in French as* L'Innommable *in 1953) and Yevgeny Zamyatin's essay "On Synthetism" (1922). Considering that the quotes are interrupted with notes on a "movie treatment" and storyboard sketches of the jetty, it is likely that the quotations relate to the film about the making of* Spiral Jetty, *which was shown at the Dwan Gallery in New York City in 1970.*

FOR TRANSCRIPTION,
TURN TO PAGE 197

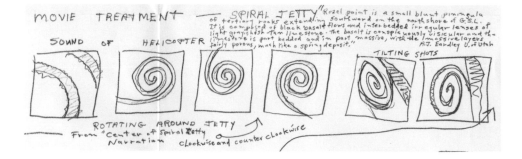

A Metamorphoses of the spiral [1]

1 "Large rectilinear trapezoidal spaces were also cleared, and there are furthermore a number of spirals and large figures of animals." (Nazca region). <u>The Ancient Civilizations of Peru</u>, J Alden Mason

2 "When a hurricane is fully formed its maelstrom of winds moves in a vast spiral around the center of the storm — hence "cyclone" (one of the popular names for a hurricane meaning 'coil of the snake'." <u>The Elements Rage</u>, Frank W. Lane

3 "However, later experimental evidence has not only beautifully confirmed the spiral growth of crystals, but has also been helpful in understanding the phenomenon of polytypism." <u>Polymorphism and Polytypism in Crystals</u>, Ajit Verma and P. Krishna

67 ABBOTT HANDERSON THAYER
NOTES ON CONCEALING COLORATION
IN NATURE
CA. 1915 2 PP., HANDWRITTEN, ILL.

Both an artist and a naturalist,
Abbott Handerson Thayer
(1849–1921) studied protective
coloration, or the natural
camouflage of wildlife. In his
sketches of butterfly wings, he
makes a graphic list, with each
butterfly identified by species.
Near the end of his life, Thayer
and his son, Gerald, published a
significant book on camouflage,
Concealing-coloration in the
animal kingdom; an exposition
of the laws of disguise through
color and pattern: being
a summary of Abbott H.
Thayer's discoveries. *First*
published in 1909 and reissued in
1918, the book served as a primer
for camouflage artists in the
military during World War I.

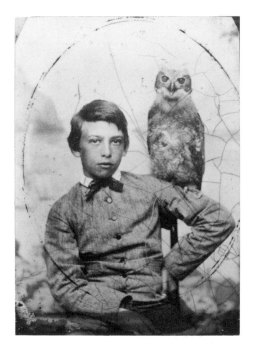

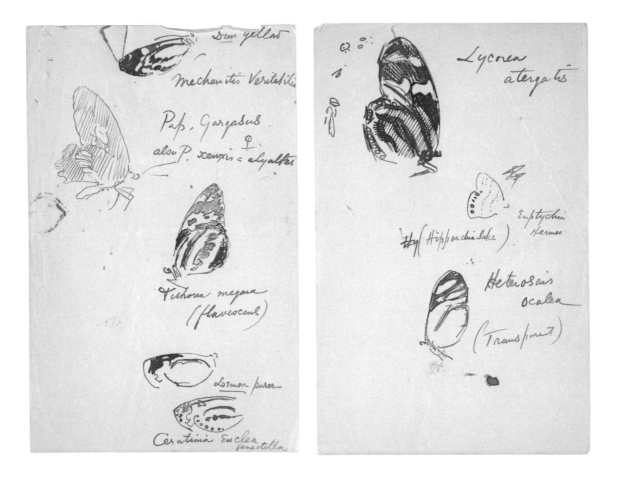

68 LEO VAN WITSEN
LIST OF COSTUMES
NOVEMBER 6, 1948

1 P., HANDWRITTEN WITH FABRIC SAMPLES ATTACHED

In 1948 Dutch costume designer Leo Van Witsen (b. 1912) sent this list of costume fabric ideas to Frederick Kiesler (1890–1965), the production manager and scenic director of the Juilliard School of Music. At the time, Kiesler was in great demand for his innovative, Surrealist-inspired sets. Van Witsen, who immigrated to the United States in 1938, was a successful designer for the New England Opera Theater. This list refers to Van Witsen's costumes for Kiesler's 1948 production of Le pauvre matelot *(The Poor Sailor), a melodramatic three-act opera composed by Darius Milhaud with a libretto by Jean Cocteau. Decades later, Van Witsen wrote an influential handbook for costume designers,* Costuming for Opera: Who Wears What and Why *(1981).*

FOR TRANSCRIPTION,
TURN TO PAGE 198

LEO VAN WITSEN .
157 Mountfort St
Brookline 46 Mass.

Brookline ___ '48

The wife's costume:

1 the Bodice
2. the lining of the white petticoat
3 the skirt. (green)
4. The apron (blue)
5. the 2nd petit coat (turquoise)
6. the veil.
(the yellow ribbon is not __ yet)

The father's costume

1 the pants
2 the coat
3 & 4 the shirt
5. the trimming of

The sailor.

1 the suit
2 the green one
3 the storm __ plastic material to be backed in black.)

The friend.

1 the pants
2 the shirt.

69 GRANT WOOD
LIST OF ECONOMIC DEPRESSIONS
NOVEMBER 1931

1 P., TYPESCRIPT, CARBON COPY ANNOTATED WITH THE DATE JANUARY 26, 1932

Born on a farm in Iowa, painter Grant Wood (1891–1942) experienced the economic instability of farming firsthand. In 1931, a year after he completed his iconic painting American Gothic *and in the throes of the Depression, he made a chronological list of thirteen prior economic depressions, beginning in 1819. In his portrait of the dour, weather-worn couple in* American Gothic, *Wood revealed both the ups and downs and the enduring optimism of American farmers. With this list he attempts to put the Depression in context as just another short-lived downturn to endure. He ends on a hopeful note that "all [depressions] came to an end except this one, mebbe [sic] this will..." Unfortunately, the economic slump would not begin to improve until 1939.*

1/26/3√

NEWS.. NOV. 1931 . MIDDLE ND.

............. CAME TO AN END.............

1.. THERE WAS A BUISNESS DEPRESSION IN 1819 LASTING 12 MONTHS.

2.. DO DO DO DO DO DO 1838 DO 20 DO

3.. DO DO DO DO DO DO 1848 DO 5 DO

4.. DO DO DO DO DO DO 1857 DO 12 DO

5 DO DO DO DO DO DO 1869 DO 8 DO

6 .. DO DO DO DO DO DO 1873 DO 30 DO

7 DO DO DO DO DO DO 1884 DO 22 DO

8.. DO DO DO DO DO DO 1887 DO 10 DO

9.. DO DO DO DO DO DO 1893 DO 25 DO

10 DO DO DO DO DO DO 1903 DO 20 DO

11.. DO DO DO DO DO DO 1907 DO 12 DO

12.. DO DO DO DO DO DO 1914 DO 8 DO

13... DO DO DO DO DO DO 1921 DO 14 DO

14.. DO DO DO DO DO DO 1931 & 32 ALL CAME

TO AN END EXCEPT THIS ONE.. MEBBE THIS WILL.

Selected Transcriptions and Translations

These verbatim transcriptions preserve the original spelling and punctuation of the original lists. The format of the lists, however, has been standardized according to the modified block style for greater clarity. All dimensions are height by width.

LIST AS ART

1 Vito Acconci
to Dorothy and Herbert Vogel, instructions, 1971
1 p., mimeographed typescript
9 x 22 cm
Dorothy and Herbert Vogel papers, 1960–90

.

2 Karl Knaths
color studies in his sketchbook, ca. 1923
2 pp., excerpted, colored pencil and ink
25 x 20 cm
Karl Knaths papers, 1890–1971

.

3 Adolf Konrad
packing list in his sketchbook, 1962–63
2 pp. (1 folio), excerpted, watercolor and ink
14 x 21.5 cm
Adolf Ferdinand Konrad papers, 1962–2002

.

4 Benson Bond Moore
studies of ducks, undated
1 p., pencil on paper
21 x 28 cm
Benson Bond Moore papers, 1895–1995

.

5 Joan Snyder
response to "What is Feminist Art?" 1976
2 pp., handwritten
28 x 22 cm
Woman's Building Records, 1970–92

BY JOAN SNYDER　　①
FEMALE SENSIBILITY IS LAYERS, WORDS, MEMBRANES,
COTTON, CLOTH, ROPE, REPETITION, BODIES, WET,

OPENING, CLOSING REPETITION, LISTS, LIFESTORIES, GRIDS, DESTROYING GRIDS, HOUSES, INTIMACY, DOORWAYS, BREASTS, VAGINAS, FLOW, STRONG, BUILDING, PUTTING TOGETHER MANY DISPARAGING ELEMENTS, REPETITION, RED, PINK, BLACK, EARTH FEEL COLORS, THE SUN, THE MOON, ROOTS SKINS, WALLS, YELLOW, FLOWERS, STREAMS, PUZZLES, QUESTIONS, STUFFING, SEWING, FLUFFING, SATIN, HEARTS, TEARING, TEARING, TEARING, TYING, DECORATING, BAKING, FEEDING, HOLDING, LISTENING, SEEING THRU THE LAYERS, OIL, VARNISH, SHELLAC, JELL, PASTE, GLUE, SEEDS, THREAD, MORE, NOT LESS, REPETITION, WOMEN CRITICS, WOMEN, WRITERS, WOMEN ARTISTS, EITHER NOURISHING US OR EATING US UP ALIVE, TOKENISM, CURATORS, UNIVERSITIES, TOKENISM, FEAR OF OTHER WOMEN TO AKNOWLEDGE FEMALE SENSIBILITY, HOSTILE BOY ARTISTS, ACCEPTING MEN ARTISTS, SEPARATING THE MEN FROM THE BOYS, DIVIDING WOMEN, PIECE OF PIE-ISM, MONEY, ART, SEX, BREASTS, LAYERS, SYMPHONIES, MULT-IROLED, MULTI-PART, STORIES, NARRATIVE, PAINT/FLESH, SERIOUS, OVERWHELMING, SOFT, HARD, WOMEN WORKING, WORKING WOMEN, HANGING, DANGLING, BREAKING, BEING FRUITY, ANGRY, NAIVE, BORN AGAIN AND TRYING TO DESCRIBE HOT WHITE FLESH TIES.

.

EXPENSES

6 Paula Cooper
to-do list, ca. 1968
2 pp., handwritten
28 x 22 cm
Paula Cooper Gallery records, 1965–73

Paula Cooper, Inc.
Work to be Done
[*Prepared by*] Y

<u>Claire</u>
① 　Work on New Corp
　　　Books Required
　　　　　1) General Ledger & General Journal
　　　　　2) Sales Journal
　　　　　3) Cash Receipts
　　　　　4) Cash Disbursements
　Buy loose ledger sheets for
　　　　　1. General Ledger Paper
　　　　　2. 10 Column for journals
　　　　　Continue Cash Receipts & Cash Disbursements
　　　　　as you are now doing. Keep in mind that the
　　　　　corporation is a separate entity & not to be
　　　　　confused with Paula Cooper or transactions prior to
　　　　　the setting up of the gallery.
　Since most sales are concurrent with the specific purchase keep

the Sales journal as follows:

Date	Invoice #	Buyer Purchases	Total Sales Price (Accounts Receivable)	Sales Tax WH	Sale	Name of Artist	Due to Artist (Accounts Payable)	Purchases
10/9/68	1300	John Jones	1050–	50–	1000–	C. Davis	400–	400–

This would get posted to general ledger. ↙

I'll leave the additional details to you. But the ultimate goal is to record the sale and purchase from artist at the same time and to account for their collection or payments by using an accounts receivable or payable account.

Paul Cooper, Inc.
Work to be done
2/ [*Prepared by*] Y
②Additional work for Paula Cooper
 Analyze separately Paula's bank statement for
 Jan 1968
 & leave it for me.
③ Make sure you file the following tax returns the forms
come in:
 1) NYC Commercial Rent Tax
 2) NYS Sales Tax
 3) Form 941 for 4th Qtr 1968
 4) NYS Unemployment Insurance
 Paula will speak to her insurance broker about
 disability & workmen's compensation insurance.

.

7 Elaine de Kooning
notes for joint tax return, 1954
2 pp., annotated typescript
28 x 22 cm
Elaine and Willem de Kooning financial records,
1951–69

Joint Return—Willem and Elaine de Kooning—1953 Siegel
Income
A. from sale of pictures (Janis Gallery) ✓$9632.00
 minus commission to gallery ✓3429.98
 actual income from gallery 6202.76 *

B. from service on painting jury (Chic.) $100.00 W
 articles for Art News 270.00 E
 '' '' New Mex. Quarterly 25.00 E
 sale of drawings from studio 66.50 E
 461.50 *
 $6202 plus 461 equals Total Income $6664.26 *
Expenses
Exemptions $ 1200.00 *
Rent for studios ✓1700.00 * W

$50 per mo. 88E. 10 St. W
 50 per mo. 132 E. 28th St. E
 500 for summer studios (Easthampton) W+E

Charity:

 $65 American Cancer Society
 50 American Red Cross
 50 March of Dimes
 25 Cerebral Palsy
 25 Tuberculosis Society
 10 Salvation Army
 50 Heart Fund
 100 Catholic Church charities

 total: $375.00 *

Telephone (studio and outside business calls W+E ✓150.00
Heat (88 E. 10th St.)W ✓520.00
electric (88e. 10th St. and 132 E. 28th St.) W+E ✓120.00
cleaning of the studios W+E ✓260.00
maintenance, repair of studios ✓88.00

 total: $938.00 *

Travel to and from N.Y.C., Chic., Montauk,
 Easthampton, Phila. in connection with
 lectures, serving on painting juries,
 interviews for articles $350.00W
Taxis to formal events, openings, lectures, etc. 250.00
Telegrams 50.00

 total: $650.00 *

Photographs of paintings for publicity
 (releases to Museum of Modern Art,
 Time Mag. Harpers Bazaar, Janis
 Gallery, etc.) newspapers, mags. $150.00 *
Art books, magazines, prints, art club
 fees, etc. $208.00 *
Entertainment 450.00 *

Joint Return Willem and Elaine de Kooning – page two '53
 Siegel
Expenses
Models: Gandy Brodie $112
 Milton Resnick $96
 Giorgio Spaventa $80
 Alfred Leslie $108

 Total ✓$396.00 * W item 4

Art Materials: paint, canvas, brushes,
 stretchers, turpentine,
 linseed oil, varnish,
 paint remover, paper, charcoal,
 pastels, crayons, homosote
 boards, pads, etc. $986.00 * W item 5

179

Hardware: Lumber, frames, staples, nails,
 Miscellaneous, <u>$149.00</u> * W item 5
Capital loss – repurchase of painting
 (constitutes short sale because
 option exhibited to repurchase
 same at higher price) sold in 1944
 for $50 to John Graham. Repurchased
 1953 for $500 <u>$450.00</u> *item 2
Capital loss –
 return of payment on painting
 sold elsewhere and paid for in
 taxes of that year ('52) Attic $1000.00 * item 2

Total Expenses	$8652.00 *
Minus Income	$6664.26
Loss	$1987.74

[*signed*] Elaine de Kooning

.

8 George Peter Alexander Healy
price list, May 1860
1 p., handwritten
20 x 13 cm
Robert C. Graham collection of artists' letters,
1783–1935

Mr. Healy's Terms
Heads of

Gentlemen	22.27	$ 200
of Ladies	22.27	250
Gentlemen	25 30	250
Ladies	25 30	300
GentlemenKitCat	29 36	350
Ladies KitCat	29 36	400
Small half length	36.42	500
Ladies do		600
Half length	4050	750
Ladies Do		800
Grand size	47 62	1000
Children the same		
as ladies		

New Orleans May 1860

.

9 Reginald Marsh,
"Expenses in the pursuit art,"
1934, in his account book, 1934–54
1 p., excerpted, handwritten
21.5 x 14 cm
Reginald Marsh papers, 1897–1955

.

10 Henry Mosler
expenses, January 23 to June 9, 1877,
in his account book, 1877
2 pp., excerpted, handwritten
18.5 x 12 cm
Henry Mosler papers, 1856–1929

.

11 Gordon Newton
to Samuel J. Wagstaff, voucher, undated
1 p., handwritten
14 x 16 cm
Samuel J. Wagstaff papers, 1932–85

.

12 Belon to John Vanderlyn
invoice for art-related supplies and services,
January 27 to October 18, 1808
2 pp. (1 folio), handwritten in French
32 x 21 cm
John David Hatch papers, 1790–1995

	List of canvases and colors furnished to Mr. Vanderline by Belon, rue de l'arbre sec 120 3. Accumulated from January 27, 1808—	D	c
	One box of colors	7	10
	One place clip		15
	An assortment of colors	1	17
January 28	Oil of {liete} grease oil essence of varnish	2	15
	White pencil		1
January 30	One easel	5	
	One handrest		6
	Two canvases measuring 25	6	
February 8	Color		15
	½ ounce of Chinese vermillion in a box	1	12
February 16	One box of colors	10	
	One [place clip]		15
	One palette	4	10
	Cinnabar		10
	Varnish		18
	Two pencils		1
	Oil of {liete} in bottle		6
	grease oil		6
	White oil		12
	An assortment of colors	2	15
	Two canvases measuring 25	6	
	One horn knife		15
February 17	One canvas measuring 30	3	12
February 25	Color		8
March 10	Essence of color		16
March 16	Varnish		18

March 17	Stretched canvases [paintings?] on key stretcher [frame?], one measuring 6 feet 10 inches by 5 feet 4 inches	15	
	one measuring 3 feet 3 inches by 2 feet 2 inch	3	10
	one measuring 2 feet 6 inches by 2 feet	3	
	One stretched on a common stretcher [frame?] measuring 2 feet 3 inches by 2 feet	1	10
March 22	For having degreased a large canvas [painting?]	3	
	Pencil		4
March 23	Color		6
March 30	Color	1	4
	Eight brushes	2	8
April 1	On half bottle of oil	1	4
April 18	One handrest		6
	One box of colors	7	10
	On [place clip]		15
	One easel measuring 6 feet	6	
	Oil of {liete}		8
		105	18
	Balance carried from previous page	105	18
	White oil		12
	Grease oil		7
	Varnish		15
	Six white pencils		3
	One canvas measuring 20, red	3	
	One measuring 15, red	2	10
	An assortment of colors	2	17
May 10	One canvas measuring 20	2	10
August 24	Color		8
September 25	One large painting varnished	6	
	Two portraits varnished	3	
October 1	For having transported a painting to the salon	9	
October 17	For having varnished a portrait at the salon	1	10
	Total	138	10
	In settlement of the account, received the amount above today the 18th of October 1808		
	Belon		

INSTRUCTIONS

13 Art Workers' Coalition
13 Demands, January 28, 1969
1 p., mimeographed typescript
28 x 22 cm
Virginia Admiral papers, ca. 1947–80

.

14 George Biddle
to Edward Bruce, letter, December 15, 1938
1 p., typescript
25 x 17 cm
Edward Bruce papers, 1902–60

.

15 Arthur Wesley Dow
teaching diagram, ca. 1910
1 p., handwritten
25.5 x 20 cm
Arthur Wesley Dow papers, 1858–1978

.

16 Francis Alexander Durivage
list of human proportions and colors on a palette in his notebook, 1845
2 pp., excerpted, handwritten, ill.
22 x 19 cm
Edward Augustus Brackett notebook, 1845, 1888

	Woman		Child	
	head	part	front	
		front	head	part
Total height of body head included	8	"	5	"
Distance from chin to lower part of pectorals	1	"	"	"
do from chin to lower part of pectorals	"	"	1	"
do from chin to narrowest part (children	"	"	1	"
do from pectorals to navel	1	"	"	"
do from navel to base of torso	1	"	"	"
do from chin to base of torso (child)	"	"	2	"
Length of thigh	2	"	1	"
do of leg	1	"	1	"
do of foot	"	3 ½	"	2
do of arm upper part to end of fingers	3	2	2	" ¼
do of do " below to do	3	"	2	"
do of the hand	"	2 ¾	"	~~7/8~~ 1 7/8
Breadth of the head	"	3	"	3 ½
Height of the neck	"	1 ½	"	" 1/3
Breadth of the neck	"	2	"	1 7/8
do of the shoulder to the other (front)	2	"	1	"
" of the form at the narrowest part	1	"	3	7/8
do of the cavity of the stomach	1	3	1	"
do of the thigh at the thickest part	"	3 ¼	"	2 1/8
do of the do at the middle	"	2 ¾	"	"
do of the do at knee	"	2 1/16	"	1 ¾
do of the leg below the knee	"	2	"	1 ½
do of calf	"	2 ¼	"	1 ¾
do of ~~upper~~ lower part of ~~arm~~ leg	"	" 7/8	"	" ¾
do of upper part of arm	"	2 1/8	"	1 1/3
do of arm above the bend	"	1 2/3	"	"
do of arm below the bend	"	2	"	1 ½
do of wrist	"	"	7/8	" ¾
Length of hand without the fingers	x	1 1/3	"	15/16
do of fingers	"	1 1/3	"	15/16
Breadth of hand	"	1 1/3	"	15/16
do of foot	"	1 1/3	"	1
Height of foot (profile	"	"	"	
Length of heel		1 ¼		2/3
do of arch of foot		1 ¼		2/3
do of toes		1 ¼		2/3

Primary Pallette

1 – White
2 – Naples yellow
3 – Raw Siena
4 – Chinese Vermilion
5 – Light red or Vnetian
6 – Indian Red
7 – Raw Umber
8 – Burnt Umber
9 – Vandike Brown
10 – Black
11 – Antwerp Blue
12 – Ultramarine Ashes
~~Allston~~
Vie Read
Oxford Ochre for draperies and back ground

· · · · · · ·

17 Hugo Gellert
list of slogans, ca. 1945
1 p., handwritten, ill.
36 x 22 cm
Hugo Gellert papers, 1916–86

Name of Ship – S/S Victory

——————————▶

{We thousands of 'Shipyard Workers' are toiling to day for
Democracy to have its way Our Local Officers are representing
us Today.}
50 here representing 100,000 at work.
~~{We build the Ships to Smash the Axis Blitz}~~
NOTE – Explain to boat Builder to make sure names of Locals and
companys they represent must be made big enough for People
watching Parade to see very plainly.

————————

{We build the Ships to 'Sail The Seas To Blast to Hell the NIPPONESE
~~{Buy~~ We Buy Bonds to day to speed ships on their way.}
{Fraternal Greetings special to the Workers of The United Nations
from the 'Shipyard Workers – CIO. ✓}
—National Port Council— Port [IUMSWA]
←26-8 wide – cab 8 ½ → body is 21 ft. → [*illegible*]→⑧
~~{3 dots and a dash — making hash out of Japs}~~
Howard Carr 34 St and 37 Ave←L.I. City Plant
8⁰⁰ ?
{The Ships we build ~~are sailing~~ sail the Seas Bearing the flags of
Democracy"
19E

*CIO is the Congress of Industrial Organization, formed in 1935; IUMSWA is the Industrial Union of
Marine and Shipbuilding Workers of America, formed in 1934.*

· · · · · · ·

18 Frederick Hammersley
notes on "An Idea," undated
3 pp., handwritten, ill.
20 x 14 cm
Frederick Hammersley papers, 1944–2007

1. AN IDEA
2. AN IDEA IS MORE THAN GRAPHICS
it can be
3 its line, + shape + value + color
4 its man + beast
5 + flesh + fantasy

————————————————————————

[*page 1 illustrations*]
8 GRAPHICS
~~graphics is not~~
an idea is not graphics
an idea is more than graphics
[*illustrations*]
ideas first

————————

tools 2nd
idea │ graphics
conception │ tools
[*page 2 illustrations*]
first
begin
start
#1
germ
nucleus
seed
[*page 3 illustrations*]
an idea
more than
bigger
before – after
first – second

1 2 3 sequence that causes the movement
→│→│→│
reading habit
seeing "

· · · · · · ·

19 Hans Hofmann
"About the relation of students and teachers," undated
1 p., handwritten
28 x 22 cm
Hans Hofmann papers, ca. 1904–1978

1.) About the relation of students and teachers:
 What a teacher should know from the beginning: "there
 is always an apostel who will deny his master.

 ————

182

1.) I like what Leonardo da Vinci had to say. "I feel sorry for the pupil who does not surpass his master."

———

2.) Some sickening ambitious man cannot stand the fact that they have been nursed by a superior mind.

———

3.) The man (painter) who calls him, self thought does not know, that in reality he cultivates a smal inferior ego. –

———

5.) It is amusing to observe that the smalest dog prefer to soil the biggest poles.

———

6.) In the animal world there are certain species which bite the hand that feeds them.

———

7.) Ignorance is the mother of arrogance.

———

.

20 Lee Krasner
to Susan Rowe, letter, March 22, 1981
1 p., handwritten (with 1 p., handwritten letter from Rowe
to Krasner, March 14, 1981, on verso)
28 x 22 cm
Jackson Pollock and Lee Krasner papers, ca. 1905–84

403 E. Maple
River Falls, WI 54022
March 14, 1981
Dear Ms. Krasner—

I am an art student at the University of Wisconsin – River Falls doing research on post-creative aspects in artists. As there is very little information on this topic in books I would appreciate your thoughts, especially as they relate to the following questions:

① How do you feel emotionally immediately after completing a work of art?
② How do you feel towards the completed work?
③ Does this feeling change in time?
④ Does a sense of "birth" relate in any way to the completion of a piece? If so, how?
⑤ How does the aspect of preciousness relate to your work?
⑥ Can you sell or part with your work easily?
⑦ How do you feel concerning the knowledge that many viewers see your work?

Thank you for your time and thoughts. Please find enclosed an SASE for your convenience.

Sincerely yours—
Susan Rowe

Reply →

[*on verso Lee Krasner to Susan Rowe*]
March 22, 1981
Dear Ms. Rowe,

In response to your questions:

1. The emotion I feel upon completing a work of art varies. Among the responses, I may be pleased, uncertain, or have other reactions.
2. I'm not sure I understand what distinction you are making between q. #1, how I feel when I finish a work of art, and q. # 2, how I feel toward that finished piece. Perhaps you can clarify what you mean. The emotional response is part of the response to the work of art.
3. My feeling toward a piece can change in time.
4. Never having borne a child, I cannot make the comparison between completing a work of art and birth.
5. Again, I'm not sure I understand your question. If what you mean is, do I consider my work "precious", the answer is no. It has to withstand the wear and tear of the world.
6. At this stage in my life, I can sell or part with my work more easily.
7. My feelings about a lot of people seeing my work is that it's made to be seen.

I hope these thoughts have been helpful to you and good luck with your research.

Sincerely,
—LK—

.

21 Henry Varnum Poor
to William Kienbusch, letter, December 9, 1937
4 pp. (2 folios), handwritten, ill.
35.5 x 21.5 cm
William Kienbusch papers, 1920–79

Dec 9 37
Thursday
Dear Bill

I enclose my little catalogue. The show looks pretty good even to my eyes so bored with seeing them all. The room of drawings is the best. Rehn says the critics were <u>very</u> enthusiastic—(no reviews yet as it opened on Monday) but as there are no critics worth a damn I can't care much about that. After all it's a pretty small audience for which you paint—or anyhow a very scattered audience, & you never have the actor's satisfaction of loud applause, but I guess an artist is another sort of critter. Since coming home from Colorado I've done about 15 things of some merit, four of them large canvases. To date 4 oils & 6 water color drawings have sold which is <u>good</u>. Of course it's a relief to have it past tho it was not half what it should be. As usual I feel I'm just starting, almost as fresh & green as you, but since in another 20 yrs at most I'll be a doddering old man I had better get going. When your portrait comes back Rehn will let your Mama know & she can buy it for $300, but I hope she wont feel bound to as I can well guess it may be poison in your house, & I'm not sorry to keep it for some time.

I suppose Anne is leaving about now. We'll be glad to see her. Hope she wont leave too big a hole in your sky. Dont be afraid of simple & more or less dumb friends. With tolerance, they all have their merits & dispel that tight throat that comes from saying nothing & seeing nobody for too long a time—especially in a foreign country. Ain't there <u>any</u> decent classes in all Paris? How about Beaux Arts? I would approach Segonzac by all means—he probably speaks some English too. Also Rattner will soon be back & you might arrange somewhat as Anne did—why not organize a class or school of a few students (I did that in Paris) & approach Segonzac to teach it?

I think you're wrong in feeling ~~teaching~~ is lessons 90 to 100 & you need 1 to 10. After all you've got a mind, & you've heard quite a lot of teaching by now. What you need is manual dexterity for one thing—just easy & familiar terms with your chosen material in paint & drawing, & then the detached & <u>inclusive</u> eye which allows you to see & feel relationships of the whole while touching any part, & copying in a free way is a great help. Little drawings from fotos of things you love are fine.

Arranging still life is a <u>devil of a job</u> at first & for a long time. I used to try arranging still lifes <u>after</u> some favorite painting like Rubens "Lion Hunt." Draperies, & fruit & stuff in that order of crossing & inter laying forms.

[*sketch of still life*]

I like to plunk a few simple & contrasting things down in a simple sort of solid geometry order like this ground plan, and then ~~move~~

[*sketch of fruit with list*]

pears or apples

grapes

move slowly around them studying the relationship of planes & lines that happens from each point of view. If there is a simple fundamental order in the <u>ground plan</u> you'll find there is order in the elevation from any point of view.

[*sketch of fruit with list*]

1 pitcher
2 grapes
3 apples
4 red bananas
5 plums etc. seems silly, but I dont explain it well

[*sketch of fruit with list*]

1 vase
2 petite-pains
3 grapes
4 lines of drape
5 plums etc.

Several times, after doing one canvas of a still life, I've then done another changing my point of view but not touching the objects, & have gotten a much better thing in the second. Taken in an experimental way still life can be lots of fun. Think of order & contrast in color & tone too. Draw some Cezanne & Chardin still lifes. I dont know why its so hard for present day students to do intelligent copying. Guess they have a lot of false pride & ambition to swallow. Anyhow Bill, excuse my giving all this advise, but learn as much as possible to enjoy the actual <u>means</u> & forget a little about the sky-aiming <u>ends</u>. They will stay with you enuf anyhow, but you'll get more patient.

Guess this is enuf. Hope you wont be too lonely over Xmas & this is wishing you all the luck in the world.

Jeanne writes she'll be up here after Xmas for a spree & to see everything. It will be pleasant to see her as she's a kind & sweet girl, & really takes her work very hard I think.

Please feel free to write & air all your troubles. What else is any wisdom? You may have gathered in reaching my great age good for, if not to be helpful.

As ever

Henry

Rehn is Frank K. M. Rehn (1886–1956), owner and operator of Frank K. M. Rehn Galleries; Segonzac is painter André Dunoyer de Segonzac (1884–1974); Rattner is painter Abraham Rattner (1895–1978).

· · · · · · ·

22 Arturo Rodríguez
list of paintbrushes, ca. 1978
1 p., handwritten, ill.
28 x 21.5 cm
Demi and Arturo Rodríguez papers, 1982–97

RECORDING NAMES

23 Paul Bransom
alphabetical list of animals, undated
1 p., handwritten, ill
29 x 22 cm
Paul Bransom papers, 1862–1983

· · · · · · ·

24 Alexander Calder
address book, ca. 1930
1 p., excerpted, handwritten
28 x 22 cm
Alexander Calder papers, 1926–67

<u>A</u>

M. and Mme. Hans Arp
21 rue des Chataigniers meudon (S & O)
Artigas 32 rue de l'Orne 15)
Brancusi 11 Impasse Rousin 15)
Mlle. Ilse Bing 146 Ave du Maine.
M. & Mme. Maurice Bos 3 r. de Rouvay Neuilly
• Mme Marcelle Bechman 94 Ave. Mozart (16)
George Antheil Hotel Glycine rue Jules Chaplain
• Mme. Muriel Ames 29 rue Boulard (14)
Mr. & Mrs. Clark Minor
Hotel Matignon
6 Ave. "
Bilbao, 53 rue de la Glaciere

Hans Arp is sculptor Hans [Jean] Arp (1886–1966); Artigas is ceramist and sculptor Josep Llorens Artigas (1892–1980); Brancusi is sculptor Constantin Brancusi (1876–1957); photographer Ilse Bing (1899–1998); composer and pianist George Antheil (1900–1959).

.

25 Philip Evergood
list of contacts, ca. 1947
9 pieces taped, printed, handwritten
54 x 21 cm and irregular
Philip Evergood papers, 1910–70

10th Friday Goby{Sat. Review of Literature Woman with cork?
[*underneath business card*]
MERILL V. AMES
Frames Mats Passe Partout
523 Hudson Street
New York 14, N. Y.
Telephone: Watkins 9-9766
April 25, 1947
[*on business card*]
Murray Hill 6-1320
M. Toberoff Co., Inc.
MANUFACTURERS OF PICTURE FRAMES
M. TOBEROFF CO. Inc
130 Lexington Ave (near 29th
mu 6-1320
Herbert J. Benevy
Mu 8-4779 ~~Cp 3-6444~~
~~116 E 18~~ 403 E52
Bumpei Usui 33E 12
AL4-5062
Henri Heydenry K
68 W 56 CO5-5094
Sam Lieterman
40 E 8 Al 4·1095
Zinn Tony Pasata-Walsch
AL 4-7961 2 W [*pencil marks erased*]
Jules Rubinstein
Sieger Frame Co
En 3·3749
85 Fourth
David Kovcsi X Frames
Orch -4 2255
101 East 16
Peerless Photos
849 First Ave mu 8-0347
George Karfiol
Monday
Wed
Friday
4 East 41st NY 17

Irvington N.Y. 9-4394

[*on business card*]

alexander lazuk
MIDTOWN FRAME SHOP
individual framing
61 west 74th street, n.y. 23 – endicott 2-1284
Custom Prints.
Ernest Hopf
Ch 3-4078
302-W. 13th. St.
NYC.
Sell Screen

Soby is art historian James Thrall Soby (1906–1979); Herbert J. Benevy owned Herbert Benevy Gallery, New York; Painter Bumpei Usui (1898–1991); Framer and art dealer Henri Heydenryk, Jr. (1905–1994); Painter Jules Rubinstein; David Kovesi is painter Deszo "David" Kovesi (1893–1973); Painter George Karfiol; Painter and printmaker Ernest Hopf (1910–1999).

.

26 Ray Johnson
to Ellen H. Johnson, thank-you note, ca. 1979, and list of silhouette portraits, October 13, 1978
© 2010 Estate of Ray Johnson. Courtesy of Richard L. Feigen & Co.
1 p., handwritten on photocopied list
36 x 22 cm
Ellen Hulda Johnson papers, 1939–80

.

27 Walt Kuhn
list of models, 1946–48
2 pp., excerpted, handwritten
22 x 18 cm
Walt Kuhn, Kuhn family papers, and Armory Show records, 1859–1978

Irene MalinKovicz Lenner
WIS 7,6000
blond, fashion? Model
Rita Benay
Harmeyer 6 0880
Mario Roma
N. V. A.
c/o Washington
302 E 75
Mann
Detroiter Hotel
Miss Dixon
1105 Park Ave-
~~Sae. 2 5992~~
5.30 Margot Gaznor
155-10-8302
Wed Tues Sat
~~Col J 4458~~
EL. 5. 0986
404 E55
Joseph ~~Joe~~ Allen

Mansfield Hall Morid,
Co. 5.5070 226 W50
284-14-5878
Leon and Eddies EL 5-9415

.

28 Pablo Picasso
recommendations for the Armory Show for Walt Kuhn,
1912
1 p., handwritten
26 x 21 cm
Walt Kuhn, Kuhn family papers, and Armory Show
records, 1859–1978

Juan Gris
13 rue Ravignon
Metzinger
Gleizes
Leger
Ducham
Delaunay
Le Fauconnier
Marie Laurencin
DeLa Fresnay
Braque

Painter Juan Gris (1887–1927); Metzinger is painter Jean Metzinger (1883–1956); Gleizes is painter Albert Gleizes (1881–1953); Leger is painter Fernand Léger (1881–1955); Ducham is painter and sculptor Marcel Duchamp (1887–1967); Delaunay is painter Robert Delaunay (1885–1941); Le Fauconnier is painter Henri Le Fauconnier (1881–1946); Painter Marie Laurencin (1885–1956); DeLa Fresnay is painter Roger de La Fresnaye (1885–1925); Braque is painter Georges Braque (1882–1963). Walt Kuhn added Braque's name to the list.

.

29 Ludwig Sander
list of members of The Club, ca. 1949
1 p., handwritten
25 x 20 cm
Ludwig Sander papers, 1910–75

Helena Newman OR3–0680
1. Lewitin — 117 Waverly br 7–5416
Grippe 113 W 13th CH 3-3819
2. Rosati — 252 W. 14 St. WA 9–0267
3. Pavia — 53 W. 8. GR 5–5864
4. De Kooning — 85 Fourth Ave. c/o ~~Single~~ Frames Siegle GR3–3749
5. Resnick. 47 East 8 St.
6. Corrad — 52 East 9 St. AL-4–8470
7. Lassaw — 487 — 6 Ave. WA 9–6293
8. Kline — 52 East 9 SP 7–1945
9. Alcopley — 29 Charles Ch 2–6267
10. Falk — 186 Spring St. WA 5–5072
11. Reinhardt — 7 Washington Pl. OR4–9176
12. Cavallon — 20 Leroy St Ch 3–7678

13. ~~Ben Schmuel~~ — 324 E. 21 St. LE2–2482
14. ~~Newell 1 AVE B GR 3–7027~~
Navaretta MV9–4272 247 W. 10th St CH 3–0935
15. Roelants 63 East 11 –OR 4–2176
16. Sander 67 W 3rd 17. (OR4–2898)
17. Charles Egan 63 E 57 DL. 512415
18. LEO CASTELLI MV 3 OFF.–3684 4 E. 77 BV 8–8343
19. [Jack Tworkov] 234 E 23 MU 6–9198
20. [Aaron Siskind] (47 E 9 St Gr. 3–5497)
[Rudy Burckhardt] 116 W 21 WA 4 6928
Janice Biala 220 E. 17th St OR.3–1790
Joop Sanders 479 6th Av. CH.2–2096
P ILL
JU 2 1762
16 W 55
Ice cubes
Gr. 5–2592
Ch. 3-4836
(Price MU 3 9546)
Jobe (Sanders)

[upside down text, starting from top of page]
Fannie Hillsmith 915 2nd Ave N. Y. C. 17
EVSA MODEL
55 GROVE STREET N.Y. 14. N.Y.

NITZSCHKE 43 W 8th GR 7–1874
SAL SIRUGO 536 E. 13th ST. N. Y. C. (91)
Callas-
Reg 4-0709
FRIEDEBALD DZUBAS 235 7th Ave. Chelsea 2-7435

Lewitin is painter Landes Lewitin (1892–1966); Grippe is sculptor Peter Grippe (1912–2002); Rosati is sculptor James Rosati (1911–1988); Pavia is sculptor Philip Pavia (1912–2005); De Kooning is painter Willem de Kooning (1904–1997); Resnick is painter Milton Resnick (1917–2004); Corrad is Conrad Marca-Relli (1913–2000); Lassaw is sculptor Ibram Lassaw (1913–2003); Kline is painter Franz Kline (1910–1962); Alcopley is painter Alfred Lewin Alcopley (1910–1992); Falk is Gus Falk; Reinhardt is painter Ad Reinhardt (1913–1967); Cavallon is painter Giorgio [George] Cavallon (1904–1989); Ben Schmuel is sculptor Ahron Ben-Shmuel (1930–1984); Newell is painter Roy Newell (1914–2006); Navaretta is poet Emanuel Navaretta (1914–1977); Roelants is painter Jan Roelants; Sander is painter Ludwig Sander (1906–1975); Charles Egan (d. 1993) is founder of Charles Egan Gallery; Leo Castelli (1907–1999) is founder of the Leo Castelli Gallery; painter Jack Tworkov (1900–1982); photographer Aaron Siskind (1903–1991); Rudy Burckhardt is photographer Rudolph Burckhardt (1914–1999); painter Janice Biala (1903–2000) and Jack Tworkov's sister; painter Joop Sanders (b. 1921); painter Fannie Hillsmith (1911–2007); painter Evsa Model (1901–1976); Callas is likely art critic, Nicholas Calas (1907–1989); painter Sal Sirugo (b. 1920); and painter Friedel Dzubas (1915–1994).

INVENTORY

30 Oscar Bluemner
list of works of art, May 18, 1932
1 p., handwritten, ill.
22 x 28 cm
Oscar Bluemner papers, 1886–1939, 1960

.

31 Alexander Calder
to Agnes Rindge, letter, ca. 1942
© 2009 Calder Foundation, New York/Artists Rights
Society (ARS), New York
2 pp., handwritten, ill.
25.5 x 20.5 cm
Agnes Rindge Claflin papers concerning
Alexander Calder, 1936–54

Dear Agnes,
I have at 244 E. 86 ask for Mr. Uhlan, supt.

1	4′	
2	2′	
3	3 ½	
4	wood	
5	wood	
6	turns	
	wood	
	rather hard to balance	
7	3′	4′
8	4′	5′
	yel	

gray white red black

2/ and one very large (overhead)

9 red white

> enlarged for use by M. Graham

Not included in Ex. MS
14′
(which you may have seen at Hartford)
at (Martha Grahams Studio 66—5ᵗʰAve N.Y.C.
I have written them to let you have it
If you can let them, and particularly Mr. Uhlan know
when youre coming
 Success
 Sandy

Martha Graham (1894–1991) was a dancer, choreographer, and founder of the Martha Graham School of Contemporary Dance and the Martha Graham Company.

· · · · · · ·

32 Joseph Cornell
list of items purchased at the thirteenth National Antiques
Show, New York City, March 1957
1 p., annotated typescript
28 x 22 cm
Joseph Cornell papers, 1804–1986

· · · · · · ·

33 Margaret De Patta
list of production jewelry, ca. 1946
1 p., handwritten, ill.
28 x 11 cm
Margaret De Patta papers, 1944–2000

· · · · · · ·

34 William Mills Ivins
list of prints in his notebook, 1927–28
1 p., excerpted, handwritten
30 x 22 cm
William Mills Ivins papers, 1878–1964

What twelve prints that you have do you most prefer?

 x x Mantegna's Oblong Entombment
 x x Durer's St Michael
 x x Durer's Flagellant
 x x Rembrandt's Raising of Lazarus
 Florentine Mount of Olives
 x x Florentine Monks in the Mountains
 x x Ugo da Carpi's Miraculous Draught of Fishes
 x x Delacroix's Juive d'Alger
 x Ingres's Odalisque
 x x Daumier's Mère d'une actrice
 Degas's Le Baine
 x x Gauguin's Woman on Beach.
 Girtin's Poste St. Martin.
 Venetian woodcut Pietà.
 x Baldung's Conversion of S. Paul.
 ~~Goya's~~ all are bound.
 x Canaletto's Porte al Dolo (round basin)
 Piranesi's Arch of Trajan
 Holbein's Erasmus with the Term.
 x x Hokusai's Army in the Mountains
 x x ~~Matisse's~~ Portrait of a Young Girl.
 x x Rodin's Lithograph.
 Durer's Woman of Babylon.
 Durer's Sudarium & one Angel.
 Hogarth's Lord Lovat.

Ivins.	G.	
Foster.		G.
Mansfield		G.
Veeder		G.
Ledoux		G.
Dr. Norrie		G.
Dr. Goodridge.		
Geo.	Central Union.	
Geo. Pratt		

It simply cant be done!

Foster is probably Lansford Foster, a donor to the Metropolitan Museum of Art; Mansfield is Howard Mansfield (1849–1938), a collector of Japanese prints and a trustee of the Metropolitan Museum of Art; Ledoux is Louis V. Ledoux (1880–1948), a Japanese print collector; Dr. Norrie is Van Horne Norrie (d. 1933), a donor to the Metropolitan Museum of Art; Geo. Pratt is George Dupont Pratt (1869–1935), a trustee of the Metropolitan Museum of Art.

· · · · · · ·

35 David Trumbull Lanman
to his sister Abigail Trumbull Lanman, letter, December 2, 1844, and auction catalog
4 pp. (1 folio), handwritten letter on annotated printed broadside
28 x 22 cm
Albert Duveen collection of artists' letters and ephemera, 1808–1910

OIL PAINTINGS, PRINTS & C.
NEW-YORK, DEC 2 1844
My dear Sister,
[*Excluding printed broadside*]

 Most of the above were apprised by Mr. Josleyn at New Haven; those not apprized I have put their Value as I estimate them; If you would like any of them bought in for you, because you dont wish them sold for less than what you suppose they are worth or what you would be willing to give for them. I want you to name the price I shall bid for you or let them go to any one will give more, they are now all up for exhibition & on Saturday Miss Lentner called to see if I had recd the miniature from Co Mr. Silliman of the Cols. as probably Mr. Buckingham would take that & Mrs. J. at the apprisal price of $30 for Mrs & $20 for the Col. Mr Silliman wrote me to day that he would send it down by his Son on the 5th he also said he did not know how any mistake could have occurred in counting your prints. But this P.R Messrs [*illegible*] Williams & Stevens where they they were sent say they examined them & counted them when opened & that they were short as stated by them. Miss Lentner has not yet counted hers. Messrs Williams and Stevens say if any of the prints are sold at Auction it will very much interfere with the sale of those in their hands & they request me to get Miss Lentner to put hers in their hands so that they could have the controle of the whole of the Cols prints & in that way they think they can in time work them off to much better advantages than to sell them at Auction. They ask now $10 Ea for the Declarations of which they receive as commission $2.50 ea. I asked them to make me an offer outright for the whole of the prints, you & Miss Lentner have, & they are to give me an answer tomorrow, & if any thing near the apprisal price is offered I shall take it. I told them we did not want the money if they would pay the interest. If it would be any object to have them on a credit of one or two years. Miss Lentner wanted to know what we should do if the Pictures did not bring as much as we supposed they were worth. I told her that this Auction was to close all partnership business, & that if she thought any thing was selling too cheap she could purchase it her Self or get some of her friends to do it for her, & that I should do so for you, as I had allready taken more trouble for her than I would again. She said not for her, but for you, & that she was willing to pay for the trouble, & I Said I should charge for it.—We are sending to about 100 Gentlemen these letters, but I doubt if the articles sell for as much as they ought to do. I suppose you will say, do what you think best in regard to the whole matter & purchase what you think is going too cheap, & every body Mr Mooney & all, do the same thing so that all the responsibility is thrown upon my shoulders. So I would be glad to have you express your opinion in the matter & write to me soon for on Tuesday next they are to be sold.
 Aff. yours
 D.T.L.

· · · · · · ·

36 Morris Louis
to Leonard Bocour, letter, May 22, 1962
1 p., annotated typescript
27 x 19 cm
Leonard Bocour papers and business records, 1933–93

· · · · · · ·

37 Germain Seligmann
list of objects to transfer to the USA, 1947
1 p., typescript in French
27 x 21 cm
Jacques Seligmann & Co. records, 1904–78

Translation
Mr. Germain SELIGMANN
LIST of OBJECTS to TRANSFER to the U.S.A

 Estimates. –

 1947. –

1.	Two ancient tapestries	1,400,000 Frs.
2.	Ancient tapestry panel representing a young woman holding a candle	420,000 "
3.	Marble bust "The Empress"	1,050,000 "
4.	Earthenware platter with Hebrew inscription	315,000 "
5.	Small earthenware basin	175,000 "
6.	Portrait of a young man, copied after Dürer	210,000 "
7.	Pair of silver torches	98,000 "
8.	Silver vegetable dish with lid and tray	140,000 "
9.	Four Chinese gouaches	14,000 "
10.	Blue porcelain candlestick	21,000 "
11.	Black bronze column in three pieces	5,500 "
12.	Drawing representing a "Nude"	56,000 "
13.	Jewel case with silver plate	7,000 "
14.	Large long dish in silver-plated metal	24,500 "
15.	2 silver-plated coffee filters	700 "
16.	Spoons with mother-of-pearl handles	700 "
17.	Three drawings	
18.	Small tapestry pictures, lengthwise	24,500 "
19.	Two earthenware jardinières	3,500 "
20.	One stone on pedestal	Memo
21.	One empty jewel case	Memo
22.	One Directoire sofa and eight chairs, wood painted white, covered in needlepoint tapestry	240,000 "
		4,205,400 "

NOTE.–

 Mr. Germain SELIGMANN, American citizen since 1937 left Europe for America at that time. He formerly lived in Paris at 23, rue de Constantine and also had a pied-a-terre on Avenue Foch.

 Having been unable to complete the removal of his possessions before the war, he wants to transport to New York the above-listed objects, which are his personal furnishings. An earlier shipment was authorized and carried out in 1946.

 The above listed objects were mostly relocated after

having been taken away by the Germans or hidden by friends or servants.

Offered for the disposition of the Administration:
- A certificate of US residence, notarized, certified by the Consulate of France
- Certificate of American Nationality (Notary, French Consul)
- Declaration of property (Notary, French Consul)

- Excerpts from catalogs, copies of photographs of rooms, and collated letters (Notary and French Consul) attesting ownership of said objects and proving notably that the two tapestries had only been brought into France for a pre-war exhibition.

.

38 Carol Thompson
list of Bob Thompson's paintings and drawings destroyed by fire, 1977
1 p., annotated typescript
26 x 21 cm
Bob Thompson papers, 1955–2000

.

39 Worthington Whittredge
"Completed Commissions and other Pictures" in his ledger, 1849–59
2 pp., excerpted, handwritten, ill.
30 x 24.5 cm
Worthington Whittredge papers, ca. 1840–1965

[*page #*] 129
Completed Commissions and other Pictures
April 21st 1852
From the Harz Mountains 33/24 3/4 inches. To Cincinnati for sale. Accepted by Mr. Chas. Stetson for his Commission May 6th 1849. $100.
April 21st 1852
Composition from studies made in the Harz Mountains. Motive near Langenfeld. 63 1/3 / 46 1/4 inches. To John Groesbeck Cin. Commissioned May 5th 1849. $400.
June 10th 1854
Duplicate of the above with alterations 35 1/2 / 26 in. To James L. Claghorn Philadelphia. Commissioned by T. B. Read Esq Sept 20th 1853. Price $150.
Oct. 6th 1854
One picture to A. G. Burt Cincinnati Price $100.
Oct. 6th 1854
One picture to Mr L. B. Harrison Cincinnati Motive from the river Nahe. Commissioned Sept 25th 1852. Price $500.
Oct 6th 1854
One small picture to Cincinnati for sale $25.
April 1855
Composition from studies made with Weser Gebirge

near Minden 66/57 inches. To B. W. Burnet Cincinnati Price $500.
June 1855
Composition from a motive in the Harz Mountains about Kit Kat size 29/36 in To W. W. Scarborough Cincinnati intended as a present to Dr Richards Commissioned in the Autumn of 1850. Price–$150
Oct. 14th 1855
Motive from the Weser Gibirge [*illegible*] Minden about 20/20 in. To William [*Russmann?*] Cincinnati Commissioned June 1st 1833. Price $100.
[*page #*] 130
Completed Commissions and other Pictures
April 1853
From a study made near Bourg Steinfurt Westphalia About 30/40 in. To Davis B. Lawler Cin. Commissiond June 1850. Price $200
June 14th 1852
Composition from Studies made in the park at Cappenberg. To Mr. Griffin Taylor for Mrs. Dixon Commissioned 1850. Price $250. Size near 4 1/5 feet.
Oct. 1855
[*illegible*] Emilie Schwartz aus [*illegible*] im [*illegible*] Rhine
April 19th 1856
Compositions from studies on the lake. about 20 by 25 inches To a lady. ordered by Baldwin. price $100.
April 19th 1856
Subject from the Elbe, Dessau. About 30 by 42 inches To Reuben Springer, price
Subject from Brunnen Switzerland about 3 1/2 by 4 ft. 9 in. To Mr. Davis B. Lawler. Painted in Rome
June 1857
Subject from Brunnen about 4 by 5 feet. To Mr. H. N. Beecher. Sent in march 1858 to the Philadelphia Academy and sold to Mr. Sam B. Fales for $350. Rome

TO-DO PERSONAL AND PRIVATE

40 William E. L. Bunn
"Grief list," December 24, 1938
2 pp. (1 folio), handwritten
14 x 10 cm
William Edward Lewis Bunn papers, 1935–86

GRIEF LIST Dec 24th
Faces on all people✓
Adobize buildings✓
~~Weatherstrip buildings~~
Whites on commanders' stable
"———" ~~hospital~~
Doctor block on building down left.
Telegraph Wires✓
Outhouses & wells
Lettering✓ & modeling on canvas tops
Put in buffalo skull

" " " hunt

~~Tree foliage repainted~~

~~Glaze ends of wagon covers~~ –

Glaze distance lighter✓

Glaze hills into being

Glaze stagecoach✓

Stripes on ordinance✓ (red) red color strips

" " cavalry (yellow)

Paint cats and dogs

~~Put in Nancy's dog Skeeter✓~~

Buggy in front of Frontiermasters place

Flower garden colored wash on wash line

Cannon in stockade. more indians.

Some cassons, accordion player.

Sentinels, ✓ guards & ~~prisoners~~

~~Prisons & guard at roads intersections~~

Cows in corral, paths in corrals.

~~Manure & straw piles~~

~~Glaze chimney sides~~

Muzzles & hoofs of Le Roys' mules✓

Doctor the white ox.

Lighten figures in forground.

chopped wood piles

wells?

.

41 Leo Castelli
to-do list, ca. 1968
2 pp. (1 folio), handwritten
18 x 16 cm
Leo Castelli Gallery records, ca. 1957–1990

<u>DRUG STORE</u> SCHICK, BLADES, TOOTH POWDER
 PLASTIC BAG ANACIN

- SCARPITTA
 {REPRINT PHOTOS FOR EUROPE, NEW PRICES
 REPRINTS
 (DISTRiBUTION)} iVAN
- STELLA FROM DAVIDSON (SHOW TO ASHER)
- PHIL JOHNSON (WINDOW SKETCHES) —MEMOS—
INVOICES (TOM, ARTHUR)
- ✓ FRAMING RR DRAWINGS
- AIR PLANE TICKETS {L.C. NICK
- PHONE IVAN
- CHECK 1200.—<u>TAXES</u>
- TRAVELLER'S CHECKS
- PHONE NAUMAN (PRICE FiLMS)
 " MORRIS
 " J.J.
 " ANDY
- RR CHOICE PTING FOR JAPAN, ALSO REBUS!!
- PHON SYD FELSEN
- ✓DOUGLAS <u>MONEY</u> FOR BOB'S PIECES
- TEL. NANCY

• ALAN?
• PETER YOUNG
IVAN TO MINNEAPOLIS
DIANE SOPHA <u>ORDER FOR ROY</u>
 MAZZOTA, GIANI
- BRADSHAW
-✓OLD DRAPES <u>SAM</u>

Scarpitta is sculptor Salvatore Scarpitta (1919–2007); Ivan is Ivan Karp (b. 1943), who worked at Leo Castelli Gallery; Stella is painter Frank Stella (b. 1936); Phil Johnson is architect Philip Johnson (1906–2005); Nauman is artist Bruce Nauman (b. 1941); Morris is Robert Morris (b. 1931); J.J. is artist Jasper Johns (b. 1930); Andy is artist Andy Warhol (1928–1987); RR is artist Robert Rauschenberg (1925–2008); Syd Felsen is Sidney B. Felsen (b. 1924); painter Peter Young (b. 1940); and Roy is painter Roy Lichtenstein (1923–1997).

.

42 Miguel Covarrubias
to Nickolas Muray, letter, ca. 1940
2 pp. (1 folio), handwritten
25 x 17 cm
Nickolas Muray papers, 1911–78

Dear Nick –

 I am terribly sorry to have let go all this time without writting and you are right to be mad at me as I could see by your letter. Still, you know my greatest weakness has always been letter writing, particularly when I get into one of those hectic impasses of work. I can really say I have never been so bussy in all my life; here is a sample:

 1—The organization of the G..D.... Mexican Exhibition which took every minute of two months and the details of which I am still struggling with.

 2—The preparation of my section (Modern Art) for the catalogue.

 3—My own book which has suffered heavily.....

 4—A drawing for Vogue of the opening of the Exhibition with about 50 people in it.....

 5—The arrangement of a great reception of all the worker's, women, etc organizations with banquets etc for the frustrated flight of Ya Ching, plus emmigration and Federal Communications permits, etc.

 (I have extra-official information that Chinese official circles discouraged the flight, of which no doubt Hilda Yen had a hand. What a shame that such petty feminine jealousies prevented putting the name of China high in Mexico, not that Mexico is so important to the Chinese cause, but because we here were determined to change the point of view of the Mexicans of what Chinese are like. Here they know only coolies and laundry men)....Well, we did all we could and Mexican government circles and the labor organizations are disappointed.....

6—Attendance and extra official work at the 1st Inter-American Indian Congress which is just over.

7 —George Macy's book........

8 —and last, to help Joseph Steinbeck and Herbert Kline to make a film in Mexico. He arrives tomorrow. If after

reading this you don't weep for me you have no pity in your heart. Here is some quick gossip on Mexico...Have hardly seen Frida; after endless engagements to which she never appeared I finally gave up.....Diego more of a horse's ass than ever. For the sake of publicity he is providing Senator Dies with the most fantastic and slanderous gossip about a Nazi-Communist plot prepared in Mexico against the U.S!!!.... Chester Fritz is now in Mexico.....Carmen came back with a fine story about M. (Juliet) please dont let it happen again... Where is "Juliet" living, I didn't even know she was back in N.Y. I am coming to N.Y. about the 5th or 6th of May by plane, not alone as the Rockefellers invited Rose.....Give everybody my love: Mai may whom I have not written (shame on me!), to Helen, to Marina, to Mam, etc

 Best everything, Miguel

The Mexican exhibition is Twenty Centuries of Mexican Art at the Museum of Modern Art in New York, 1940; Lee Ya-Ching was a Goodwill Ambassador for United China Relief during World War II who piloted a goodwill mission to South America in 1940; Hilda Yen (1905–1970) was a relief pilot in China during World War II; George Macy (1900–1956) founded Limited Editions Club, a publisher of illustrated books; Chester Fritz (1892–1983) worked in the American-Chinese Silver trade in China prior to 1941; Rose is Rose Covarrubias (1904–1957), wife of Covarrubias; Mam is Marion Meredith, Muray's studio manager.

.

43 John D. Graham
to-do lists, September 8–11, 1937, in his diary, 1937
2 pp., excerpted, handwritten, ill.
13 x 8 cm
John D. Graham papers, 1890–1961

Tlalengantla
September 1937
Wed. 8 Remedias fiesta
Collect: 7 Milk 7B
Weston — 3 horses package idols
Sanborn $18 2 dishes
16 [*illegible*] about [*illegible*] prepare all mail
Crespo paint
Covarrubias write
Thurs. 9 milk 8B
Oaxaca Malu Cabrera–belt
Iguala Crespo–manu–Alma
Juchitan thumb tacks
Guatemala pencils
San Salvador
(Constance)
 Pont Euxine
Fri.10
Milk 9B
[*illegible*] F Crowninshield
Paint: ⊗Alma Reed
Childhood: [*illegible*] Hudson
 Bible Gabrielsen
 color ~~Pelagya~~
White to Red: finish Frieda–Esther
 expand ⊗ Covarrubias

correct ⊗ Crespo
 Orozco
 ⊗ Weston: 3 horses package
 ⊗ Sanborn: $18
 2 dish; idols

Mexico
Sat. 11 Milk 10B
System & D. of ART:
rewrite
retype
correct
American:
African Art:
Photographs
Descriptions
Preface
Text
Jorge Enciso
Rio Tamesis 11
MECIO D.F.
4-58-87–Eric.

Tlalengantla is a town in Mexico; Crespo is artist and educator, Jorge Juan Crespo de la Serna (1888–?); Covarrubias is painter and caricaturist Miguel Covarrubias (1904–1957); Oaxaca, Iguala, and Juchitan are towns in Mexico; Alma is dealer Alma Reed (1889–1966); Pont Euxine is the Black Sea; F. Crowninshield is Frank Crowninshield (1872–1947), editor of Vanity Fair; Gabrielsen is Galin Gabrielsen; Frieda is painter Frida Kahlo (1907–1954); Orozco is painter and muralist José Clemente Orozco (1883–1949); Jorge Enciso (1879–1969) is a muralist and scholar of pre-Columbian Mexican art.

.

44 Janice Lowry
to-do list, August 9, 2003, journal no. 101, 2003
2 pp., excerpted, handwritten, ill., various media
22.5 x 23 cm
Janice Lowry papers, 1957–2008

Aug. 9th Saturday
~~1 Letter to Stampton for Home Tour~~
~~2. Mikes Book zerox~~
~~3 Taylor Fri~~
~~4 Appt for skin~~✓
~~5 Letter to Women Museum Journal~~
6 Bio to Women Shrine Book
~~7 Start working on show~~
~~8 fix door Jon office~~
~~9 Call Meldoy Lunch~~
~~10 Get Announcments~~
11 Mail Announcments
~~12 Mikes W Book Done~~
13 Marians Birthday
~~15 letter for Marlene~~
~~16 Letter to Resturants~~
~~17 work on "Home" Journal~~
18 call about stairs Idyllwild
19 get rain gutters✓
~~20 appt for Dog~~✓

~~21~~ ~~[Bauloque DLS?]~~ ✓
~~22~~ ~~air plane Res~~ ✓
~~23~~ ~~dep $~~
_____ Write food Letter Home tour
_____ MAke Plane Res

Idyllwild is a mountain community in California, where Lowry has a second home.

· · · · · · ·

45 James Penney
to-do lists in his sketchbook, July 1932
2 pp., excerpted, handwritten, ill.
20 x 26 cm
James Penney papers, 1913–84

Concentrate on

 P.P.
① Mural (Y.M.C.A. Brooklyn)
② Roslyn Exhibit
③ {K.U. Washburn (KANSAS) Exhibit
 {Also <u>Cedar Rapids</u>.
 Yellow Springs
④ oils & watercolors for exhibition both in N.Y.
 <u>Washington Sq. show,</u>.
⑤ portraits {make up & good one day place in windows &
 galleries–B'klyn} & N.Y. both)

⑥ <u>Spend what you have on materials</u>
⑦ <u>don't go back to Kansas</u>
⑧ <u>Depend on signs for subsistence</u>
⑨ Keep in contact with village painters or publishers &
 <u>dealers</u>
⑩ Post sign (see Lee about portraits)
 Coney Island Station Celebration

BIOGRAPHICAL DETAILS

46 Harry Bertoia
"May-Self Rating Chart," in "My Career," school
assignment, 1932
1 p., excerpted, handwritten, ill.
28 x 21.5 cm
Harry Bertoia papers, 1917–79

· · · · · · ·

47 Louis Michel Eilshemius
calling card, undated
2 pp., 1 item, printed
11 x 16 cm
Hyman Kaitz papers relating to Louis Eilshemius,
1933–78

· · · · · · ·

48 H. L. Mencken
to Charles Green Shaw, letter, December 2, 1927
Published by permission of the Estate of H. L. Mencken
and the Enoch Pratt Free Library, Baltimore.
5 pp., typescript
14 x 22 cm
Charles Green Shaw papers, 1874–1979

December 2nd—1927
Dear Charles:–
A few notes:
1. I bought some brown shoes six or eight years ago, and have worn
them off and on ever since. I have also taken to brown oxfords.
2. I have now seen about twelve movies, four or five of them to the
end. I liked them all pretty well, but am not tempted to go back.
3. My favorite drinks, in order, are: beer in any form, Moselle,
Burgundy, Chianti, gin and ginger-beer, and rye whiskey. I use
Swedish punch only as a cocktail flavor. I dislike Scotch, and seldom
drink it. It makes me vaguely uneasy. I also dislike Rhine wine, save
the very best. I never have a head-ache from drink. It fetches me by
giving me pains in the legs. When I get stewed I go to sleep, even in
the presence of women and clergymen.
4. Curiously enough, I greatly dislike the common American dirty
stories, and avoid the men who tell them habitually. They seem dull
to me. I love the obscene, but it must have wit in it.
5. As for politics, I always go to national conventions, and have
missed very few in 28 years.
6. Of my inventions I am vainest of Bible Belt, booboisie, smuthound
and Boobus americanus.
–2–
7. I have been in the Johns Hopkins Hospital but once, and then
it was for medicine, not for surgery. I think all of the Baltimore
hospitals are good, but prefer those run by nuns.
8. I changed my collar to a lower level two years ago.
9. I never use mullen on my hair. Nothing but soap and water ever
touches it. George has gone gray greasing his hair.
10. I believe in marriage, and have whooped it up for years. It is
the best solution, not only of the sex question, but also of the living
question. I mean for the normal man. My own life has been too
irregular for it: I have been too much engrossed in other things. But
any plausible gal who really made up her mind to it could probably
fetch me, even today. If I ever marry, it will be on a sudden impulse,
as a man shoots himself. I'll regret it bitterly for about a month, and
then settle down contentedly.
11. I believe in and advocate monogamy. Adultery is hitting below
the belt. If I ever married the very fact that the woman was my wife
would be sufficient to convince me that she was superior to all other
women. My vanity is excessive. Wherever I sit is the head of the
table. This fact makes me careless of ordinary politeness. I don't
like to be made much of. Such things please only persons who are
doubtful about their position. I was sure of mine, such as it is, at the
age of 12.
12. Pilsner should be in Roman type, and begin with a capital.
–3–
13. I usually lie to women. They expect it, and it is pleasant to watch
them trying to detect it. They seldom succeed. Women have a hard

time in this world. Telling them the truth would be too cruel.

14. I am completely devoid of religious feeling. All religions seem ridiculous to me, and in bad taste. I do not believe in the immortality of the soul, nor in the soul. Ecclesiastics seem to me to be simply men who get their livings by false pretenses. Like all rogues, they are occasionally very amusing.

15. I can't get rid of certain superstitions, and suspect that there must be some logical basis for them. My mother and father both died on the 13th.

16. I am always in trouble around Christmas, and usually about a woman. The fact makes me dread the season.

17. I have another superstition: that all men who try to injure me die. I happens almost invariably. Of the six bitterest enemies I had two years ago, five are dead, all suddenly and unexpectedly.

18. My belief is that happiness is necessarily transient. The natural state of a reflective man is one of depression. The world is a botch. Women can make men perfectly happy, but they seldom know how to do it. They make too much effort: they overlook the powerful effect of simple amiability. Women are also the cause of the worst kind of unhappiness

–4–

19. I have little belief in human progress. The human race is incurably idiotic. It will never be happy.

20. I believe the United States will blow up within a century.

21. Being an American seems amusing to me, but not exhilarating. But I am very proud of the fact that I am a native and citizen of the Maryland Free State. I like to believe that I have had a hand in keeping it free.

22. I hope to write at least one good book before I die. Those that I have done are all transient and trivial: they will be forgotten in 25 years. I have ideas for five good books, but shall be content if I manage to write one.

23. I live pretty well, but am careful about money, and greatly dislike extravagant persons. I believe that it is discreditable to be needy. Economic independence is the foundation of the only sort of freedom worth a damn.

24. Most people regard me as very energetic. I am actually very lazy, and never work when I don't want to. On most days I take a nap. I also take frequent short holidays. But I dislike long ones.

25. I drink exactly as much as I want, and one drink more.

26. I never lecture, not because I am shy or a bad speaker, but simply because I detest the sort of people who go to lectures, and don't want to meet them. So with the fools who go to public dinners.

–5–

27. I have been reported engaged during the past year to six women. It consoles me to reflect that all were charming, and that all save five were beautiful. Their total net worth ran to $2500.

28. I dislike receiving presents, and never accept them if I can get out of it. But I like giving them to women and children. Many a worthy gal has lost a handsome beau by giving me something nifty.

29. My apologies for inflicting so long a letter upon you.

Yours,

[*signed*] Mencken

.

49 Henry Ossawa Tanner
notes on his childhood, undated
4 pp. (1 folio), handwritten, ill.
45 x 47 cm
Henry Ossawa Tanner papers, 1860s–1978

To Alexandria
mother put off
①Changes & troubles came me & mine early.
An infant: arms found my parents [*illegible*] in Alexandria, & by some unhappy chance, found my mother in Washington with me a babe in arms night came suddenly down & with it a snow storm, She would risk it & take the Street Car:
So down went her veil & up went the, but the very thing that she had hoped might Save her was her undoing
 I never knew this story till I was a man grown, We were living in our Diamond St house in Phila near East Park. ② Phila I left the house immediately & I took several hours walking in among the trees & under the night skies to cool my what hatred [*illegible*] in capital & red at that, that [*illegible*] –my bosom, for years it seemed to me that that hell preached at that time so much yes hell with fire & brimstone was too good for such fiends, ③ & yet eternal fire & brimstone we moved away from Washington & I have no memory of even coming back till on a trip from Paris I found my mother living there with my sister & went there for a few days. One day we took a St car going some where very crowded, my mother had hardly entered when a [*illegible*] a distinguished looking middle age man of the same race that had formerly ejected that same mother & son–arose & gave my mother a seat. My mother said it was not a very rare thing, but I always thanked God I had seen it.

 ③ & yet with all the hate that I had bottled up within me I could never wish them ~~say the word~~ eternally damnation.

 ② When I first heard the story from my ~~gray haired~~ mother. remembrance of the war–we were in Fredrick Md. house nailed up as if abandoned cooking done at night, Rebel soldiers passing all day ⑤ one stopped & banged at the door spreading terror through this house finally a officer came & sent him on a 2ⁿᵈ time in 1914 our little house in the North of France was nailed up & an American flag drawn in color upon the shutters. & our valuables buried in the garden

 ⑤ & from our attic window the rebel camp & soldiers could be seen once my father for some cause was at the little station & by his clothes was recognized as a minister, "Hello! Sambo what are you doing with these duds on." Take this & he was kicked out if the Station–I believe my father said he was drunk

 we early heard the story of [*Barberie Frotichie?*]

Write my atobi [*autobiography*]–I suppose I should commence as most that I have read commence –I first saw the light of day Jun 11 1859 at Pitts Pa. or at least that is what I am told. I have no reason to doubt it accuracy. ~~After~~ this one event for which I depend upon others, ~~all seems a blank until~~ To me life only commenced when I was about 5 yrs old. When my sister Halle was born, & I was sent to my grandmothers "on the Hill" I got milk for her. Nearly the first time a cow in a nearby field Moo & I struck a bee line for home after that my mother or some one had to sit at the Window and wave a

~~flag of truce to the cow~~ & to me & thus keep my courage up–as long as the signal waved I moved ahead–but if the figure at the window disappeared [*illegible*] arm wearied–[*illegible*] ~~gained~~ prevailed–troubles commenced early in my life.①

Learning my letters –without tears did not existe in those days, I am sure ~~if they ha~~ What would have their had existed those numerous tests that are so much in vogue now ~~These days~~ (to my poor mother &) father I refuse to think ~~would have been disconsolate~~ ~~[*illegible*] eldest~~

This job of learning me my letters was committed to a Mr Jones a most patient individual, I am told all I knew was that I could never tell if he was looking at me, as mine was only an eye source–I was always in trouble with my self when I found he was not looking at me, I had thought he was, or with him when I thought he was not looking at me he was regarding me intently –but to learn abc to z and then z y x w to [*illegible*] was a task such as the Egyptian ~~loaded~~ required of the Israeles & afterwards when that was accomplished. I was asked to know each letter for itself it was indeed like requiring bricks without straw, to me Mr Jones no Egyptian taskmaster had ever been more unreasonable. Could now anything be more unreasonable, I had spent weeks learning abcde, & then other weeks z y x w to a–like lightning & without fault,–to have imagined that these Herculean tasks having been accomplished your education was on a fair road to be completed, to them this be required to know; from g without commencing abcd–why–it was simply too much, life

EXHIBITION

50 Joseph Kosuth
to Leo Castelli, letter, ca. 1971
1 p., annotated typescript with nail attached
28 x 22 cm
Leo Castelli Gallery records, ca. 1957–90

.

51 Charles M. Kurtz
list of works of art for the U.S. galleries of the World's Columbian Exposition, Chicago, 1893
1 p., handwritten, excerpted
30 x 15 cm
Charles M. Kurtz papers, 1843–1990

United States

	Rev	
Gallery 3—	✓577—	Sargent — Ellen Terry
	✓532—	Hitchcock — Tulips
	✓573—	Melchers — Sermon
Gallery 5—	✓353	Vonnoh —November
	✓300	Dannat — Spanish Girls—
	✓307	MacMonnies — June Morning
	✓285	Robb. Reid — Port. of Little Miss S.
	✓276	Twachtman — Brook in Winter
Gallery 4—	✓254—	Jouett — Portrait of John Grimes.

	✓212—	Smybert — Bp. Berkley
	✓214—	Stuart — Washington.
	✓218—	Bingham — Election.
	✓220—	Bingham — Election Returns.
Quiet	✓209—	Bingham — Stump Speech
	✓206—	Bingham — Jolly Flatboatman.
	✓198—	W.S. Mount — The Long Story.
	✓234—	Allston – Paul & Silas.
	✓243—	Cole — Roman Aqueduct
	✓249—	Copley — Port. of Madam Boylston.
		H.P. Gray — Judgment of Paris.
		~~(Hovenden) – Bringing Home the Bride~~
		Dielman — A N.Y. Arab
Gallery 7—	✓502—	McEwen — Sorceress
	✓476 —	Orrin Peck — The Letter
Gallery 6—	✓410v	E.L. Weeks — The Ganges

Rev refers to Revised Catalogue Number, the position of the work within the Fine Arts building. Complete artist, titles, and dates are as follows: John Singer Sargent (1856–1925), Portrait of Ellen Terry as Lady Macbeth (ca. 1889); George Hitchcock (1850–1913), Tulip Culture, Holland (1887); Gari Melchers (1860–1932), The Sermon (1886); Robert W. Vonnoh (1858–1933), November (1890); William T. Dannat (1853–1929), Spanish Women (1892); Frederick MacMonnies (1863–1937), June Morning (1888); Robert Reid (1862–1929), Portrait of Little Miss S.; John Henry Twachtman (1853–1902), Brook in Winter (ca. 1892); Matthew Harris Jouett (1787–1827), Portrait of John Grimes; John Smibert (also spelled Smybert, 1688–1751), Portrait of Bishop George Berkeley (ca. 1727); Gilbert Stuart (1755–1828), Portrait of George Washington (aka, The Lansdowne Portrait, 1796); George Caleb Bingham (1811–1879), County Election (1852), Election Returns (aka, The Verdict of the People, 1854–55), Stump Speech (1853–54), Jolly Flatboatmen in Port (1857); William Sidney Mount (1807–1868), The Long Story (aka, The Tough Story, 1837); Washington Allston (1779–1843), Paul and Silas in Prison (1981); Thomas Cole (1801–1848), Roman Aqueduct (aka, Aqueduct near Rome, 1832); John Singleton Copley (1738–1815), Portrait of Madame Boylston (subject is likely Sarah Morecock Boylston, 1766); Henry Peters Gray (1819–1877), Judgment of Paris (ca. 1961); Thomas Hovenden (1840–1895), Bringing Home the Bride (1883); Frederick Dielman (1947–1935), A New York Arab; Walter McEwen (also spelled MacEwen, 1860–1943), The Witches; Orrin Peck (1860–1921), Love's Token (ca. 1892); Edwin Lord Weeks (1849–1903), The Last Voyage: A Souvenir of the Ganges (ca. 1885).

.

52 Marvin Lipofsky
price list for the State University of New York at Binghamton, October 15, 1971
1 p., handwritten, ill.
28 x 22 cm
Marvin Lipofsky papers, 1946–2004

.

53 Betty Parsons Gallery, New York
checklist for the exhibition Paintings by Bob Rauschenberg, May 14, 1951
1 p., annotated typescript
28 x 22 cm
Betty Parsons Gallery records and Betty Parsons papers, 1927–85

.

54 Ad Reinhardt
list of paintings, ca. 1966
1 p., handwritten, ill.
22 x 28 cm
Ad Reinhardt papers, 1927–68

.

55 Juta Savage
to Dorothy Weiss, letter, October 6, 1984
1 p., handwritten, ill.
36 x 43 cm
Dorothy Weiss Gallery records, ca. 1964–2001

.

56 Everett Shinn
list of paintings for The Eight exhibition in his account
book, 1908
1 p., excerpted, handwritten
22 x 15 cm
Everett Shinn collection, 1894–1953

1908.
National Arts Club.
(Send Dec. 20) (oil)
1. Spanish Dance, Music Hall. 300.
2. Outdoor Stage. France. 250.
Exhibition of the Eight.
Macbeth's — Feb. 3 to 18.
1. Gaieté Montparnasse. 300.
2. Rehearsal of the Ballet 400.
3. White Ballet. 400.
4. Leader of the Orchestre. 400.
5. The Gingerbread Man. 400.
6. ~~Orchestre pit~~ (Trapeze Artist) 400.
7. Girl in Blue. 300. ~~Sold. Mrs. Harry Payne Whitney.~~
8. Hippodrome London. 500.
Exhibition of the Eight.
Phila. Penn'a Academy.
March 7 to 28.
1. Gaieté Montparnasse. 300.
2. Rehearsal of the Ballet. 400.

After the original exhibition at the Macbeth Gallery, the show went on a tour that began in March at
the Pennsylvania Academy of Fine Arts.

.

57 N. C. Wyeth
"List of titles for Andrew Wyeth's watercolors," October
6, 1937
3 pp., handwritten
26.5 x 20 cm
Macbeth Gallery records, 1838–1968

List of titles for (A)
Andrew Wyeth's water colors.

Large papers.

Mrs Pegram Coast farm

1	The Lobster Trap	Mrs C V Whitney
2	The Lobster-man	Sold Miss Emmett
3	The Gray House in Martinsville	Ret
4	The Bobsled	Balto W. C. Ex.
5	Patching the Roof	Mr Geo Barsow Jr.
6	Surf –An impression	Janie Homesy
7	Fishermans Houses	Ret
8	The Bay	
9	The Gam	Stock
10	Early Morning	B. [*illegible*]
11	Sunrise	Stock
12	In Port Clyde	Ret
13	Silver Sunrise	F. M. [*Weed?*]
14	Maine Fisherman	Balto WC Ex

small papers

15	Church of the Fishermen	ER Bromley
16	Fisherman's Son	Ret
17	Impression	Ret
18	Caldwell's Island	Mrs Robt F. Welch
19	The Lobster Car	Stock
20	After the Shower	Robt Brackman

List of titles continued (B)

21	A telephone pole near the sea	Ret
22	The Artist	Stock
23	Herring Fishermen in the Wiers	Stock
24	The Clam Digger	Geo E Kelley
25	Lone House	Ret
26	Opalescent Sea	Mrs Rott Wheelwright
27	The Sail Loft	Stock
28	The Spring Tooth Harrow	Ret
29	Head of the Cove	Stock
30	Dory on the Beach	Mrs. Robt Wheelwright
31	Off Teals Island	" " "
32	Cove on Mosquito Island	Stock
33	Harbor Ice House	Vincent Price
34	Rockweed on Monhegan	Ret.
35	Gull and Water	Stock
36	In the Churchyard	Ret
37	The Ledge at the Island	Stock
38	Clam Bake	J. H. Coneter
39	Off the Flat Ledges	F. A. Godley
40	On the Glenmere Road	Mrs. H M Lloyd
41	Pot. Buoy and Kelp	Ret
42	Black Spruce	Ret
43	The Shower	Mrs E C Crosnett

List Continued (C)

| 44 | In the Harbor | Mrs Frederic Marsh. |
| 45 | The wood Pile | Ret |

46	Across the Cove	S. J. [*Schrann?*]
47	The Blue Pot Buoy	Ret
48	The Apple Tree	Mrs. Robt
		Wheelwright

INSPIRATION

58 Jonathan Borofsky
to Lucy R. Lippard, letter, August 14, 1974
2 pp. (1 folio), handwritten
28 x 22 cm
Lucy R. Lippard papers, ca. 1940–2006

Aug. 14, 74
Dear Lucy,

Im still counting (2,166,003 as of this morning) and making those personal "feeling" or "psychological" paintings on canvass board. The paintings have taken on a greater importance for me recently. Some of the latest ones are titled–

1. I'm afraid of death
2. I dreamed I could fly
3. Sabby makes me angry when he barks
4. I'm afraid to sleep alone in the house
5. Im afraid Benita didn't get home safely.
6. I dreamed my sailboat was spotlighted on a stage.
7. Paul inflicts his need to be perfect on others
8. I feel like crying.

As you can see, the subject matter has become more immediate and "everyday" rather than deal with the past ("man I lost the elections") I've also had one full dream that I've been able to paint.

So things have been going very well here in Southampton. You have a standing invitation to come out here for some ocean when you wish. Bring Charles and Ethan for a weekend or come alone. Our telephone is 516 283 1707.

Otherwise we'll see you soon. (Maybe you'll come out in the fall.

Part of the purpose of writing this letter is to thank you for writing the article about me–It was a simple and clear explanation of what I was doing–no baloney! I'll look forward to seeing it in print. I have two presents ~~for you~~ that I'll give to you in Sept. —rather than trust them to the mails.

So thanx again.
Hope you are having an enjoyable summer.
Jon

Ethan is Ethan Ryman, son of Lippard and Robert Ryman. Charles is sculptor Charles Simonds (b. 1945).

.

59 George Catlin
"Amusements," in notebook no. 6, ca. 1830
1 p., excerpted, handwritten
18 x 15 cm
George Catlin papers, 1821–1904, 1946

Amusements
Ball play dance
Ball play – Ball up
Ball play – Ball down
Ball play of the women
Game of 'Tchung=Kee"
horse Race
Foot Race
Canoe race
Archery. Mandans
Dance of the Chiefs. Sioux –
Dog Dance. Sioux –
Scalp Dance. Sioux.
Begging Dance. Sacs & Foxes.
Buffalo Dance. Mandans
Ball play Dance. Choctaw
Dance to the Berdash. Sac.
Beggars Dance – Sioux
Dance to the Med. Bag of the Brave Sac.

.

60 Arthur Dove
list of weather abbreviations, in log of the *Mona*, 1924
1 p., excerpted, handwritten
20 x 12 cm
Arthur and Helen Torr Dove papers, 1905–74

b	Blue Sky clear or hazy
c	Cloudy. detached opening clouds
d.	drizzly rain
f.	fog.
g	gloomy — dark
h	hail
l	lightning
m	Misty so as to interrupt view
o	overcast impervious clouds
p	passing Showers
q	squally
r	rain — continuous
s	snow
t	thunder
u	ugly heavy
v	visibility

AGD 1924 [*on tape*]
Log of Mona [*underneath tape*]
　　May 4 Sunday.
At wharf. Caught T winds
7.30 AM. wind, SE
Rips B [*blue sky*]. 5 gal. Gas 3 gal Oil. —
　　May 5
Worked on Pict. Rev. "Bros."
Smooth SE. 2. B [*blue sky*]. 7.30 AM. F [*fog*]. Low.
　　May 6
Pict. Rev. Tested R.P.M.
350. poor. Gasket. rocker

196

arms. SE, Smooth B [*blue sky*].
11:30. 7 even.
 May 7.
6. AM. SE. 1 Rps. R.T.L. [*rain, thunder, lightning*]
 May 8 9 10 11 12
Rain S.E. 4–9

.

61 Reginald Marsh
to Lawrence A. Fleischman, letter, June 10, 1953
1 p., handwritten
28 x 22 cm
Lawrence and Barbara Fleischman papers, 1863–1970

June 10–53–
Dear Mr. Fleischman:

 In response to your letter reprinting.
 The artists conception of, Eyes Tested—
No. 1– In 1944—I was making a series of drawings in monochrome in Chinese ink
No. 2– The location painted ~~was~~ is situated near my house—I saw the eyes tested "signs" almost daily.
No. 3– The doorways of 3rd Ave were often used by drunks for resting places
No. 4– Although I am male and well married, I like to think about young girls, and to paint them—
No. 5– I am not senile. I am 55.
No. 6– The 3rd Ave El. station and tracks eventually to be torn down—are good to paint.
No. 7– I like to play with light & shadow effects.
No. 8– all these together would be good picture materials
No. 9– After your version I tried again once or twice—but didn't seem to do it well.
No 10– The "eyes" blew away in the hurricane
 Yours truly—
 Reginald Marsh

.

62 Robert Morris
to Samuel J. Wagstaff, postcard, February 13, 1967
© 2009 Robert Morris/Artists Rights Society (ARS), New York
1 item, typescript
9 x 14 cm
Samuel J. Wagstaff papers, 1932–85

.

63 Ad Reinhardt
to Katherine Scrivener, postcards, April 16, 1951
3 items, handwritten
8 x 14 cm
Ad Reinhardt postcards to Katherine Scrivener, April 16, 1951

.

64 Eero Saarinen
list of Aline Bernstein's good qualities, ca. 1954
1 p., handwritten
28 x 22 cm
Aline and Eero Saarinen papers, 1857–1972

.

65 Charles Green Shaw
"The Bohemian Dinner" poem, undated
1 p., typescript
28 x 22 cm
Charles Green Shaw papers, 1874–1979

.

66 Robert Smithson
"A Metamorphosis of the Spiral," in his sketchbook, ca. 1970
9 pp., excerpted, handwritten
30 x 23 cm
Robert Smithson and Nancy Holt papers, 1905–87

A Metamorphoses of the Spiral

1 "Large rectilinear trapezoidal spaces were also cleared, and there are furthermore a number of spirals and large figures of animals." (Nazca region). The Ancient Civilizations of Peru, J Alder Mason

2 "When a hurricane is fully formed its maelstrom of winds moves in a vast spiral around the center of the storm — hence "cyclone" (one of the popular names for a hurricane meaning 'coil of the snake'." The Elements Rage, Frank W. Lane

3 "However, later experimental evidence has not only beautifully confirmed the spiral growth of crystals, but has also been helpful in understanding the phenomenon of polytypism." Polymorphism and Polytypism in Crystals, Ajit Verma and P. Krishna

4 "The Mysterious Gnosis raises up endlessly its spiral, and, driven by us, thou shalt ascend ceaselessly toward the irradiating syzygia, which will carry thee high above in the bosom of the perennial Bythos, in the immovable circle of the perfect Pleron." Tentations – Gustave Flaubert

5 "One of his most symptomatic literary projects is that of

La Spirale, [*arrow pointing to the word "Spirale"*] (Flaubert), which was to describe a state of permanent somnambulism of a hallucinated madman."
<u>The Novels of Flaubert</u> Victor Brombert

[*unnumbered*] "He (Flaubert) talked much of writing a story called <u>La Spirale</u>. He died before he began it…"
<u>A Vision</u> W. B. Yeats

6 "Brancusi's 'symbol of Joyce' is a spiral suggesting visual as well as aural contexts of the labyrinth."
<u>The Cyclical Night</u> – L. A. Murillo

7 "Sometimes he (Joyce) would tell picaresque tales of his father's wit, and the last one I remember was one that concerned his father's reaction in Dublin to a minuscule sketch of Joyce made by Brancusi. It was merely a geometrical spiral study symbolizing the ear. "Well Jim hasn't changed much," said his father on seeing the portrait.
<u>My Friend James Joyce</u> – Eugene Jolas

8 "I must have got embroiled in a kind of invented spiral, I mean one the coils of which, instead of widening more and more, grew narrower and narrower and finally, given the kind of space in which I was supposed to evolve, would come to an end for lack of room."
<u>The Unnamable</u> – Samuel Beckett

9 "If we consider the simplest spiral, three stages may distinguished in it, corresponding to those of the triad, we can call the 'thetic' the small curve or arc that initiates the convolution centrally: 'antithetic' the larger arc that faces the first in the process of continuing it; and 'synthetic' the still ampler are that continues the second while following the first along the outer side."
<u>Speak, Memory: A Memoir</u> – Vladimir Nabokov

10 "Spirals seen on edge cannot always be placed with precision, but they can be assigned with some confidence to general regions of the sequence.
<u>The Realm of The Nebulae</u> Edwin Hubble

11 "In this series of drawing in the exhibition and in the works that derive from the same rhythm of proliferation, the spiral figuration is the dilation of the space as it develops in accordance with the Fibonacci series." <u>Note on an Exibition</u> Mario Merz

12 "The oldest form of the spiral associated with the lotus are found in Egyptian tomb ceilings."
<u>Spirals in Art and Nature</u> Theodor Cook

13 "For, just as Proffessor Cayley recorded the past in the two dimensions of a black surface, so the progress of the solid future entwined the body in spirals." <u>Concerning the Line</u> Alfred Jarry

14 "He had just been treading the 'Shepherds Labyrinth' a complicated spiral maze traced there upon the turf ; and was boasting of his skill, how dexterously and truly he would pursue its windings without a single false step, and how will a little more practice he would wager to go through it blindfold!"
<u>The Washingtons</u> N. J. Simpkinson

15 "Again, by its trajectory of line the spiral, like the circle completes itself, it is 'introvertive', if I may so put it."
<u>Some Unorthodox Reflections on the Spiral in Maori Ornament</u> – W. Page Rowe

16 "I knew simply by instinct that the spirals of Maya-land were indubibitably connected with Mu the Motherland!"
<u>The Spirals of Mu-Land</u> Louis R. Effler

17. "The culmination of the curved figure is the spiral, which the last of the baroque artists, Pironesi, was later to invent with a hullicinatory character in the spiral of the <u>Carceri</u>."
<u>Mnemosyne</u> Mario Praz

18. "In Sant Ivo alla Sapienza, the chapel of the University of Rome, Borromini has set soaring above a hexagon a round dome surmounted by a lantern which is continued in a spiral."
<u>The Age of Grandeur</u> Victor L. Tapié

19. "A spiral; a winding staircase in the Tower of Babel; a path of an airplane rising aloft in circles – such is the way of art."
<u>On Synthestism</u> Yevgeny Zamyatin

20. "Then I remembered the huge, compact spiral of dazzling suns which once, with intolerable glare of fierce white light, had etched every bone of the Desert."
<u>The Time Stream</u> John Taine

.

67 Abbott Handerson Thayer
notes on concealing coloration in nature, ca. 1915
2 pp., handwritten, ill.
21 x 13 cm
Abbott Handerson Thayer and Thayer Family Papers, 1851–1999

.

68 Leo Van Witsen
list of costumes, November 6, 1948
1 p., handwritten with fabric samples attached
28 x 22 cm
Frederick Kiesler papers, 1923–93

Brookline Nov. 6. '48
LEO VAN WITSEN
157 Mountfort St
Brookline 46 Mass.
<u>The wife's costume:</u>

1	the Bodice
2.	the lining of the white petticoat.
3	the skirt (green)
4.	the skirt (blue)
5.	the 2nd petit coat (turquoise)
6.	the veil
	(the yellow ribbon is not there yet)

the father's costume:

1	the pants
2	the coat
3 & 4	the shirt
5	the trimming of the coat

the sailor.

1	the suit
2	the green outlining
3b	the stormcoat (the plastic material to be backed in black.)

The friend

1	the pants
2	the shirt.

.

69 Grant Wood
list of economic depressions, November 1931
1 p., typescript, carbon copy, annotated with the date
January 26, 1932
27 x 21 cm.
Grant Wood papers, 1930–83

THE LIST AS ART

Samuel J. Wagstaff, from an untitled lecture on "multiplicity in art," ca. 1965. Samuel J. Wagstaff papers, ca. 1932–85.

EXPENSES

Robert Rauschenberg, from an interview conducted by Dorothy Seckler for the Archives of American Art, December 21, 1965.

INSTRUCTIONS

William Mills Ivins, from his notebook, 1927–28. William Mills Ivins papers, 1878–1964.

RECORDING NAMES

Ludwig Sander, from an interview conducted by Paul Cummings for the Archives of American Art, February 4, 1969.

INVENTORY

Ray Johnson, from an interview conducted by Sevim Feschi for the Archives of American Art, April 17, 1968.

TO-DO PERSONAL AND PRIVATE

Charles Green Shaw, from untitled short writings, undated. Charles Green Shaw papers, 1874–1979.

BIOGRAPHICAL DETAILS

Philip Evergood, from "An autobiographical sketch," ca. 1957. Philip Evergood papers, 1910–70.

EXHIBITION

Walt Kuhn, from a letter to his wife, Vera, December 14, 1912, concerning the 1913 Armory Show. Walt Kuhn, Kuhn family papers, and Armory Show records, 1859–1978.

INSPIRATION

Oscar Bluemner, from "Foreword," handwritten draft, ca. 1935. Oscar Bluemner papers, 1886–1939, 1960.

INTRODUCTION

Page 8 Margaret De Patta, list of orders for jewelry, ca. 1946. Margaret De Patta papers, 1944–2000.

Page 10 Janice Lowry, to-do list, July 5, 2003, journal no. 101, 2003. Janice Lowry papers, 1957–2008.

Page 13 Ad Reinhardt, "Artist's Chronology by Ad Reinhardt," ca. 1966. Ad Reinhardt papers, 1927–68.

Page 14 Benson Bond Moore, list of prints sold, 1937–39. Benson Bond Moore papers, 1895–1995.

Page 15L Franz Kline, grocery list, ca. 1962. Elisabeth Zogbaum papers regarding Franz Kline, 1928–65.

Page 15R Franz Kline, receipt, December 31, 1960. Elisabeth Zogbaum papers regarding Franz Kline, 1928–65.

Page 17 Oscar Bluemner, notes for a landscape painting of Little Falls, New Jersey, from his painting diary, 1917. Oscar Bluemner papers, 1886–1939, 1960.

Page 18 Stanton Macdonald-Wright, "Plate I, Inherent—saturation spectrum," undated. Stanton Macdonald-Wright papers, 1907–73.

LIST AS ART

Page 22 Vito Acconci, November 29, 1975. Polaroid prints possibly by Bruce D. Kurtz. Bruce D. Kurtz video and audio recordings and papers, 1966–95.

Page 24 Karl Knaths, 1960. Photograph by Arnold Newman. Arnold Newman/Getty Images. Arnold Newman photographs of artists, ca. 1940–60.

Page 28 Benson Bond Moore, ca. 1945. Photobooth photo strip by Benson Bond Moore. Benson Bond Moore papers, 1895–1995.

Page 30 Joan Snyder at work on her painting *Resurrection*, 1976. Photograph by Larry Fink. Courtesy of Joan Snyder.

EXPENSES

Page 34 Paula Cooper during the installation of a Dean Fleming and Anthony Magar exhibition, September 18, 1966. Photograph by Peter Moore. © Estate of Peter Moore/VAGA, NYC. Paula Cooper Gallery records, 1965–73.

Page 36 Willem de Kooning in his studio at 85 Fourth Avenue, New York City, 1952. An early version of *Woman I* (1952) is in the background. Photograph by Kay Bell Reynal. Photographs of artists taken by Kay Bell Reynal, 1952.

Page 38 George Peter Alexander Healy stands with his palette and brushes in his studio on the rue de la Rochefoucauld in Montmartre, Paris, with an unidentified visitor, ca. 1885. Photographer unknown. Photographs of artists in their Paris studios, 1880–90.

Page 40 Reginald Marsh sketching on the carousel at Coney Island, undated. Photograph by Gene Pyle. Reginald Marsh papers, 1897–1955.

Page 42 Henry Mosler in his Paris studio with his painting *The Wedding Feast*, 1892. Photographer unknown. Henry Mosler papers, 1856–1929.

INSTRUCTIONS

Page 50 Art Workers' Coalition, flier for a demonstration at the Museum of Modern Art, ca. May 1969. Virginia Admiral papers, ca. 1947–89.

Page 52 George Biddle at work on his mural *Society Freed through Justice* in the fifth-floor lobby of the Attorney General's Office, United States Department of Justice Building, Washington, D.C., 1936. Photographer unknown. Federal Art Project, Photographic Division collection, 1935–42.

Page 54 Arthur Wesley Dow, 1913. Photograph by James S. Radcliffe. Arthur Wesley Dow papers, ca. 1826–1978.

Page 60 Frederick Hammersley, study for "An Idea," undated. Various media, 8 x 8 cm. Frederick Hammersley papers, 1944–2007.

Page 62 Hans Hofmann teaching at the Hans Hofmann School of Fine Arts, Provincetown, Massachusetts, ca. 1945. Photographer unknown. Hans Hofmann papers, ca. 1904–78.

Page 64 Lee Krasner, ca. 1938. Photographer unknown. Jackson Pollock and Lee Krasner papers, ca. 1905–84.

Page 66 Henry Varnum Poor in his studio, ca. 1930. Photographer unknown. Forbes Watson papers, 1900–50
Page 68 Arturo Rodríguez, 1993. Photograph by Glick. Demi and Arturo Rodríguez papers, 1982–97.

RECORDING NAMES

Page 72 Paul Bransom sketching a leopard in Hollywood, California, ca 1928. Photographer unknown. Paul Bransom papers, 1862–1983.

Page 74 Alexander Calder, *Cirque Calder* invitation, October 14 [1930]. Block print, ink on paper, 21 x 13 cm. Alexander Calder papers, 1926–67.

Page 76 Philip Evergood working on his mural *Cotton— From Field to Mill* for the U.S. Post Office in Jackson, Georgia, 1938. Photographer Unknown. Philip Evergood papers, 1910–70.

Page 78 Ray Johnson, 1971. Photograph by Jack Mitchell. © Jack Mitchell. Jack Mitchell photographs of artists, 1966–77.

Page 80 Walt Kuhn with models. Photograph by George Karger for *Collier's Magazine*, January 1948. Walt Kuhn, Kuhn family papers, and Armory Show records, 1859–1978.

Page 82 Art dealer Samuel Kootz and Pablo Picasso, December 29, 1947. Photographer unknown. Kootz Gallery records, 1931–66.

Page 84 Ninth Street Show, 60 East Ninth Street, New York City, May 21 to June 10, 1951. Photographer unknown. Leo Castelli Gallery records, ca. 1957–90.

INVENTORY

Page 88 Oscar Bluemner, landscape study, ca. 1911, from his painting diary, June 12, 1911 to January 30, 1912. Crayon and ink on paper, 12 x 18 cm. Oscar Bluemner papers, 1886–1939, 1960.

Page 90 Alexander Calder, 1956. Photograph by Foto Mercurio. Alexander Calder papers, 1926–67.

Page 92 Joseph Cornell, 1933. Photograph by Lee Miller. © Lee Miller Archives, England 2009. All rights reserved. www.leemiller.co.uk. Katherine Segava Sznycer papers, 1949–76.

Page 94 Margaret De Patta at work, 1948. Photograph by George Straus. Margaret De Patta papers, 1944–2000.

Page 96 William Mills Ivins, ca. 1900. Photograph by Gertrude Käsebier. William Mills Ivins papers, 1878–1964.

Page 98 Asher B. Durand, *John Trumbull*, 1833. Engraving, ink on paper, 28 x 21 cm. Charles Henry Hart autograph collection, 1731–1912.

Page 100 Morris Louis, ca. 1950. Photographer unknown. Miscellaneous photograph collection.

Page 102 Germain Seligmann, 1920s. Photographer unknown. Jacques Seligmann & Co. records, 1904–78.

Page 104 Bob Thompson, undated. Photograph by Charles Rotmil. Bob Thompson papers, 1955–2000.

Page 106 Worthington Whittredge, ca. 1864. Photograph by George Gardner Rockwood. Miscellaneous photograph collection.

TO-DO PERSONAL AND PRIVATE

Page 110 William E. L. Bunn painting his mural *1848, Fort Kearney, Protectorate on the Overland Trail, 1871* in his studio in Muscatine, Iowa, for the Minden, Nebraska, post office, ca. 1938. Photographer unknown. William Edward Lewis Bunn papers, 1935–86.

Page 112 Leo Castelli at the Leo Castelli Gallery, 420 West Broadway, New York City, 1978. Photograph by J. Woodson. Castelli Gallery records, ca. 1957–99.

Page 114 Nickolas Muray (left) and Miguel Covarrubias (right), ca. 1940. Photograph by Nicolas Muray. © Nickolas Muray Photo Archives. Nickolas Muray papers, 1911–78.

Page 116 John D. Graham in an antique military uniform, ca. 1938. Photographer unknown. John D. Graham papers, ca. 1890–1961.

Page 118 Janice Lowry in her studio in Whittier, California, 1983. Photographer unknown. Janice Lowry papers, 1957–2008.

Page 120 Inscribed on verso: James Penney. Lawrence, Kansas, 1929–31. Photographer unknown. James Penney papers, 1913–84.

BIOGRAPHICAL DETAILS

Page 124 Harry Bertoia at Knoll Associates, Inc., ca. 1952. Photograph by Herbert Matter. Gyorgy Kepes papers, 1825–1989.

Page 126 Louis Michel Eilshemius, October 4, 1913. Photograph by Jim Saah. Louis M. Eilshemius letters and photograph, ca. 1892–1931.

Page 128 Charles Green Shaw, *H. L. Mencken*, ca. 1929. Ink caricature with photograph of Mencken, 25 x 19 cm. Charles Green Shaw papers, 1874–1979.

Page 130 Henry Ossawa Tanner, 1907. Photograph by Frederick Gutekunst. Henry Ossawa Tanner papers, 1860s–1978.

EXHIBITION

Page 134 Joseph Kosuth, 1979. Photograph by Sarah Charlesworth, Castelli Gallery records, ca. 1957–90.

Page 136 Charles M. Kurtz, assistant to the chief of the Fine Arts Department, World's Columbian Exposition and Halsey C. Ives, chief of the Fine Arts Department, ca. 1893. Photographer unknown. Charles M. Kurtz papers, 1843–1990.

Page 138 Marvin Lipofsky in Kansas City Missouri, March 1972. Photograph by Kathe Hamilton. Marvin Lipofsky papers, 1946–2004.

Page 140 Robert Rauschenberg, 1962. Photographer unknown. Leo Castelli Gallery records, ca. 1957–99.

Page 142 Ad Reinhardt in his studio, 1955. Photograph by Walter Rosenblum. © Rosenblum Photography Archive.Thomas Hess papers, 1941–78.

Page 146 Everett Shinn, Robert Henri, and John Sloan, ca. 1896. Photographer unknown. Miscellaneous photograph collection.

Page 148 Andrew Wyeth and N. C. Wyeth, ca. 1940. Photographer unknown. William E. Phelps papers, 1939–79.

INSPIRATION

Page 152 Jonathan Borofsky, *Self Portrait in the Mountains of Southern California*, 1979. Photograph by Megan Williams. Courtesy of Jonathan Borofsky.

Page 154 George Catlin, *Catalogue of Catlin's Indian gallery of portraits, landscapes, manners and customs, costumes, &C. &C., collected during seven years' travel amongst thirty-eight different tribes, speaking different languages.* New York: Piercy & Reed, 1837 (first edition). Annotated on cover: "This gallery I visited at Washington City D.C. May 2nd & 3rd 1838 in company with I. [illegible] Richards a very interesting exhibition. W. T. S." George Catlin papers, 1821–1904, 1946.

Page 156 Arthur Dove and Helen Torr, ca. 1925. Photographer unknown. Arthur and Helen Torr Dove papers, 1905–74.

Page 158 Reginald Marsh, sketch of a woman, ca. 1948. Ink on paper, 26 x 25 cm. Reginald Marsh Papers, 1897–1955.

Page 164 Aline and Eero Saarinen, ca. 1954. Photographer unknown. Aline and Eero Saarinen papers, 1857–1972.

Page 166 Charles Green Shaw, self-portrait, ca. 1930. Colored pencil on paper, 25 x 21 cm. Charles Green Shaw papers, 1874–1979.

Page 168 Robert Smithson, Great Salt Lake, Utah, exhibition poster (detail), Dwan Gallery, New York City, October 31 to November 25, 1970. Dwan Gallery records, 1959–71.

Page 170 Abbott Handerson Thayer, ca. 1861. Photograph by Buckingham's Inc. Abbott Handerson Thayer and Thayer family papers, 1851–1999.

Page 174 Grant Wood in his studio in Cedar Rapids, Iowa, with his painting *The Midnight Ride of Paul Revere* (1931), 1931. Photograph by John W. Barry. Grant Wood papers, 1930–83.

Acconci, Vito 22–23
Antheil, George 74
Arp, Hans 12
Art Workers' Coalition 50–51
Beckett, Samuel 168
Belon 46–47, 180
Bernstein, Aline 9, 164
Bertoia, Harry 124–25
Betty Parsons Gallery 140–41
Biddle, George 52–53
Bing, Ilse 74
Bluemner, Oscar 16, 17, 88–89, 150
Bocour, Leonard 99
Borofsky, Jonathan 152–53, 196
Brackett, Augustus 56
Brancusi, Constantin 12, 74
Bransom, Paul 72–73
Braque, Georges 82
Brodie, Gandy 35
Bruce, Edward 51
Bunn, William E. L. 110–11, 189
Burr, Aaron 45
Calder, Alexander 9, 12, 74–75,
 90–91, 184–86
Castelli, Leo 112–13, 134–35
Catlin, George 154–55, 196
Cézanne, Paul 24
Club, The (also known as The Eighth
 Street Club) 11, 84
Cocteau, Jean 172
Cooper, Paula 11, 34–35, 178
Copley, John Singleton 136
Cornell, Joseph 92–93
Covarrubias, Miguel 114–15, 190
Cummings, Paul 84
Dale, Chester 12
Davidson, Jo 82
Davies, Arthur B. 146
de Kooning, Elaine 12, 16, 36–37, 179
de Kooning, Willem 12, 16, 36
De Patta, Margaret 8–10, 94–95
Dirk, Gus 72
Dove, Arthur 156–57, 196
Dow, Arthur Wesley 54–55
Dreier, Katherine S. 125
Duchamp, Marcel 11, 82, 126
Durivage, Francis Alexander 56–57, 181
Eight, The 146
Eilshemius, Louis Michel 126–27
Evergood, Philip 12, 76–77, 122, 185
Felsen, Sidney 112
Fleischman, Lawrence A. 158
Frankenthaler, Helen 100
Gellert, Hugo 58–59, 182
Glackens, William 145
Goldberg, Michael 16

Graham, John D. 10, 36, 116–17, 191
Grahame, Kenneth 72
Gris, Juan 11, 82
Guston, Philip 16
Hammersley, Frederick 60–61, 182
Harrison, Jr., Joseph 154
Healy, George Peter Alexander (G. P. A.)
 38–39, 180
Heizer, Michael 44
Henri, Robert 146
Hofmann, Hans 62–63, 182
Ives, Halsey C. 136
Ivins, William Mills 48, 96–97, 187
Johns, Jasper 112
Johnson, Ellen H. 78
Johnson, Ray 78–79, 86
Judd, Donald 112
Kelly, Ellsworth 112
Kienbusch, William 66
Kiesler, Frederick 172
Kline, Franz 15–16, 62, 84
Kline, Herbert 114
Knaths, Karl 24–25
Konrad, Adolf 26–27
Kosuth, Joseph 134–35
Krasner, Lee 64–65, 183
Kuhn, Walt 11, 80–82, 132, 185
Kurtz, Charles M. 11, 136–37, 194
Lanman, Abigail Trumbull 98
Lanman, David Trumbull 98–99, 188
Lawson, Ernest 146
Léger, Fernand 11–12, 82
Leslie, Alfred 36
Lichtenstein, Roy 112
Lipofsky, Marvin 138–39
Lippard, Lucy R. 30, 152
London, Jack 72
Louis, Morris 100–101
Lowry, Janice 10, 118–19, 191
Luks, George 146
Macbeth, Robert 148
Macdonald-Wright, Stanton 18
Man Ray 12
Marsh, Reginald 40–41, 158–59, 197
Martin, Henry 77
Maurer, Alfred 81
Mencken, H. L. 9, 128–29, 192
Milhaud, Darius 171
Miró, Joan 12, 90
Mondrian, Piet 12
Moore, Benson Bond 12, 14, 28–29
Morris, Robert 16, 112, 160–61
Mosler, Henry 42–43
Muray, Nickolas 114
Nauman, Bruce 112
Newton, Gordon 44–45

Ozenfant, Amédée 12
Pach, Walter 82
Pavia, Philip 83
Penney, James 120–21, 192
Perkin, Marlin 72
Picasso, Pablo 11, 82–83, 186
Pollock, Jackson 62
Poor, Henry Varnum 66–67, 183
Prendergast, Maurice 146
Rauschenberg, Robert 32, 112, 140–41
Raven, Arlene 30
Reinhardt, Ad 13, 16, 84, 142–43,
 162–63
Resnick, Milton 36
Rindge, Agnes 90
Rivers, Larry 16, 62
Rodríguez, Arturo 68–69
Rothko, Mark 16, 62
Rowe, Susan 64
Saarinen, Eero 9, 164–65
Saarinen, Lily Swann 164
Sander, Ludwig 70, 84–85, 186
Savage, Juta 144–45
Scrivener, Katherine 162
Seligmann, Germain 9, 102–3, 188
Shaw, Charles Green 108, 166–67
Shinn, Everett 146–47, 195
Siskind, Aaron 140
Sloan, John 146
Smithson, Robert 168–69, 197
Snyder, Joan 16, 30–31, 178
Spaventa, Giorgio 36
Steinbeck, John 114
Takis, Vassilakis 50
Tanner, Henry Ossawa 130–31, 193
Thayer, Abbott Handerson 170–71
Thompson, Bob 104–5
Thompson, Carol 104–5
Torr, Helen "Reds" 156
Twachtman, John Henry 136
Van Witsen, Leo 172–73, 198
Vanderlyn, John 46
Vogel, Dorothy and Herbert 21
Wagstaff, Samuel J. 20–21
Warhol, Andy 112
Weiss, Dorothy 144
Whittredge, Worthington 106–7, 189
Wood, Grant 174–75
Wyeth, Andrew 148
Wyeth, N. C. 148–49, 195
Zamyatin, Yevgeny 168